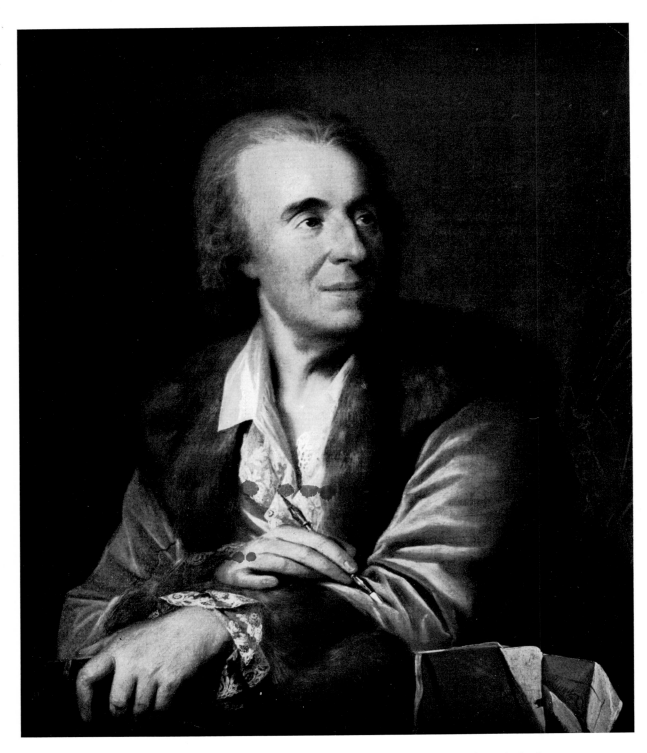

Portrait of Lambert Krahe, 1781, by Erik Pauelsen (1749–90). Düsseldorf, Staatliche Kunstakademie

Victoria & Albert Museum and Scottish Arts Council

Master Drawings of the Roman Baroque

from the Kunstmuseum Düsseldorf

A Selection from the Lambert Krahe Collection

Catalogue and Introduction by Dieter Graf

London and Edinburgh 1973

Price £1·75 net

SBN 901486 56 6

Printed in England for
Her Majesty's Stationery Office
by Eyre & Spottiswoode Ltd
Thanet Press, Margate

Foreword

When the proposal was mooted for exhibiting in London drawings from the Kunstmuseum der Stadt Düsseldorf, attention was first concentrated on the holding of a single exhibition which would represent the full range of the Düsseldorf collection. It became evident, however, that an anthology of this kind would do less than justice to the collection, and that it would be greatly preferable to hold two exhibitions of a more specialized kind. The first, in 1968, was devoted to the nineteenth century German drawings, and made available a wealth of material that had not previously been seen in London. The second is devoted to Roman drawings of the seventeenth century. For students of Seicento art the Roman drawings at Düsseldorf enjoy a legendary reputation – they rank indeed with those at Windsor and in the Louvre – and the catalogue of the Sacchi and Maratta drawings in the Kunstmuseum by Ann Sutherland Harris and Eckhard Schaar (1967) is among the most recent contributions to our knowledge of Roman painting in the second half of the seventeenth century. The present exhibition is devoted to the eleven Roman artists who are most strongly represented in the Düsseldorf collection. The initiative for this as for the previous exhibition is due to the Director of the Kunstmuseum der Stadt Düsseldorf, Dr Wend von Kalnein. We are greatly indebted to Dr von Kalnein for proposing and sponsoring the exhibition, and to Dr Dieter Graf for preparing the excellent catalogue.

JOHN POPE-HENNESSY
Director, Victoria & Albert Museum

This is not only a magnificent exhibition in its own right, but also a more-than-worthy successor to the two exhibitions of Italian 16th and 17th Century Drawings from British Private Collections shown at the Edinburgh International Festivals in 1969 and 1972.

The Scottish Arts Council is deeply grateful to the Kunstmuseum der Stadt Düsseldorf, and particularly to Dr Wend von Kalnein and Dr Dieter Graf, for allowing the exhibition to be seen in Scotland. Our thanks are also due to Keith Andrews of the National Gallery of Scotland for suggesting the idea; and to Sir John Pope-Hennessy, Graham Reynolds, and Peter Ward-Jackson of the Victoria and Albert Museum for their willing assistance and co-operation; and to Ivor Davies and the University of Edinburgh for displaying it in the Talbot Rice Arts Centre.

ALEXANDER DUNBAR
Director, Scottish Arts Council

Acknowledgments

During my visits to Print Rooms abroad I received very friendly encouragement from Matthias Winner and Peter Dreyer in Berlin, J. H. van Borssum Buisman in Haarlem, Dieter Kuhrmann in Munich, Roseline Bacou and Françoise Viatte in Paris, Lidia Bianchi in Rome and Eckhart Knab in Vienna.

I recall with gratitude the fruitful discussions on problems of attribution and dating I have had either by correspondence or in conversation with Ursula Fischer, Jennifer Montagu, Mary Newcome, Sabine Jacob, Ann Sutherland Harris, Jacob Bean, Peter Dreyer, John Gere, Hugh Macandrew and Eckhard Schaar.

Erich Schleier very generously placed his still unpublished studies on Giovanni Lanfranco at my disposal. I also owe to him the identification of nearly all the Lanfranco studies exhibited here. On a visit to the Düsseldorf Print Room Eckhart Knab helped me with valuable advice on the selection of drawings by Gaspard Dughet.

The preparation of this catalogue would not have been possible without the unfailing hospitality of the Bibliotheca Hertziana, for which I am most deeply grateful to Professor Wolfgang Lotz. In the library Hildegard Giess, Eva Stahn and Volker Hoffman were particularly helpful in assembling the photographs and Ernst Guldan in providing me with literature not available in Düsseldorf.

For photographs of drawings from collections in their care I am grateful to Gisela Bergsträsser, Darmstadt; Jennifer Sherwood and Teresa Fitzherbert, Windsor Castle; Anna Forlani Tempesti, Florence; Keith Andrews, Edinburgh; Per Bjurström, Stockholm; Erik Fischer, Copenhagen; Belinda Gore and R. C. Stodge, Courtauld Institute; and Gunther Thiem, Stuttgart. Professor Dr Eduard Trier, the former Director of the Düsseldorf Kunstakademie, was kind enough to let me have a photograph of Lambert Krahe's portrait (frontispiece).

Ernst Bickel, Restorer to the Düsseldorf Print Room, was responsible for the mounting of the drawings. I am grateful to him and to Wilhelm Chojnacki for their untiring help in solving the many and varied technical problems.

I should also like to express my thanks to Antonie Krüger, Margot Stark, Irmgard Herzog and Helene Steinberg for the patient way in which they typed the final draft of my manuscript – often in their free time.

My deepest gratitude by far is to Peter Ward-Jackson, Deputy Keeper of the Department of Prints and Drawings at the Victoria and Albert Museum, for the constant encouragement and thoughtfulness he has given to this project in all its aspects.

D.G.

Introduction

The Lambert Krahe Collection

The Düsseldorf Print Room has the most comprehensive collection of Roman baroque drawings in existence apart from the collections in Windsor Castle and the Louvre. It owes this to the efforts of a single collector, the Düsseldorf painter Lambert Krahe (1712–90), who lived for more than twenty years in Rome, where doubtless he acquired this vast treasure of more than 10,000 Italian drawings.

Krahe came from a modest social rank. Nothing has come to light regarding his early training as an artist in Düsseldorf. Count Ferdinand von Plettenberg was his first patron. When von Plettenberg was appointed Imperial Ambassador to the Papal Court in 1736 he took Krahe with him to Rome, where soon afterwards the count died, in March 1737.

After the unexpected loss of his patron Krahe at first earned his living by painting small religious pictures for the Jesuits' Indian mission. In the 1740s he seems in addition to have been given some larger commissions in Rome. He painted the altarpiece *St Felix of Valois* for the church SS. Trinita degli Spagnuoli and the altarpiece *St Peter of Alcantara* for SS. Quaranta Martiri. He appears to have gained something of a reputation through these public commissions: at all events he became a member of the Accademia di San Luca in 1751. Among his patrons in Rome were the influential Cardinals Albani and Valenti. On the recommendation of Cardinal Valenti, who was Papal Secretary of State, Krahe was given a pension in 1749 by the Elector Charles Theodore, whose subject he was. This was originally intended to run for three years but then in 1752 was extended for another two. During these years he was also given commissions by the Palatine court, including altarpieces for the Jesuit church in Mannheim and a *Rape of the Sabine Women*, which he painted in 1752/53 for the Duke of Pfalz-Zweibrücken.

In 1755 the Elector Charles Theodore asked Cardinal Albani to recommend him a painter to whom he could entrust the direction of his Düsseldorf picture gallery. Albani recommended Lambert Krahe to the Elector, and in July 1756 Krahe returned to his native city of Düsseldorf, having stayed in Rome for more than twenty years.

When he left Rome Krahe left behind him debts amounting to 1,425 scudi, of which 480 scudi were owed to his landlady in the Vicolo della Purificazione and were paid by the Elector the following year.[1] As nothing is known of later journeys by Krahe to Italy, it may be assumed that he had already assembled his

[1] Towards the end of his stay in Rome Krahe had apparently been buying prints for the Elector and had incurred debts in this way (cf. Wolfgang Wegner, *Kurfürst Carl Theodor von der Pfalz als Kunstsammler*, Mannheim, 1960, pp. 14–5).

extensive collection of Italian drawings before July 1756, the date of his return to Düsseldorf.[2]

In 1758, during the Seven Years' War, when Düsseldorf was threatened by the advance of Prussian troops, Krahe, as Director of the Electoral Art Gallery, was transferred to Mannheim, and the most important pictures from the famous collection were taken there for safe-keeping. In 1761 Krahe returned to Düsseldorf, where, in the following year, taking the Roman Accademia di San Luca as a model, he opened a private academy of drawing in the house of the sculptor Gabriel Grupello. Out of this grew the 'Palatinate Academy of Painting, Sculpture and Architecture'. It is not certain when Krahe's academy was granted this official status.[3] An announcement dated 4 January 1766 on the appointment of the privy councillor Heinrich Jacobi as an honorary member of the *Kurfürstlich-Pfälzische Akademie der Schönen Künste*, signed by Count C. von Nesselrode as Patron, by Krahe as Director and by F. Bislinger as Secretary, allows us to conclude that by 1765, at the latest, Krahe's private academy had already been accorded official status.

Krahe's extensive collection must already have been used to illustrate and provide the basis for teaching in his private academy and now he placed it at the disposal of the Electoral Academy, of which he was the Director, for use in teaching there.

Krahe had apparently again fallen into debt when on 28 October 1776 he offered his collection to the Elector Charles Theodore for the Academy, at a price of 31,000 talers. He maintained that the collection would play an important role in the pupils' education. Krahe's offer, endorsed by the Elector, was submitted to the provincial estates of the Duchy of Berg. The upper house, the gentry, approved the purchase on 11 February 1777, but the towns of Berg, under the leadership of Düsseldorf, protested against this decision on the grounds that the collection was not worth the purchase price Krahe had asked. Following this Joseph Brulliot and Jean Victor Fredon de la Bretonnière were engaged to assess the value of the collection. The assessment, concluded by 1 April 1777, valued it at 51,155 talers.

In spite of this assessment, which was 20,000 talers more than his original price, in a letter to the Elector dated 7 January 1778 Krahe declared he would be content with a price reduced to

[2] For Krahe's acquisitions of drawings from the Netherlands see E. Schaar, Cat. Exh. *Niederländische Handzeichnungen 1500–1800 aus dem Kunstmuseum Düsseldorf*, Städtische Kunsthalle Düsseldorf, 10 March–5 May 1968, p. 5, and E. Schaar, Cat. Exh. *Düsseldorf 1969*, p. 7. For the origin of the French and German drawings in Krahe's collection see D. Graf, Cat. Exh. *Düsseldorf 1969*, pp. 9–10.
[3] Compare Johann Heinrich Schmidt, 'Zur Geschichte der Düsseldorfer Akademie' in *Jahresbericht der Staatlichen Kunstakademie 1941–1944*, Düsseldorf, 1944, pp. 53 ff.

26,000 Reichstalers, because he hoped in this way to overcome the opposition of the towns in Berg to the sale. On the same day Charles Theodore gave the order that the whole sum should be raised by his 'subjects and principal cities'. Apart from the 4,000 talers paid to Krahe immediately, there remained a further 22,000 talers, which were to be paid to him over a period of six years.[4]

After his collection had been taken over by the Academy, Krahe prepared an inventory of it headed as follows:[5]

Catalogue d'une Collection consistant

1ment En Esquisses colorées des plus illustres Maîtres plûpart Italiens

2ment En Dessins Originaux des plus fameux Auteurs, et des Dessins copiés apres le Chef-d'oeuvre des grands Maîtres.

3ment En Estampes choisies ce que les Graveurs de différentes Nations ont produit de plus beau et de plus intéressant dans la Peinture, Sculpture, Architecture & Gravure

4ment En livres choisis des meilleurs Auteurs utils aux études des beaux Arts

5ment En grandes & petits Statues, des Plâtres, comme aussi des Bustes et partie detachée.

Cette Collection a été achetée par Messieurs des Hauts Etats du Duche de Berg pour L'utilité de L'Académie Electorale des beaux Arts à Düsseldorf.

The inventory was signed by Krahe on 10 February 1779 and its table of contents give an idea of the range of the individual sections, which are listed as follows:

Esquisses colorées:	332
Dessins originaux determinés:	5542
Supplément (des études):	7725
Estampes originales determinées:	15563
Supplément (des estampes):	7040
Plâtre:	268
Livres:	111

Krahe had arranged the drawings and prints in schools. The majority of the 5542 *Dessins originaux determinés* are designs for compositions. Most of them, like the sketches in oil, are recorded individually with a note giving their subject and size (in *pouces*); but some that are by the same artist, of the same subject and of roughly the same size are listed several together. But, as well as the individual entries of designs for compositions attributed to

[4] Compare Johann Heinrich Schmidt, 'Der Ankauf der Kunstsammlung Lambert Krahe' in Cat. Exh. *Von Gabriel Grupello bis Paul Klee. Von Lambert Krahe bis Theo Champion*, Kunstakademie Düsseldorf, January–February 1953, pp. 7–20.

[5] The inventory is in the Hauptstaatsarchiv Düsseldorf, Inv. No. Bergische Landstände, VIII, 10.

Lazzaro Baldi, Giacinto Calandrucci, Guglielmo Cortese, Giovanni Battista Gaulli, Carlo Maratta, Giuseppe Passeri and Andrea Sacchi, Krahe sometimes brought together groups of figure studies by these artists. The artists mentioned are in fact those who are particularly well represented in Krahe's collection.

Landscape drawings form a separate section at the end of the catalogue of the *Dessins originaux*, headed by a group of 78 *Dessins de Paisages par Nicolas & Guaspre Poussin. La plûpart d'après les principales Vues aux Environs de Rome,* from which most of the Dughet drawings in this exhibition have been taken.

Most of the figures and drapery studies were entered by Krahe in the 'Supplément des Etudes' of his inventory. With the exception of Poussin and Dughet, the same artists appear again in this list as the authors of many of these studies, so that it is not always clear whether Krahe has not listed the same items twice, as, for instance, the 84 copies from Bernini's colonnade figures from St Peter's, which are shown on both folio 124 recto and folio 124 verso in the inventory. In some groups in the 'Supplément des études' there are sheets with no artist's name on them which are arranged in groups according to subject, as, for example, on folio 123 verso *44 Pièces pour l'anatomie & les Proportions* and *100 Des Academies, Figures par de bons Maîtres;* or on folio 125 recto *189 Etudes d'enfans après nature, par différens Maîtres Italiens* and *150 Animaux & Batailles par divers Maîtres, dessinés après Nature* or, finally, on folio 126 recto *314 Décorations & Ornemens de Bâtimens.*

The copies of antique statues and ornaments which one would expect to find in such a comprehensive collection, the copies of Gian Lorenzo Bernini's sculpture, of Raphael's frescoes in the Vatican and of those by Annibale Carracci in the Palazzo Farnese, are also entered in the 'Supplément des études', as are both the sketch books of Guglielmo della Porta, published by Werner Gramberg[6] and the *Trattato* of Pietro Testa,[7] of which Elizabeth Cropper is preparing a critical edition.

How Lambert Krahe, with his clearly very modest financial resources, managed to amass this exceptionally rich collection and from what sources the drawings – at least the Italian ones – were obtained, cannot be explained in any detail until new evidence is forthcoming. According to an old tradition which was still current in the Düsseldorf Academy in the nineteenth century,[8]

[6] W. Gramberg, *Die Düsseldorfer Skizzenbücher des Guglielmo della Porta*, Berlin, 1964.

[7] For Testa's *Trattato* see Elizabeth Cropper, 'Bound theory and blind practice: Piero Testa's Notes on Painting and the Liceo della Pittura' in *Journal of the Warburg and Courtauld Institutes*, vol. xxxiv, 1971, pp. 262–96.

[8] Theodor Levin, *Repertorium der bei der Königl. Kunstakademie zu Düsseldorf aufbewahrten Sammlungen*, Düsseldorf, 1883, p. iv.

the drawings of Carlo Maratta (1625–1713) were originally in the possession of Maratta's godson, Pier Leone Ghezzi (1674–1755). Whether Pier Leone inherited them from his father Giuseppe Ghezzi (1634–1721) or received them direct from Maratta cannot so far be established. Yet it seems reasonable to agree with Eckhard Schaar[9] when he suggests that the sheets were originally in the possession of Giuseppe Ghezzi. Giuseppe Ghezzi, himself a painter and from 1678 to 1721 secretary of the Accademia di San Luca, was after all a well-known *marchand-amateur* and it was from his collection that the sketchbooks of Guglielmo della Porta just mentioned and a sheet of studies by Perino del Vaga in the Krahe collection were obtained.[10]

The drawings of Andrea Sacchi (1599–1661) must originally have been in his pupil Carlo Maratta's possession. One may likewise assume that the studies by Lanfranco came from Maratta's studio, because there were also drawings by Lanfranco in that section of Maratta's collection which was taken by his pupil Andrea Procaccini (1671–1734) in 1720 to Spain, where the Academia di Belle Arti di San Fernando in Madrid acquired them on his death.

It is not known when Krahe obtained Carlo Maratta's collection from the Ghezzi family. Schaar's supposition[11] that it was between the death of Pier Leone Ghezzi (1755) and Krahe's return to Düsseldorf in July 1756 is completely convincing, however.

To judge from the number of detailed studies in them, the large bundles of drawings by Guglielmo Cortese (1628–79), Giovanni Battista Gaulli (1639–1709) and Maratta's favourite pupils Giacinto Calandrucci (1646–1707) and Giuseppe Passeri (1654–1714) must have come directly from these artists' studios. It is still not clear whether Krahe acquired them from the Ghezzi family or direct from the artists' heirs.

Lambert Krahe's collection was still being used in the nineteenth century by pupils of the Kunstakademie as a source of models for copying, as the existence of copies of individual sheets shows. Even Peter Cornelius, Director of the Academy from 1819 to 1825, availed himself of Krahe's collection for his compositions: his fresco cycle in the Glyptothek in Munich, which was destroyed

[9] Schaar, *KSM*, p. 75.

[10] Schaar, Cat. Exh. *Düsseldorf 1969*, no. 13.

[11] Schaar, *KSM*, p. 75; Wegner, *op. cit.*, p. 15, quotes a letter from the Palatine Agent in Rome, Antonio Coltrolini, in which he writes on 30 May 1757, while mentioning Pier Leone Ghezzi's widow: 'presso di se una Cassa di Pittura e disegni fatta imballare e sigillare dallo stesso Sig. Lamberto (Krahe).' As Krahe, according to sources which are admittedly incomplete, was only acquiring *prints* for the Elector Charles Theodore from Pier Leone Ghezzi's estate, the contents of the Cassa must have included part of Krahe's own collection.

in the Second World War, is inconceivable without Giulio Romano's (1499–1546) frescoes in the Palazzo del Tè as a model. Cornelius had studied these in the copies of them by Jacopo Strada in Krahe's collection.

The preference for Italian art of the Renaissance on the part of the teachers in the Düsseldorf Academy in the nineteenth century was not, however, very favourable to an appreciation of Krahe's collection of mainly Baroque Italian drawings. This lack of understanding is expressed in the preface of the first catalogue, which appeared in 1883 and was written by Theodor Levin, *Repertorium der bei der Königl. Kunstakademie zu Düsseldorf aufbewahrten Sammlungen.* Levin wrote: 'It need only be noted here that the collection (of Lambert Krahe) – as was rightly realized at the time of its purchase – was bought for too much.' In keeping with this negative judgment Levin dealt only in a cursory way with the drawings in Krahe's collection. For instance he made a note against Passeri's sheets which reads: 'About 300 sheets. The authenticity of practically all of them is beyond doubt, but at the same time they are of little interest or value', or, under Mola: 'Over a hundred sheets. By various artists. Unimportant.'

It was Illa Budde's *Beschreibender Katalog der Handzeichnungen in der Staatlichen Kunstakademie,* Düsseldorf, 1930, which began the scholarly appraisal of the Krahe Collection. Illa Budde confined herself in her choice of about 1,000 drawings largely to the consideration of designs for compositions, which Krahe in his inventory had already attributed to specific artists as 'dessins originaux determinées'.

In 1932 the Lambert Krahe Collection, together with the other art treasures of the Academy, was transferred to the Düsseldorf Kunstmuseum on a perpetual loan from the Free State of Prussia and it lay there for another three decades forgotten like a Sleeping Princess. Only at the end of the 1950s did an intensive study of this wonderful collection begin. The discoveries that have ensued are described in the various catalogues and articles quoted here, above all in the writings of Ann Sutherland Harris and of Eckhard Schaar, who was in charge of the Print Room from 1963 to 1969.

Catalogue

The eleven artists shown in the exhibition are arranged in alphabetical order in the catalogue, with their drawings so far as possible in chronological order. The dimensions of the sheets are given in millimetres, first the height, then the width. The paper is white, unless otherwise stated. A list of bibliographical abbreviations is printed at the end.

NOTE ON THE STAMPS
Status Montium
This stamp (Lugt 2309) was impressed on many of the drawings when the Krahe collection was taken over by the Electoral Academy of Fine Arts in 1778.

FP.
The drawings of the Düsseldorf Art Academy were stamped *Kunstmuseum Düsseldorf Leihgabe FP* (not in Lugt) when they were handed over to the Düsseldorf Kunstmuseum in 1932 as a perpetual loan from the Prussian State (FP = Freistaat Preussen)

NOTE ON THE INVENTORIES
Inv. II
Hand-written inventory of Lambert Krahe's collection as it was when it was taken over in 1778 by the Electoral Academy of Fine Arts. It was signed and dated by Krahe 10 February 1779. It is kept in the main state archives at Düsseldorf (Inv. No. Bergische Landstände, VIII, 10). A secondary inventory, less comprehensive (Inv. I), is in the archives of the Düsseldorf Print Room.

1932 Inventory
Hand-written inventory of the drawings from the Düsseldorf State Art Academy taken over in 1932 by the Düsseldorf Kunstmuseum as a loan from the Prussian State.

Gian Lorenzo Bernini

Sculptor, architect and painter
Born Naples, 1598; died Rome, 1680
Cat. nos. 1–6

1

Gian Lorenzo Bernini

EIGHT STUDIES OF ST LONGINUS

On the mount – a stamp: *Status Montium*
Pen and brown ink over lead pencil on
beige paper, 183 × 252 mm.
Oil stains. The sheet is laid down on an
old mount
Inv. No. FP 13613
1932 Inventory: Studies. A. Sacchi
Bibliography: Sutherland Harris, *New
drawings by Bernini* p. 338, pl. 18;
Cat. Exh. *Düsseldorf 1969*, no. 43, fig. 41;
Kruft, p. 87, fig. 2a; Küffner, p. 171;
H. Kauffmann, *Giovanni Lorenzo Bernini*,
Berlin 1970, p. 100, fig. 56a

The sheet contains eight studies for the torso and draperies of Bernini's monumental statue of St Longinus in St Peter's, Rome. These sketches, dated by Kauffmann around 1628/29, obviously belong to Bernini's early plans for the sculpture. He had already prepared a preliminary drawing as a *modello* as early as 1628. The full-size stucco model for the statue was completed in 1631 and was placed in the niche in the pier at the south-east corner of the crossing. It was then decided that the marble statue should not be placed there but in the niche of the north-eastern pier. This decision forced Bernini to abandon his previous designs in order to allow for the new site (cf. R. Wittkower, *Gian Lorenzo Bernini*, London, 1966, pp. 196–97, pl. 41). Of the 22 small wax *bozzetti* which Bernini was able to show Joachim von Sandrart, none has survived. A clay model (Wittkower, *op. cit.*, fig. 34), which was made with the original site still in view, has been acquired by the Fogg Art Museum in Cambridge, Mass. The sparkling and wittily drawn sketches on the sheet under discussion are closer to this model than to the finished statue.

Ann Sutherland Harris kindly brought to my attention that Irving Lavin (*Bernini and the crossing of St Peter's*, New York, 1968, p. 90) has shown that the *modello* of Duquesnoy's statue of St Andrew in St Peter's was by Bernini. She recently pointed out (written communication) that the eight sketches on our sheet in fact also resemble the statue of St Andrew. Her suggestion that Bernini may have developed the poses for the two statues together is completely convincing.

Apart from this sheet Ann Sutherland Harris (*op. cit.*, Cat. nos. 2–9, 11–6) has been able to identify thirteen other sheets of studies in the Düsseldorf Print Room as being by Bernini among the drawings traditionally attributed to Annibale Carracci (1560–1609) and to Andrea Sacchi (1599–1661), seven of these sheets being for the figure of St Longinus. Two more studies for this statue have subsequently been identified by Eckhard Schaar (Inv. nos. FP 12440 and FP 12441).
See also Cat. nos. 2–4.

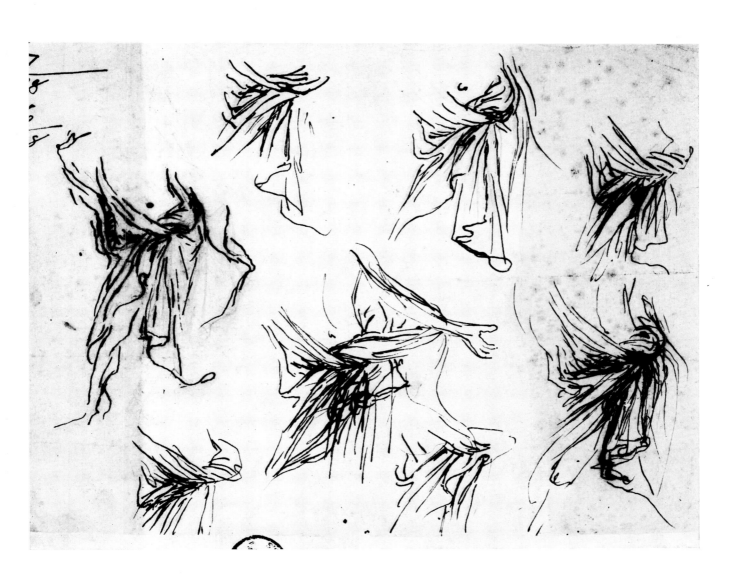

Bottom right – numerals in pen and
brown ink: *82*
Bottom left – note in lead pencil: *1 florin*
Bottom centre – a stamp: *Status Montium*
Red chalk on beige paper, 250 × 378 mm.
Left, grey paint mark. The sheet is laid
down on an old mount along the left edge
Inv. No. FP 12441 recto
1932 Inventory: Studies. Unknown
Bibliography: Cat. Exh. *Düsseldorf 1969*,
no. 45, fig. 42: Kruft, p. 87; Küffner,
p. 171; Vitzthum, p. 188

This sheet has been identified by Eckhard Schaar and consists
of studies for the cloak and left arm of St Longinus (see Cat.
no. 1). As in the pen sketch in Cat. no. 1, the direction of the
arm does not yet correspond with that finally adopted for the
statue, where it does not point down so far and is bent at the
elbow. The folds of the cloak studied here resemble those of the
clay model in the Fogg Art Museum more than they do those
of the marble statue. Kruft has queried the attribution to
Bernini of this and the related sheets in the Düsseldorf Print
Room (cf. Sutherland Harris, *New drawings by Bernini*, Cat.
nos. 4–9, 11–4 with ill.) and sees this group of studies as the
product of exercises in draughtsmanship by students of Bernini.
M. Küffner considers Kruft's doubts as 'not unjustified'. As
Harris has, however, rightly remarked (*op. cit.*, Cat. no. 4),
the sheets are manifestly drawn by the same hand, so that a
division of this group of drawings between several of Bernini's
students is in no way possible. The drawings of Bernini chosen
by her for comparison (Brauer/Wittkower, pls. 23b, 24a
and b and 53d) substantiate her attribution. We cannot accept the
'hesitant line' and 'clumsiness and minuteness of detail' which
Kruft believes he sees in the Düsseldorf studies, and we must
admit that we should imagine student drawings copied from
Bernini's *bozzetti*, which is what Kruft calls these studies, as
being on the one hand more complete and exact and on the
other as far less impressive.

On the verso: 2 studies in the same technique for the same parts

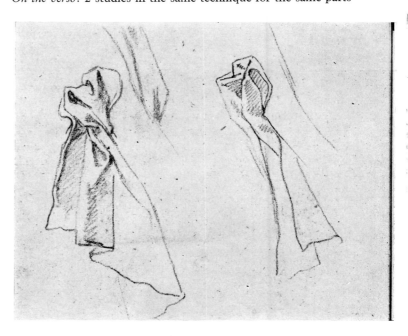

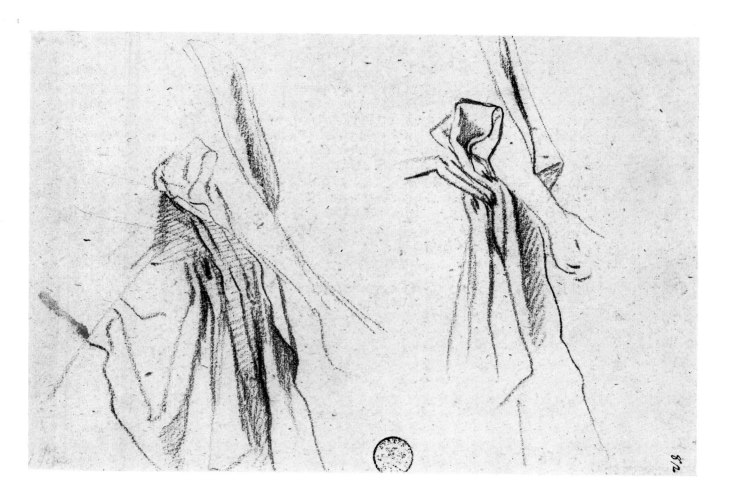

3
Gian Lorenzo Bernini
STUDY FOR THE CHEST OF ST LONGINUS

Note in lead pencil on the back of the old mount: *Anibale Caracci* and *fl. 12 x.*
Stamp: *FP*
Red chalk, heightened with white, on beige paper, 255 × 292 mm.
The sheet has been laid down on an old mount
Inv. No. FP 7716
1932 Inventory: Anatomical study. A. Carracci
Bibliography: Sutherland Harris, *New Drawings by Bernini*, p. 338, Cat. no. 3, pl. 19b; Cat. Exh. *Düsseldorf 1969*, no. 44; Kruft, p. 87; Küffner, p. 171

Study of the upper part of a male nude, drawn from a model, for St Longinus (see Cat. no. 1). The position of the arms, with the right shoulder raised and the left held lower, corresponds with the finished statue; so does the twist of the neck towards the right, clearly perceptible in this study. Bernini's statue of the saint is clad in a skin-tight coat-of-mail revealing the modelling of the body and, over this, there hangs a heavy cloak, which only covers the mailed upper part of the body below the chest. In the drawing the parts of the body not covered by the cloak are particularly carefully modelled. The use of white heightening enhances the softness of the modelling.
Harris, *op. cit.*, bases the attribution of this and the following sheet to Bernini on a comparison with the studies in the Stadtbibliothek in Leipzig for the figure of Daniel in the Chigi Chapel in S. Maria del Popolo, Rome (see Wittkower, *op. cit.*, Cat. no. 58, pl. 85). For the Leipzig drawings see Brauer/Wittkower, vol. i, pp. 56–8, vol. ii, pls. 43–7).

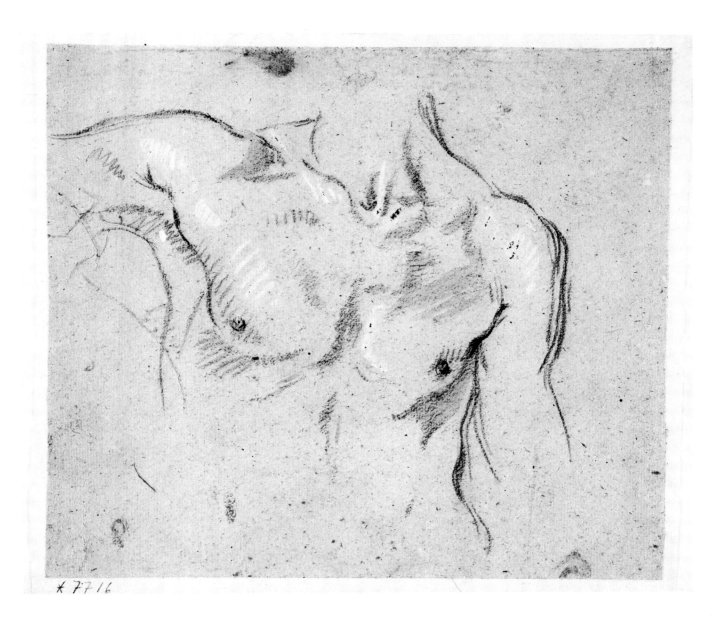

7716

4
Gian Lorenzo Bernini
STUDY FOR THE CHEST OF ST LONGINUS

Note in lead pencil on the back of the old mount: *Anibale Caracci* and stamp: *FP*
Red chalk on beige paper, 251 × 278 mm.
The sheet is laid down on an old mount
Inv. No. FP 7719
1932 Inventory: Anatomical Studies. An. Carracci
Bibliography: Sutherland Harris, *New drawings by Bernini*, p. 338, Cat. no. 2, pl. 19a; Cat. Exh. *Düsseldorf 1969*, no. 44, fig. 37; Kruft, p. 87; Küffner, p. 171

Study of the upper part of a male nude, drawn from a model, for St Longinus (see Cat. no. 1).
As in the related study (Cat. no. 3), the position of the arms and the way in which the neck is turned are the same in this drawing as in the finished statue, though here the difference in the height of the shoulders noticed in the other sheet is less pronounced.
The abstract conciseness with which this torso, drawn completely flat, has been shown in this study is perhaps even more admirable than in its counterpart in Cat. no. 3.

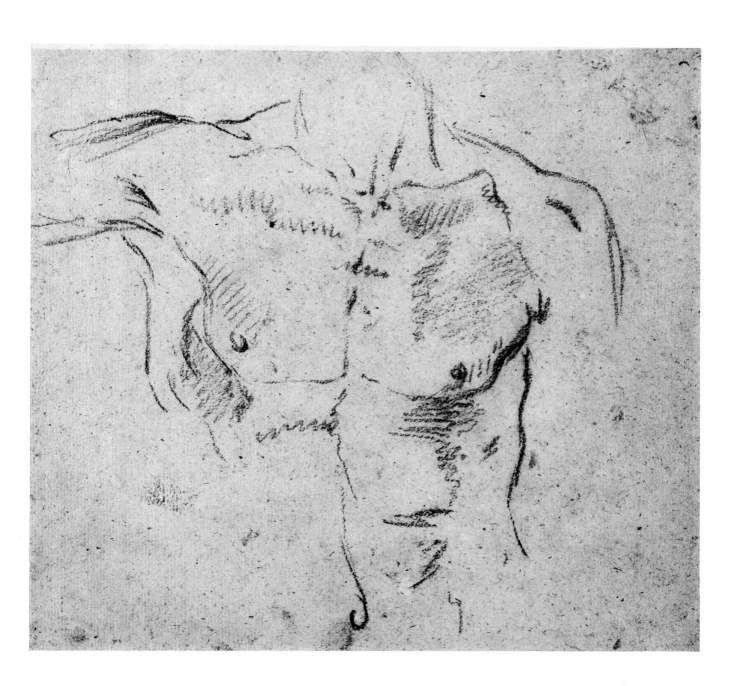

Bottom centre, fragment of the stamp
Status Montium
Red chalk, heightened with white, on
beige paper, 174 × 194 mm., cut
irregularly
At one time the sheet was fastened at the
corners to an old mount
Inv. No. FP 8910 recto
1932 Inventory: Studies. Unknown
Bibliography: Sutherland Harris, *New
drawings by Bernini*, p. 390, Cat. no. 15,
pl. 28; Cat. Exh. *Düsseldorf 1969*, no. 46a,
col. illus. on cover; Kruft, p. 88

Schaar regards this and the next sheet (Cat. no. 6) as studies of facial expression exaggerated to a grotesque degree or else as patterns for ornament. In a letter Kurt Bauch asks the interesting question whether the two sheets might not be caricatured self-portraits of Bernini. Sutherland Harris (*op. cit.*, Cat. no. 16) stresses the unique character of these sheets compared with Bernini's portrait studies and his caricatures, which are drawn with the pen. She describes the handling of these unusual studies as 'freer than most of Bernini's portrait heads but essentially the same.' As comparable sculptural works by Bernini she names, amongst others, the *Anima Dannata*, the head of Neptune, the Triton with Neptune, David's head and the head of the weeping putto by the side of *Caritas* in the tomb of Pope Urban VIII (cf. Wittkower, *op. cit.*, pls. 6, 18, 21, 27, 52). But Kruft doubts whether this and its companion sheet are by Bernini, and can see no force in the comparison between them and those works of sculpture by Bernini mentioned by Sutherland Harris. Above all, the presence of parts of one and the same study of a nude on the back of both sheets (which shows that the two grotesque heads were cut from one sheet) are for him an argument against attributing them to Bernini, because he cannot see Bernini's hand in the study of a nude.

On the verso: Part of a study of a seated nude man, in red chalk

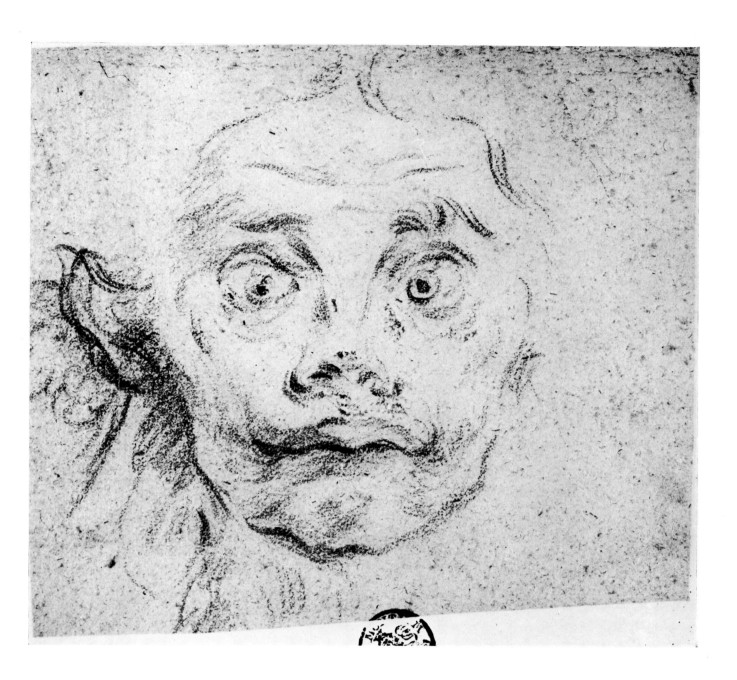

On the top edge of the sheet, a fragment of the stamp *Status Montium*
Red chalk, heightened with white, on beige paper, 197 × 202 mm., cut irregularly.
Below the nose and the left ear, grey paint marks
Inv. No. FP 8911 recto
1932 Inventory: Studies. Unknown
Bibliography: Sutherland Harris, *New drawings by Bernini*, p. 390, Cat. no. 16, pl. 29; Cat. Exh. *Düsseldorf 1969*, no. 46b; Kruft, p. 88

This drawing is discussed in Cat. no. 5.

On the verso: Part of a study of a seated nude man, together with two caricatured heads in profile, in red chalk

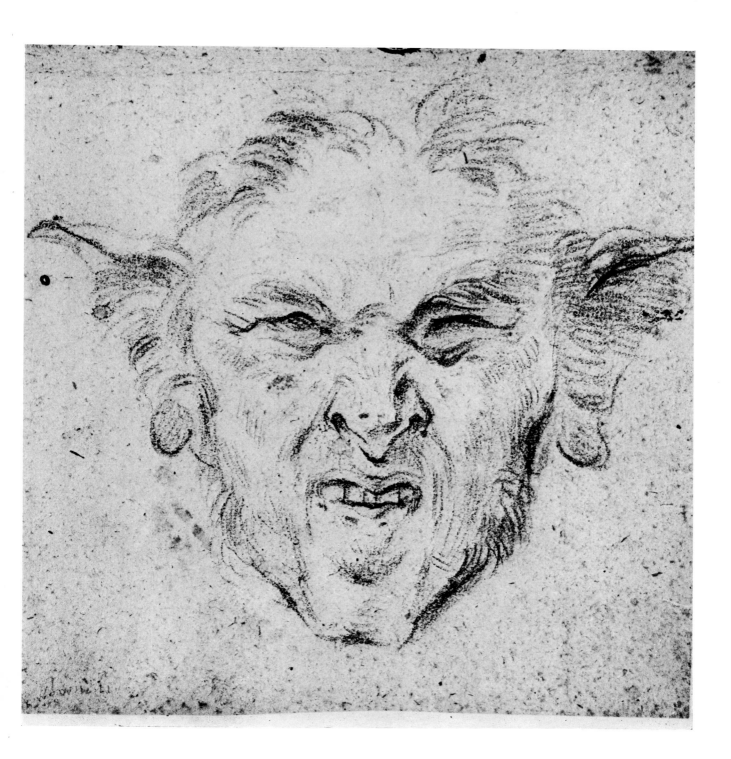

Giacinto Calandrucci

Painter
Born Palermo, 1646; died Palermo, 1707
Cat. nos. 7–14

Numerals in pen and brown ink – bottom right: *30*
Black and red chalk, heightened with white, on grey-green paper, 426 × 270 mm.
Inv. No. FP 1416 recto
1932 Inventory: Madonna with Child. Carlo Maratta
Unpublished

Study for a painting as yet unidentified, of a Holy Family or of an Adoration of the Infant Christ. The sheet was wrongly attributed to Carlo Maratta in the Düsseldorf Academy of Art, although the style of the figures and of the drawing point unmistakably to Giacinto Calandrucci (see Cat. no. 9). The Düsseldorf Print Room has a design by Calandrucci for a composition showing the Holy Family with the Infant Christ, and this has a very similar crib, but with Mary and Joseph kneeling on either side of it (Inv. no. FP 2081, Cat. Budde, no. 343). The use of red and black chalk heightened with white, which lends this sheet its special charm, is not encountered very frequently in Calandrucci's studies. However, the Düsseldorf Kunstmuseum does possess a few examples. Two of these are studies of the kneeling figure of San Filippo Neri (Inv. Nos. FP 13050 and FP 2184). Eckhard Schaar, who has commented on these two drawings (KSM, no. 773), was able to use them to show that Calandrucci was obviously working in Maratta's studio on the preparation of drawings for Maratta's paintings. Calandrucci's studies of S. Filippo Neri relate to the figure of the saint in Maratta's altarpiece for S. Giovanni dei Fiorentini in Rome, which is now in the Palazzo Pitti in Florence (Mezzetti, no. 39). Maratta's picture seems to have been painted shortly before 1674. As there is a study by Calandrucci for a head of Filippo Neri on the back of this sheet, it seems reasonable to assign a date in the same period to the study on the recto. It still remains to be discovered whether Calandrucci's Madonna with the Crib was also drawn for a composition of Maratta's.
The Düsseldorf Print Room has in addition two other sheets by Calandrucci with studies for the face of S. Filippo Neri (Inv. Nos. FP 9070 and FP 9124) as well as a sheet with very detailed studies of hands (Inv. No. FP 8503) for the kneeling figure of the saint in the drawing described by Schaar (Inv. No. FP 13050), in which the hands have only been sketched very roughly in outline.

On the verso: Study for the face of S. Filippo Neri. Red chalk heightened with white

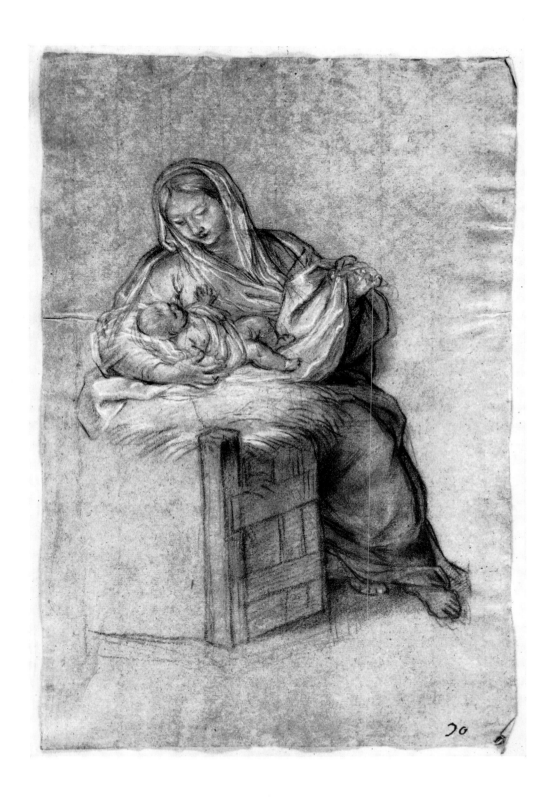

3

Giacinto Calandrucci
STUDY OF MARY

Numerals in pen and brown ink – bottom
right: *58*
Red chalk, heightened with white, on blue
paper, 283 × 417 mm.
Oil stains on Mary's chin and neck.
Damage has occurred, bottom right
Inv. No. FP 8886
1932 Inventory: Studies. Unknown
Unpublished

This sheet is a study for the face and the hands of the figure
of Mary in Calandrucci's lunette fresco – *Rest on the Flight
with the boy John* – on the right wall of the Cimini chapel
(second chapel on the right) in S. Antonio dei Portoghesi in
Rome. In the fresco Mary is shown sitting on the right, occupied
with needlework. Joseph sits on the left, a book on his lap,
looking at the Infant Christ and the boy John, who are shown
sitting at his feet with their arms round each other.
Another sheet in the Düsseldorf Print Room (Inv. No. FP
7529) has another study of Mary's face as well as of Joseph's
right hand and of the Infant Christ lying down. It also has
a study, sketched in outline only, of Joseph's head and
shoulders. A study for the whole figure of Joseph (Inv. No.
FP 13933 recto) has been identified by Eckhard Schaar (cf.
Cat. Exh. *Düsseldorf 1969*, p. 52, no. 95, fig. 83).
There is a sketch of the whole composition in the Victoria and
Albert Museum in London, Museum No. Dyce 215.
Calandrucci was commissioned to carry out all the painted
decorations in the chapel.
The lunette fresco on the left wall of the chapel shows Salome
receiving the head of John the Baptist (cf. Cat. no. 9).
God the Father is the subject of the fresco in the ceiling (cf.
Cat. no. 10). The altarpiece in the chapel, dedicated to St
John the Baptist, represents the baptism of Christ. The Berlin
Print Room has studies of the figures of Christ and John in this
baptism scene (cf. Dreyer, Cat. nos. 58–9, figs. 28–9) and the
Düsseldorf Print Room also has the following: study of Christ
and John (Inv. No. FP 13585 verso) (see Cat. no. 12); study of
Christ (Inv. No. FP 12780); study of the Angel with a cloth
behind Christ (Inv. No. FP 7527).
Waterhouse (p. 50) dates the painting of the chapel shortly
after 1682.

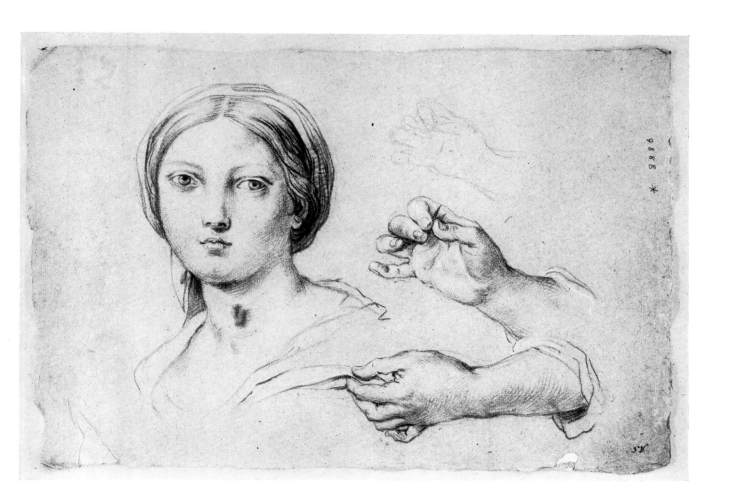

Giacinto Calandrucci
STUDY OF SALOME AND HER MAIDSERVANT

Numerals in pen and brown ink – bottom right: *13*
Red chalk, heightened with white, on blue paper, 421 × 277 mm.
Inv. No. FP 13269
1932 Inventory: Composition of Figures.
Unknown
Unpublished

Study for the left lunette fresco in the Cimini chapel in S. Antonio dei Portoghesi in Rome. The theme of the fresco is the beheading of St John the Baptist.

Calandrucci's sketch for the whole composition, in the Düsseldorf Print Room (Inv. No. FP 6513), has been identified by Eckhard Schaar (see Cat. Exh. *Düsseldorf 1969*, p. 52, no. 94, fig. 81). The present study shows Salome and her maidservant, who is holding a dish on which she is receiving the Baptist's head from the executioner. John's head has been left out on this sheet. Calandrucci has drawn it in detail in another drawing, also belonging to the Düsseldorf Print Room (Inv. No. FP 7561). As well as these, the collection of Lambert Krahe contains two more sheets with studies for this fresco: Inv. No FP 13242 shows more studies of Salome and the maidservant. The drawing Inv. No. FP 9104 shows the figure of the Baptist as it appears in the fresco, lying on the ground to the right.

Schaar (*op. cit.*, p. 52) has pointed out that in the figures of Salome and the executioner Calandrucci has followed Andrea Sacchi's handling of the same theme very closely. In 1641–49 Sacchi had painted eight scenes from the life of St John the Baptist for the church of San Giovanni in Fonte in Rome (the Lateran Baptistery). This cycle is on the inside of the octagonal lantern of the Baptistery (see Cat. no. 138).

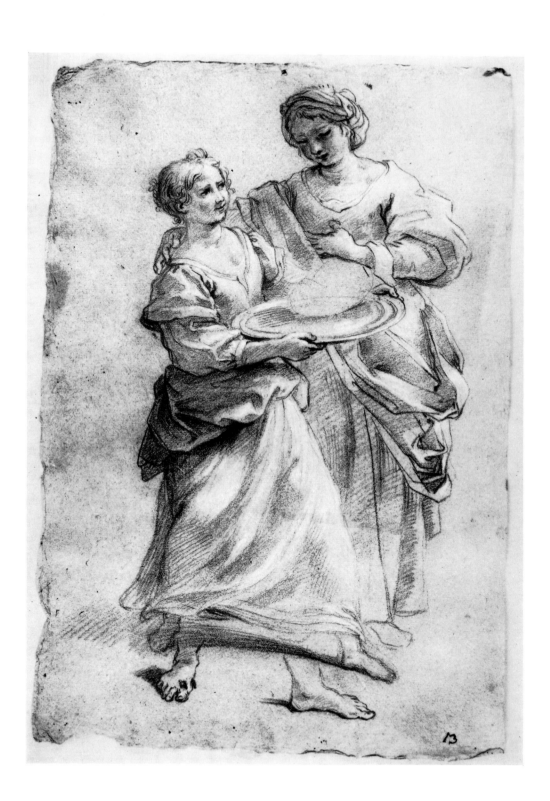

Numerals in pen and brown ink – bottom
right: *66*
Red chalk, heightened with white, on blue
paper, 276 × 427 mm.
Inv. No. FP 12972
1932 Inventory: Studies. Unknown
Unpublished

This study represents the figure of God the Father which
Calandrucci used for the ceiling fresco in the Cimini chapel of
S. Antonio dei Portoghesi in Rome soon after 1682. The pose
is similar to that in the fresco. The angel beneath his left arm
is only sketched in outline. The two arms of God the Father,
raised in blessing, are also only sketched in outline in the study
of the whole figure, but are studied again in greater detail on
the lower part of the sheet.
See Cat. no. 8 for a description of all the paintings in the
Cimini chapel.

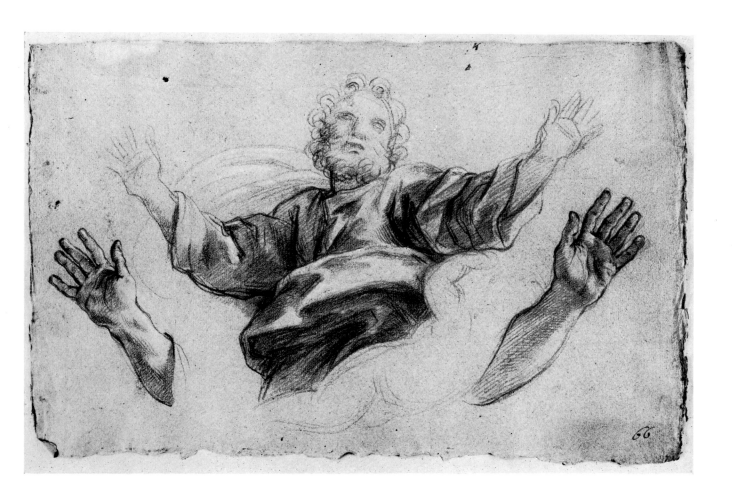

Top right – numerals in pen and brown ink: *22*
Bottom left – stamp: *Status Montium*
Note in pencil on the back: *Calandrucci*, and below this: *2 Florin*
Pen and brown ink over black chalk, with wash and water-colour, 171 × 420 mm.
The traces of red chalk were probably rubbed off another drawing
Inv. No. FP 2086
1932 Inventory: Ceiling design.
Calandrucci
Unpublished

Design for a ceiling painting in the Palazzo Lante, Rome. Paintings by Calandrucci in the Palazzo Lante are mentioned in Pascoli's Life of the artist: '*Voleva anche il Duca Lanti abellire, ed ornare di pitture il suo (palazzo); ed essendogli stato proposto Giacinto gliene parlo, e stabilito il prezzo, e ciocchè vi bramava s'accinse poco doppo all'impresa, che dovendo essere a guazzo prestamente la compi coll'aver rappresentato in una stanza Indimione, e la Luna coll'ore ed in altra diverse deità*' (Pascoli, vol. ii, p. 311).
Directly next to the *Aula rettangolare*, painted by Francesco Romanelli in 1653 (cf. Italo Faldi, *Pittori viterbesi*, pp. 70–1, figs. 270–77), there is a rectangular room – now divided by a partition wall – which has a flat ceiling divided by joists. In four of the total of six elongated panels between the joists Calandrucci has represented Bacchus, Mercury, Venus and Ceres. In the outer ceiling panels, however, only putti appear.
The design on this sheet relates to the ceiling panel which has the picture of Venus: she is shown on clouds surrounded by putti. Calandrucci has drawn two alternative designs for decorating the extremities of the panel. On the right, putti support a tondo containing the portrait of an emperor. This suggests an intention to have a series of twelve imperial portraits. On the left, on the other hand, there is a cartouche crowned by a mask, encroaching on the painted border of the main picture, which on this side projects in a semi-circle. The offer of these alternative proposals makes it seem probable that this sheet was originally a *modello* destined for the patron. The scheme given on the left was the one that was actually executed. The decoration of one of the ceiling joists which divide the pictorial panels from one another is shown at the bottom of the sheet.
At the top of the sheet, on the right, there is a console (upside down) and a cartouche, with part of a second console outlined to the left. This is a suggestion for the decoration of the narrow wall panels between the ceiling joists.
Calandrucci made individual studies of the figures for each of the gods appearing in the four ceiling pictures. The Düsseldorf Print Room has a study for Mercury (Inv. No. FP 9007 recto) and a study for Ceres (see Cat. no. 12). A study for Venus, erroneously attributed to Pompeo Battoni, is in the Munich Print Room (Inv. No. 2688).
I am extremely grateful to Dr Albini, with whose help I was able to visit the Palazzo Lante, now occupied by several tenants.

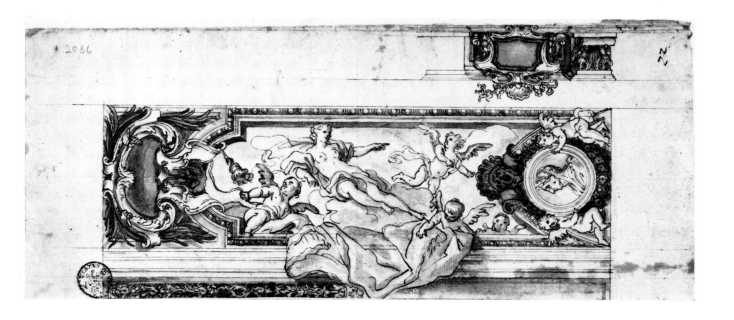

Numerals in ink and brown pen, below
right: 7 (?)
Red chalk, heightened with white, on blue
paper, 283 × 432 mm.
On the back, top left and right bottom,
there are brown ink stains which have
seeped through to the front of the sheet
Inv. No. FP 13585 recto
1932 Inventory: Studies. Unknown
Unpublished

Study for the figure of Ceres in a ceiling fresco in the Palazzo
Lante, Rome (see Cat. no. 11). The style, technique and paper
of this sheet enable us to link it directly with the studies by
Calandrucci for his paintings in the Cimini chapel in the
Roman church S. Antonio dei Portoghesi (cf. Cat. nos. 8–10),
which were executed soon after 1682. From this we may assume
that Calandrucci's ceiling frescoes in the Palazzo Lante were
painted during the same period, particularly as there is a study
on the back of this sheet for the altarpiece in the Cimini chapel.
At the same time Calandrucci produced yet another version of
the figure of Ceres. In one of the rooms on the ground floor of
the Villa Falconieri in Frascati he painted a ceiling fresco
Sacrifice to Ceres, an allegory of summer, as part of a cycle of
the four seasons of the year. The three other paintings for this
were carried out by Ciro Ferri (cf. E. Schaar, 'Düsseldorfer
Entwürfe und Studien zu Giacinto Calandruccis "Opfer an
Ceres" in der Villa Falconieri in Frascati' in *Festschrift für
Ulrich Middeldorf*, Berlin, 1968, pp. 422–28, pls. 184–86, and W.
Vitzthum, Cat. Exh. *A selection of Italian drawings from North
American collections*, Norman Mackenzie Art Gallery and
Montreal Museum of Fine Arts, 1970, Cat. no. 71 with ill.).

On the verso: Study of a Baptism of Christ, probably for the
altarpiece on the same theme in the Cimini chapel in S. Antonio dei
Portoghesi, Rome

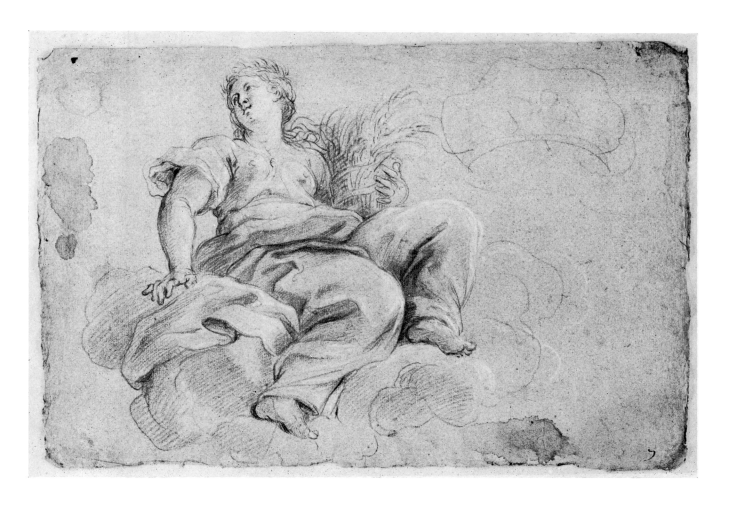

Krahe's numerals in pencil on the backing sheet: *84*
Pen and brown ink over black chalk, 315 × 227 mm.
The sheet is laid down on a white mount
Inv. No. FP 2072
Krahe, *Inv. II*, fol. 49 verso, No. *84: Le Centaure Nessus, enlevant Dejanire, 12 × 9 Pouces*, as Calandrucci
1932 Inventory: Nessus and Dejanira. Calandrucci
Bibliography: Cat. Budde, no. 351

Nessus is carrying off the wife of Hercules (Ovid, *Metamorphoses*, ix, 101–33). Hercules's outline has been sketched in to the left of the background. This design is for a painting as yet unidentified. It is hardly possible to discuss Calandrucci's composition without knowing the painting on the same theme by Guido Reni (1575–1642) (Paris, Louvre; cf. Gnudi/Cavalli, p. 71, no. 45, col. pl. following p. 68). In Reni's painting, however, Nessus is seen turning to the left and Hercules is shown to the right of the background.

As Reni's painting had reached England by as early as 1627 and came into the possession of Louis XIV in 1649, it can only have been known to Calandrucci through a copy. His model may have been the print by Gilles Rousselet (1614–86) (Le Blanc, no. 53–6: an impression is in the Düsseldorf Print Room, Inv. No. FP 6796 D).

In his virtuoso command of the pen Calandrucci's drawing is closely related in style to the pen drawings of his teacher, Carlo Maratta (cf. Maratta's drawing of Venus, Bacchus and Ceres, London, Courtauld Institute, Witt Coll., no. 3795; Vitzthum, *Il barocco a Roma*, p. 86, pl. xxxii).

The Düsseldorf Print Room has a closely related but oblong drawing by Calandrucci on the same theme (Inv. No. FP 2035; Cat. Budde, no. 352, pl. 53) and a study in red chalk for the figure of Hercules drawing his bow for use in this second composition sketch (Inv. No. FP. 12909).

...als in pen and brown ink, bottom
right: *57*
Red chalk, heightened with white, on
grey-green paper, 417 × 275 mm.
Bottom centre: oil stain
Inv. No. FP 8960
1932 Inventory: Nude study. Unknown
Unpublished

This study was presumably made from a model. The figure has
been drawn only to below the loins – the point where, in the
design for the composition (Cat. no. 13), the horse part of the
centaur's body is attached. The position of the body, arms and
head is the same as in the design. The face, with its yearning,
upturned gaze, broad nose and parted lips has not been drawn
from the model, but shows the same expression of sensuous
desire which marks the face of the centaur in the design for
the composition.

Guglielmo Cortese
(Guillaume Courtois)
called Il Borgognone

Painter and etcher
Born St Hippolyte, 1628; died Rome, 1679

Cat. nos. 15–34

Krahe's numerals in pencil on the mount:
12
Pen and brown ink over black chalk, with
brown wash, heightened with white, on
grey-brown paper, 283 × 209 mm.
The sheet is laid down
Inv. No. FP 4565
Krahe, *Inv. II*, fol. 24 recto, No. 12: *La
Fuite en Egypte, 11 × 8 Pouces*, as
Guglielmo Cortese
1932 Inventory: Flight to Egypt. G.
Courtois
Unpublished

The drawing belongs to a series of three scenes by Guglielmo
from the life of Mary, which may originally have included
other works. The two other sheets in the Düsseldorf Print
Room, which are of the same size and in the same style,
represent *The Adoration of the Kings* (Inv. No. FP 4565; cf.
Cat. Exh. *Düsseldorf 1964*, no. 31, and Schleier, 'Aggiunte a
Guglielmo Cortese', p. 6, fig. 19) and *The Meeting of Mary and
Elisabeth at the Golden Gate* (Inv. No. FP 4562). It is not
possible to decide whether these sheets, executed carefully like
paintings, were intended as designs for paintings or for
engravings, because so far neither paintings nor engravings that
correspond have been found. However, *The Adoration of the
Kings* has been squared for transfer to some other medium.
The elongated proportions of the figures in these drawings and
the long folds in the rather minutely modelled drapery make it
possible to establish that these sketches must have been carried
out as early as the 1650s. Compare this with Cat. no. 16 and
the painting by Guglielmo *The Crossing of the Red Sea*,
published by Schleier, *op. cit.*, pp. 11–2, fig. 54. A badly
preserved copy of this painting, which came from Krahe's
collection of oil sketches, is now in the Düsseldorf
Kunstmuseum (Inv. No. 2176).

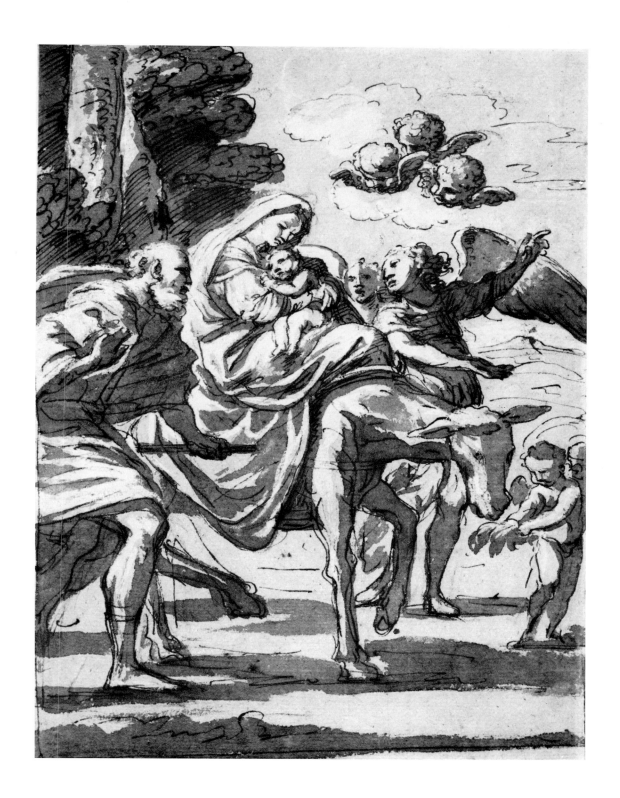

16

Guglielmo Cortese (attributed to)
SACRIFICE OF AARON

On the back in pen and brown ink,
bottom right, a note: *franco romanelli*
Bottom left – numerals: *1059*
On the mount, Krahe's numerals in
pencil: *23*
Black chalk, heightened with white, on
grey-brown paper, 520 × 425 mm.
Borderline in brown pen, oil stains, paint
marks and water stains. Horizontal marks
of folding. The sheet is fastened down on
its left edge to an old mount
Inv. No. FP 14140 recto
Krahe, *Inv. II*, fol. 107 recto, No. 23:
*Le Sacrifice d'Aaron par Romanelli, 19 ×
16 Pouces*
1932 Inventory: Sacrificial scene.
Romanelli
Unpublished

Design for the fresco on the right wall in
the Cappella del SS. Sacramento in San
Marco, Rome.
San Marco, the national church of the
Venetians in Rome, was altered and
redecorated in 1653–57 at the instigation
of the Venetian Ambassador Niccolo
Sagredo (cf. P. Dengel, *Palast und
Basilika San Marco in Rom*, Rome 1913,
p. 90 ff.). Pietro da Cortona had been
entrusted with the architectural alterations
to the Chapel of the Sacrament.
In a *Stato della fabrica*, dated 18.11.1655,
published by Dengel (*op. cit.*, p. 94, n. 7)
there is a reference to the decoration of the
Chapel: '*alle pitture sono destinate il
Borgognione per il quadro dell'altare et per
un grande delli lati e Ciro (Ferri) per
l'altro grande delli lati et per le due lunette*'.
On 3.1.1656 Guglielmo Cortese received
15 Scudi '*a conto di pitture per la cappella
del Sant^{mo}*'.
From a report – also published by Dengel
– by a canon of San Marco in 1659 on the
redecoration of the church (Dengel, *op.
cit.*, pp. 94–5) it appears that, at that time,

the work on the Chapel of the Sacrament had not yet been
completed, but the two frescoes on the chapel walls are
mentioned already: '*con pitture di doi grandi sacrificii fatti da
Moise et Aron in alludere al S^{mo} sacramento.*' Thus the date
when the frescoes were painted can be placed between the years
1656–59.
Whereas there can be no doubt that Guglielmo painted the
fresco of the sacrifice on the left wall of the chapel (see Cat. no.
17), on the basis of the present sketch we would suggest
Guglielmo was also responsible for the fresco on the right wall of
the chapel. At any rate the carefully worked design, which may
have been prepared as a *modello* for Niccolò Sagredo, seems to
us to be much closer to Guglielmo than Ciro Ferri, even
though the facial features of the women are more Cortonesque
in style than in Guglielmo's other fresco and the handling of
the drapery is less broad. Another reason for attributing this
design to Guglielmo is that there is a sheet in the Düsseldorf
Print Room with studies for Guglielmo's painting in the choir
of San Marco, *The Martyrdom of St Mark* (cf. Cat. Exh.
Düsseldorf 1969, no. 80, fig. 64), which has on the back a detailed
study of the face and upper part of Moses's body, who is
shown in the present drawing standing behind Aaron and
pressing two girls back. On another sheet of Guglielmo's in the
Düsseldorf Print Room (Inv. No. FP 13700 recto) there is a
study of the man standing to the left in the background of the
present design, where he is shown with raised arms gazing at
the figure of God the Father.
In addition the Gabinetto Nazionale delle Stampe in Rome has
a study by Guglielmo of the figure of God the Father as in the
present design (Inv. No. F.C. 124881 verso). On the recto of
the same sheet Guglielmo has repeated this study, but this time
in reverse. The possibility that our drawing could be a copy of
the fresco by Guglielmo can be ruled out – quite apart from the
high standard of the drawing – on account of the way it differs
from the fresco. In the fresco the man with his back turned near
the left edge of the picture has disappeared; some tents are
shown in the background on the left; three women and a man
stand behind Moses; the altar is higher, and the two men in the
foreground are closer together.

On the verso: In the upper half of the sheet there are barely
recognizable rough sketches in black chalk, possibly for the angels
surrounding God the Father on the recto

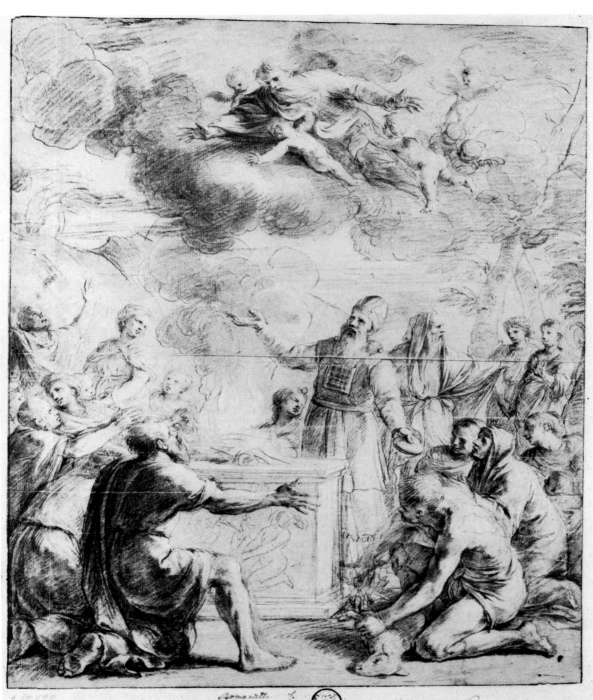

Top right – stamp: *Status Montium*
On the back, bottom right, a note in pen
and brown ink: *G. Bourgignon*
Red chalk, heightened with white, on
beige paper, 418 × 238 mm.
Bottom left, a piece of the sheet is
missing. Paint marks and water stains.
The sheet is stuck down along its upper
border to an old mount
Inv. No. FP 8120 recto
1932 Inventory: Kneeling woman.
Unknown artist
Unpublished

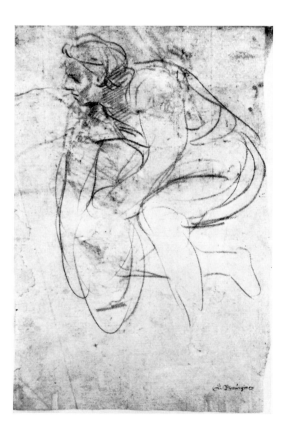

Study of the kneeling man on the right in the foreground of
Guglielmo Cortese's fresco on the left wall of the Cappella del
SS. Sacramento in San Marco in Rome. For the decorations
in the chapel see Cat. no. 16.

There is a design for the composition in Windsor Castle (Cat.
Roman drawings, no. 111, fig. 14). There a woman with a child
is shown in the foreground to the right, but in the finished
fresco she has been replaced by the kneeling man holding a jar
shown in the present study. To the left of the drawing of the
whole figure Guglielmo has made a separate study of the
draperies over the right shoulder and right arm. The Düsseldorf
Print Room has a copy of this figure drawn in reverse (Inv.
No. FP 8834).

In the fresco Aaron, dressed as a high priest, is standing in the
camp of the Israelites beside a great jar, into which he is
pouring the contents of some smaller pots which are being
brought to him by younger men. The camp of the Israelites is
shown at the foot of a mountain, presumably Mount Sinai, over
which the smoke cloud of Jehovah floats.

This presumably illustrates the command given by Moses to
Aaron: 'Take a pot, and put an omer full of manna therein, and
lay it up before the Lord, to be kept for your generations'
(Exodus 16, 33.)

On the verso: Study in red chalk for the figure on the recto, but in a
somewhat different attitude

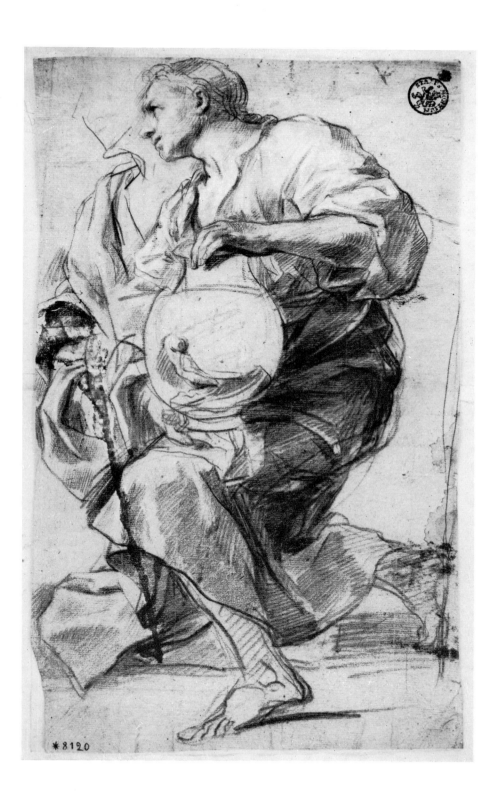

Bottom right, note in red chalk: *guilelmo Borgognone*
On the mount, Krahe's numerals in pencil: *28*
Red Chalk on beige paper, 265 × 415 mm.
Paint marks and water stains.
The sheet is laid down on an old mount
Inv. No. FP 4559
Krahe, *Inv. II*, fol. 24 recto, No. 28: *Une bataille romaine Esquisse, 10 × 16 Pouces* as Guglielmo Cortese
1932 Inventory: Battle scene. G. Courtois
Unpublished

Studies for a battle scene. It is conceivable that this is a study for part of a picture of the Battle of the Milvian Bridge, or, more likely, of Horatius Cocles defending the Tiber Bridge, as the group round the riders seem to be fighting on a bridge. The light strokes on the extreme left may possibly be intended to indicate the sail and prow or the stern of a ship.

Cortese painted a picture of the Battle of Joshua as early as 1656/57 in the Alexander VII Gallery in the Quirinal Palace (Salvagnini, pp. 150–51, fig. liii). He handled the same subject again in a thesis print engraved by Albert Clouwet (1636–79) for King John II Casimir of Poland (1648–68) (impression in the Düsseldorf Print Room: Inv. Nos. FP 16892 D, top half, and FP 16891 D, lower half).

As the group of three soldiers on the far left in this drawing reappears in the thesis engraving in the same place in the composition and in almost the same attitudes, this drawing of Guglielmo may have been drawn at that period.

The style of the drawing and of the thesis engraving is so similar to that of the frescoes carried out by Guglielmo some time after 1659 in the Cappella della Congregazione Prima Primaria al Collegio Romano (cf. Schleier, 'Aggiunte a Guglielmo Cortese', pp. 13–4; Salvagnini, pls. xlii–xlv, xlvii–xlix) that they both must have been produced in the early 1660s. As King John II Casimir had formerly been a Jesuit and a Cardinal, the thesis engraving may possibly have been commissioned by the Jesuits.

The recto of a drawing in the British Museum (Inv. No. 5223–17) has a figure which would seem to be that of the soldier at the top right of this present sketch: on the other hand, on the verso there is a study of a wounded man, who is shown in the battle scene in the thesis lying at the feet of the mounted figure of Joshua, trying to pull a spear out of his chest.

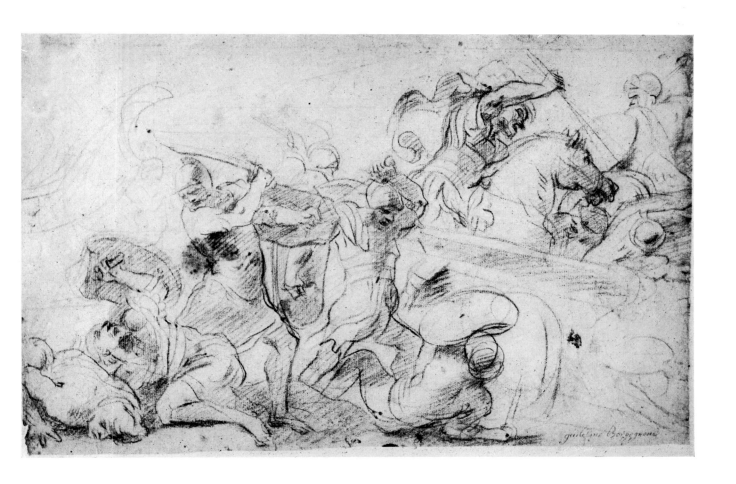

On the back, bottom right, a note in pencil: *G. borgognon(e)*; above this, in pen and brown ink, numerals: *39*
On the left – a stamp: *Status Montium*
Red chalk, heightened with white (study of the whole figure) and black chalk, heightened with white (study of the head) on beige paper, 413 × 270 mm.
The top left corner of the sheet is missing and has been restored. Paint marks
Inv. No. FP 8127 recto
1932 Inventory: Studies. Borgognone
Unpublished

Studies of the face and of the whole figure of God the Father for the ceiling fresco in the Cesi chapel (second chapel, right) in S. Prassede in Rome.
The decoration of the chapel took place in the early 1660s (cf. Waterhouse, p. 56). Guglielmo also painted the pictures for the chapel walls, an *Adoration of the Kings* (left) and *The Immaculate Virgin appears to Joachim and Anna* (right). In a central oval of the ceiling fresco there is a figure of God the Father giving his blessing, surrounded by angels. In the four individual paintings which surround this central picture Guglielmo has shown the saints Pasquale, Filippo Neri, Agnes and Francesca Romana.
The two lunette paintings were carried out by Ciro Ferri, with whom Guglielmo had previously worked on the decoration of the chapel of the Holy Sacrament in San Marco in Rome (see Cat. no. 16).
On the present sheet Guglielmo has drawn the powerful figure of God the Father as it appears later in the fresco. In this drawing his particular interest lay in the modelling of the robe over the lap and legs of the figure and in the face, of which he has made a separate study at the bottom of the sheet on the right.
Another sheet in the Düsseldorf Print Room (Inv. No. FP 7767) has on the recto two studies of drapery for God the Father and on the verso there is a small pen sketch for the same figure as well as a study of an angel's head and another study of drapery.
Pierre Rosenberg has lately published Guglielmo's design for the whole central fresco (Art Institute of Chicago, Leonora Hall Gurley Memorial Collection, No. 22,169; see P. Rosenberg, Cat. Exh. *French master drawings of the 17th and 18th centuries*, Toronto, Art Gallery of Ontario, 2 September-15 October 1972, no. 33, fig. 46).

On the verso: Study of a kneeling figure seen from behind, in red chalk, heightened with white, and below this a pen sketch of the head of a dolphin

Pen and brown ink over traces of pencil, with brown wash, on light brown paper, 126 × 340 mm.
Bevelled corners. Water stain.
The top part of this sheet has been cut. Along the top edge there are traces of the bottom part of a squared composition and a few sketched lines in red chalk, possibly representing the preliminary stages of the upper part of the composition
Inv. No. FP 352
Krahe, *Inv. II*, fol. 64 verso, No. 8: *Les Apôtres auprès du Tombeau de Ste. Marie, 6 × 14 Pouces*, as Giovanni Lanfranco
1932 Inventory: Study. Lanfranco
Bibliography: Cat. Budde, no. 49 as Lanfranco; Schleier, 'Aggiunte a Guglielmo Cortese', p. 7, fig. 31; Graf, 'Guglielmo Cortese's paintings of the Assumption of the Virgin', p. 28; Cat. no. 9, fig. 24

Design for the lower part of Guglielmo Cortese's fresco *The Assumption of Mary* in the apse of the church S. Maria dell' Assunzione in Ariccia. We owe to Erich Schleier the correct attribution and identification of this study, which was listed under Lanfranco (1582–1647) by Krahe and Budde.
The church had been built by Gian Lorenzo Bernini in 1662–64 for the family of the reigning Pope, Alexander VII Chigi, opposite their palace. The monumental fresco in the apse was painted by Guglielmo Cortese in the years 1664–66 (cf. Salvagnini, p. 164, pls. lxv–lxvii). In this charming and freely handled drawing, the apostles are so different from those in the fresco, in pose as well as in placing, that the work may be regarded as the artist's first idea. The study is drawn with pen and wash, a technique employed comparatively rarely by Guglielmo Cortese. In the concise style of drawing and the free but completely assured manner in which the wash has been applied, this study recalls the pen drawings of Pier Francesco Mola (1612–66) (cf. Cat. no. 110). It can be taken as certain that Guglielmo had seen comparable studies by Mola, as both artists had been brought together several times during the execution of some large painting projects (cf. Graf, *op. cit.*, p. 28, n. 16).
For further studies by Guglielmo for the apse fresco, in Düsseldorf, Rome and Vienna, see Graf, *op. cit.*, Cat. nos. 10–20.

Black chalk, heightened with white, on grey-brown paper, with a study for the face of the Madonna in red chalk, top left, 315 × 237 mm. The sheet is laid down on an old mount
Inv. No. FP 8126
1932 Inventory: Madonna with Child. Unknown
Unpublished

Study of Mary with the Infant Jesus in the crib, for the painting *The Adoration of the Shepherds* recently identified by Erich Schleier as by Guglielmo Cortese (Rome, Galleria Nazionale, Palazzo Barberini, cf. Schleier, 'Aggiunte a Guglielmo Cortese', pp. 3–6, fig. 6). Erich Schleier was able to identify quite a number of preparatory studies by Guglielmo Cortese in the Gabinetto Nazionale delle Stampe in Rome, for this painting and its companion picture *The Adoration of the Kings* (Schleier, *op. cit.* figs. 2, 4, 5, 7–13). These studies enable us to reconstruct the various stages in the painting's preparation. In a sketch of the complete composition, in pen and wash (Schleier, *op. cit.*, p. 6, fig. 7), Mary is still shown kneeling by the crib. The present study, on the other hand, shows Mary sitting, as she is in the finished painting. Yet even in this drawing there are still variations from the painting in the position of Mary's head and in the way in which the Infant Jesus is lying.

Amongst the other drawings in the Düsseldorf Print Room for Guglielmo's *Adoration of the Shepherds* we can only refer here to one other study, which, though somewhat less carefully finished, shows Mary in almost the same attitude as in the present study (Inv. No. FP 8175 recto). Schleier dates the painting in the 1660s. As the verso of this second drawing in Düsseldorf has on it studies for Guglielmo's altarpiece of the *Madonna del Rosario* in the church of Monte Porzio Catone, which can be assigned to 1666 by means of receipts of payments to Guglielmo, Schleier's dating – which also holds good for the present drawing – gains additional support.

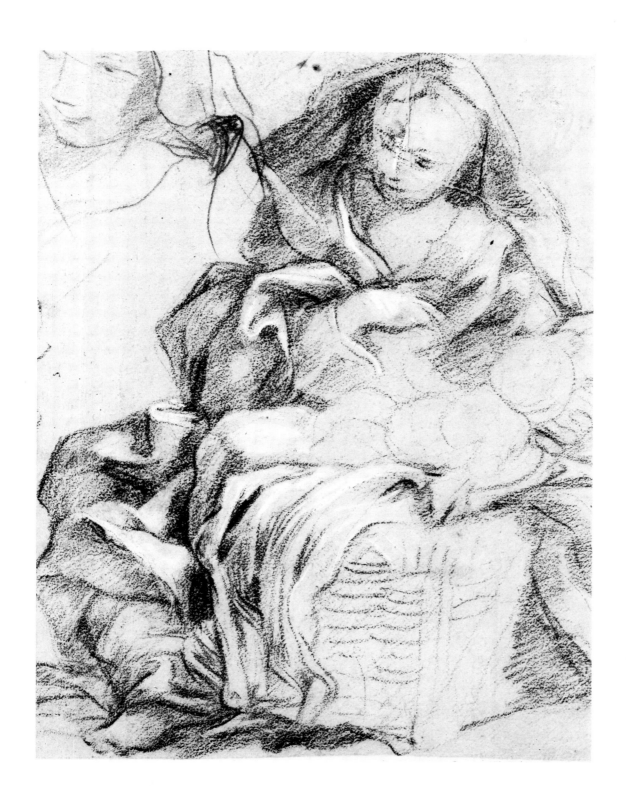

Centre left – stamp: *Status Montium*
On the back strips of an old mount adhere
to the left edge of the sheet
Black chalk, heightened with white, on
grey-brown paper, 517 × 381 mm. Paint
marks. Below the horizontal line where
the sheet has been folded there are
markings in red chalk indicating the lines
for squaring. A horizontal cut at the
bottom on the left has been reinforced
Inv. No. FP 7910 recto
1932 Inventory: Study. Unknown
Unpublished

Studies for a painting of *Hagar and Ishmael in the Desert*, which
has not yet been identified. Bottom right, a study of Hagar and
Ishmael. Left of Hagar, two studies of Hagar's left arm. Top
left, a study of the dress over the shoulders and breast of Hagar.
To the right of this, studies of Hagar's left hand and Ishmael's
left arm.

Three designs for the painting are in the possession of the
Gabinetto Nazionale delle Stampe in Rome: Inv. No. FC
127100 shows Hagar and Ishmael in the same position as in
this study. Hagar and Ishmael are sitting on the right of the
foreground in front of a tree. The angel is shown flying down
from top left. The drawing is squared and was obviously
intended for use in painting the picture. The drawing Inv. No.
F.C. 126862 recto, on the other hand, shows us an earlier stage
in the planning of the picture: in this, Hagar is kneeling on the
left looking up at an angel sweeping down from the top right
while Hagar points to Ishmael lying asleep in front of her. On
the verso there is a drawing which in the evolution of the
picture stands midway between this early idea and the squared
working design. The angel on the verso descends from the left,
while Hagar and Ishmael are on the right; but the figures are
not yet posed as in the final design and in the studies on the
present sheet. These studies can be dated in the 1660s.

I am deeply grateful to Professor Dr Lidia Bianchi for supplying
me with photographs of the drawings in the Gabinetto
Nazionale delle Stampe in Rome, and for generously giving me
permission to discuss them here.

On the verso: In the upper half of the sheet (at right angles) there are
studies of Ishmael in red and black chalk, heightened with white. In
the lower half there is a study of Hagar's dress covering her lap and
legs, in black chalk, heightened with white

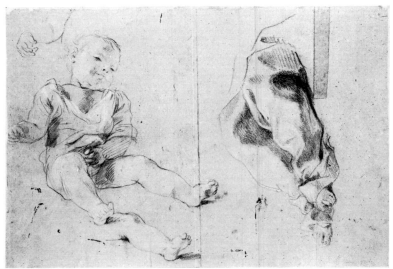

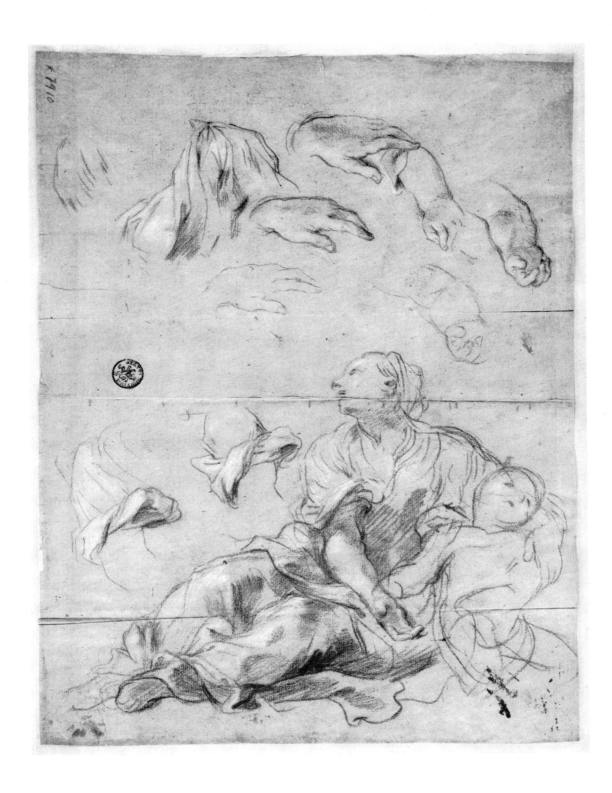

5

Bottom right – numerals in pen and brown ink: *117*
Bottom left – stamp: *Status Montium*
Strips of a backing sheet still adhere to the upper edge of the sheet
On the back, bottom right – a note in pencil: *g. borgogn(one)*
Red chalk, heightened with white, on grey-brown paper, 402 × 243 mm. Small oil spot
Inv. No. 7777 recto
1932 Inventory: Study. Unknown
Unpublished

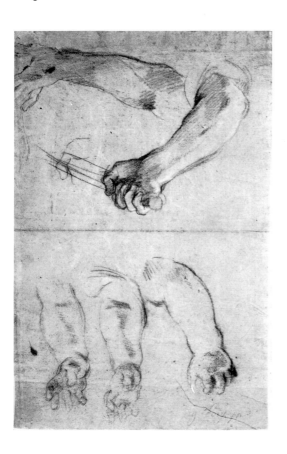

Study of a figure of Abraham for a painting of *The Sacrifice of Isaac* (Genoa, Durazzo Pallavicini Collection), recently identified by Erich Schleier (cf. *Revue de Louvre*, vol. 22, 1972, p. 324). Two designs for the composition of the whole picture have been preserved in the Gabinetto Nazionale delle Stampe, Rome (Inv. No. FC 127121): on the verso of the sheet there is a rough and quickly drawn first sketch; on the recto this has been drawn again more carefully. In both drawings Abraham has placed his left foot on the low sacrificial altar at the foot of a tree, where Isaac (see Cat. no. 24) kneels on a pile of wood. Abraham has raised the knife for the fatal blow and is looking towards the delivering angel, who is flying down to seize Abraham's raised arm while pointing to the ram, which can be seen behind Isaac at the foot of a tree. The recto is squared ready to be transferred to the painting.

This present study corresponds fairly closely with the figure of Abraham in the final composition of the whole picture, referred to above. The violent turning movement of Abraham and his fluttering robe emphasize the dramatic instant between death and Isaac's deliverance. The attitude of Abraham and the motif of the fluttering robe are akin to the figure of Abraham in the painting of the same subject by Giovanni Angelo Canini (1617–66) in the Alexander VII Gallery in the Palazzo del Quirinale (for Canini's fresco see Giuliano Briganti, *Il Palazzo del Quirinale*, Rome 1962, p. 46, fig. 75). Since Guglielmo Cortese was one of the artists who were employed in 1656–57 decorating this gallery – he painted the battle of Joshua there – he must certainly have known Canini's fresco. Canini's studies of Abraham and Isaac are also in the Düsseldorf Print Room (Inv. No. FP 430 and FP 7154, cf. Cat. Exh. *Düsseldorf 1969*, no. 81). For Guglielmo's studies of Isaac see Cat. no. 24.

I am deeply grateful to Professor Dr Lidia Bianchi, the Director of the Gabinetto Nazionale delle Stampe in Rome, for her kindness in supplying photographs of the drawings referred to above and for generously giving me permission to discuss them here.

On the verso: In red chalk heightened with white: 3 studies of arms for a putto or angel, studies of Abraham's arms which are not drawn in detail on the recto. Also a study in white chalk of a kneeling monk (?) with raised arms

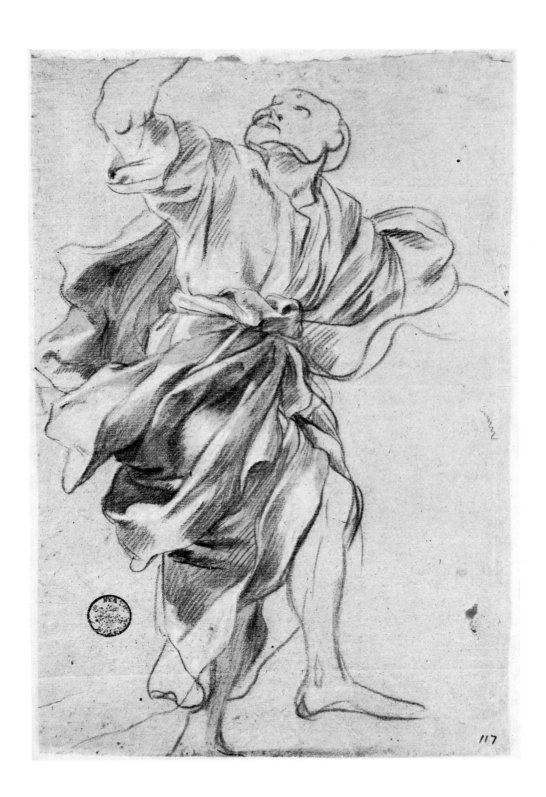

117

Guglielmo Cortese
STUDY OF ISAAC

Numerals in pen and brown ink – top right: *911* (?); bottom right: *129*; bottom left – stamp: *Status Montium*
On the back of the old backing paper a note in pencil: *g. borgogno(ne)*
Red chalk on light beige paper, 384 × 249 mm.
Top left a piece is missing (53 × 105 mm)
Paint marks. The sheet is laid down on an old mount
Inv. No. FP 7476
1932 Inventory: Study. Borgognone
Unpublished

Study of Isaac for a painting recently identified by Erich Schleier (see Cat. no. 23). Isaac is kneeling, his hands tied behind his back, and is turning away in expectation of a fatal blow from Abraham. Guglielmo's great painterly gift, which comes out equally well in his chalk studies, is clearly apparent here in the unusually sensitive modelling of this nude bathed in shimmering light. At the same time, that deeply human quality that characterizes many of his paintings is as perceptible in Isaac's face as in the submissive surrender of his body to the sacrifice required by God.
The Düsseldorf Print Room has a second, almost identical study of Isaac (Inv. No. FP 7877), which Guglielmo has drawn with black chalk, heightened with white, on greenish paper.
In this second study Isaac is wearing a loin-cloth. On another sheet Guglielmo has drawn in the same technique only the head and the upper part of Isaac's body (Inv. No. FP 7874 verso).

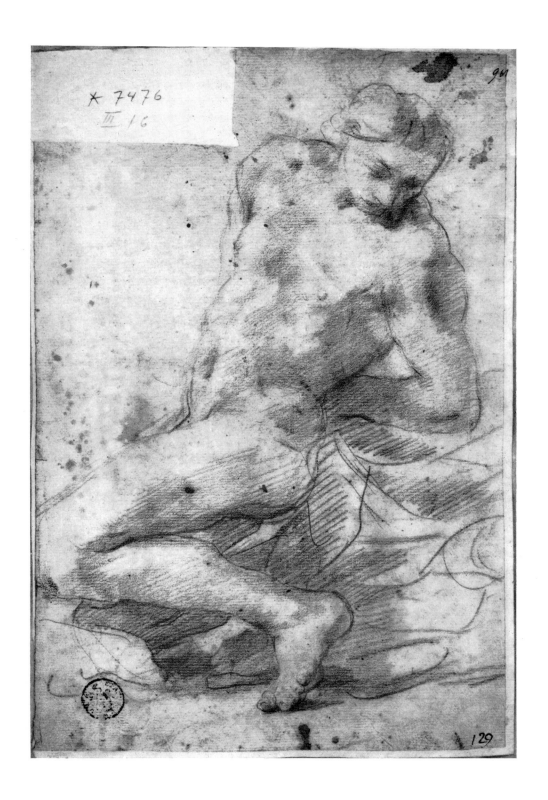

On the back there is a note in pen and
brown ink, top left: *Del borgognione*
Bottom right – numerals: *93*
Bottom centre – a stamp: *Status Montium*
Black chalk and pastel on blue-green
paper, 416 × 263 mm.
Water stains and paint marks
Inv. No. FP 7917 recto
1932 Inventory: Study. Borgognone
Unpublished

Study of a servant-girl. In her right hand she is carrying a
bucket or a basket. It has not so far been possible to identify
a painting in which this study has been used. It is perhaps
connected with a picture of the birth of Mary or of John the
Baptist. Paintings of this subject, however, are not mentioned
by Lione Pascoli, Guglielmo's biographer. In this present study
various coloured chalks have been used, particularly to render
the flesh and hair, where the artist has primarily been con-
cerned with graduations in tone between the light and dark
areas, and has achieved very subtle colour effects, which are
strengthened still further by the colour of the paper itself.
The Düsseldorf Print Room has several studies by Guglielmo
using this technique, which was not very common in Roman
drawings of the *Seicento* (see also Cat. no. 31 verso).
It seems significant that it was precisely an artist with an
eminently painterly gift, like Guglielmo Cortese, who used this
technique from time to time.

On the verso: Study of a kneeling woman, black chalk, heightened with
white, and above it a study of a head for the same figure in red chalk,
heightened with white

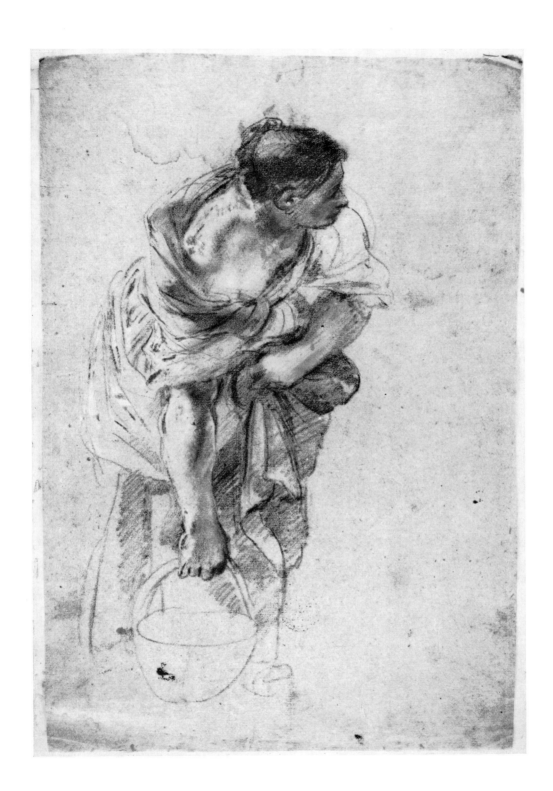

Guglielmo Cortese
STUDY OF A MOTHER AND CHILD

Bottom right – numerals in pen and
brown ink: *104*
Top left – stamp: *Status Montium*
On the back a note in pencil: *g. borgognone*
Black chalk, heightened with white, on
grey-brown paper, 354 × 259 mm.
Oil- and colour-stains
Inv. No. FP 8162 recto
1932 Inventory: Studies. Borgognone
Unpublished

Study of a mother with a child, possibly intended for a picture
of the Madonna. The delicacy of the drawing and the soulful
expression suggest it should be dated in the 1670s.
The Victoria and Albert Museum, London, has a comparable
study by Guglielmo, though in this the Madonna is facing to
the left and the child is looking up at her (Museum No.
E.4015–1919).

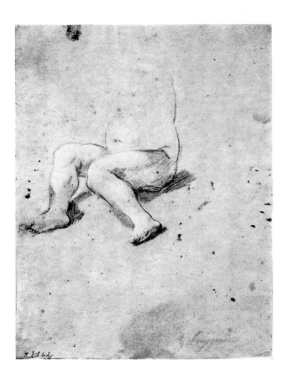

On the verso: A study in the same technique of a putto in an *Allegory
of Autumn*. This painting, of which only the figures in the foreground
were painted by Guglielmo, was kindly brought to my notice by Erich
Schleier, who was the first to recognize that Guglielmo had painted
the foreground figures. In the painting (since 1971 on the Roman
art market) this putto is holding a basket of fruit above his head

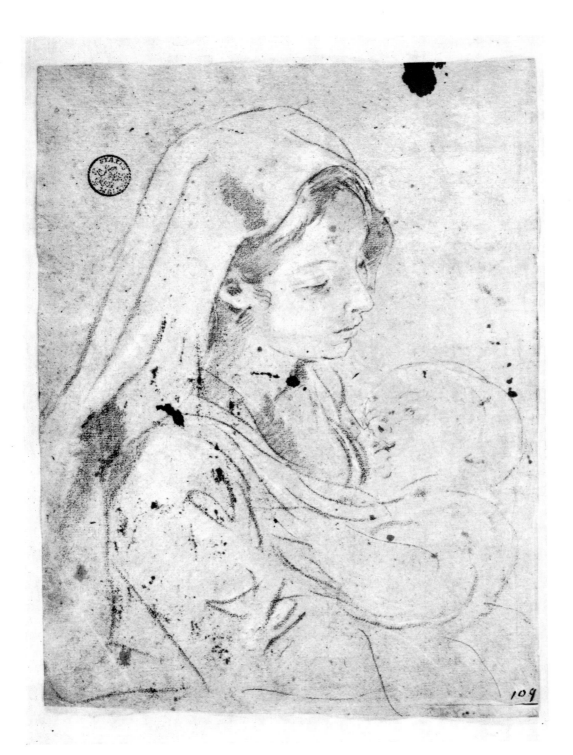

109

Numerals in pen and brown ink, top left:
57
Bottom right: *cinquanta sette* and the
remains of a stamp: *Status Montium*
Red chalk on light beige paper, 306 × 199
mm.
The sheet is laid down on an old mount
Inv. No. FP 11519
1932 Inventory: the Madonna in Glory.
Unknown
Unpublished

Probably a design for a painting which is in private ownership in Rome. I am grateful to Ursula Fischer for bringing this painting to my notice. The saint may be S. Margherita of Cortona. The Gabinetto Nazionale delle Stampe in Rome has another design for exactly the same composition, somewhat more fully worked out, though it may not all be by the hand of Guglielmo (Inv. No. FC 127111), and also a study of the saint's head (Inv. No. FC 127073). This study of a head is connected with another drawing in the Düsseldorf Print Room (Inv. No. FP 8084), which shows the saint sitting in the clouds and was first attributed to Guglielmo Cortese by Eckhard Schaar. Individual studies for the saint in the Düsseldorf Print Room are Inv. No. FP 8171 recto and verso (see Cat. no. 28) and Inv. No. FP 8161 recto. On Inv. No. FP 8161 verso there is a study of the leg of the angel on the right. In the painting mentioned the kneeling saint faces to the left and has her hands crossed on her breast. The angels in the painting are also shown in different attitudes. In spite of these deviations from the present drawing and from the other designs for the composition in Düsseldorf and Rome, it seems unlikely that Guglielmo painted the same subject in two different pictures, of which only the one mentioned here would have so far been identified.

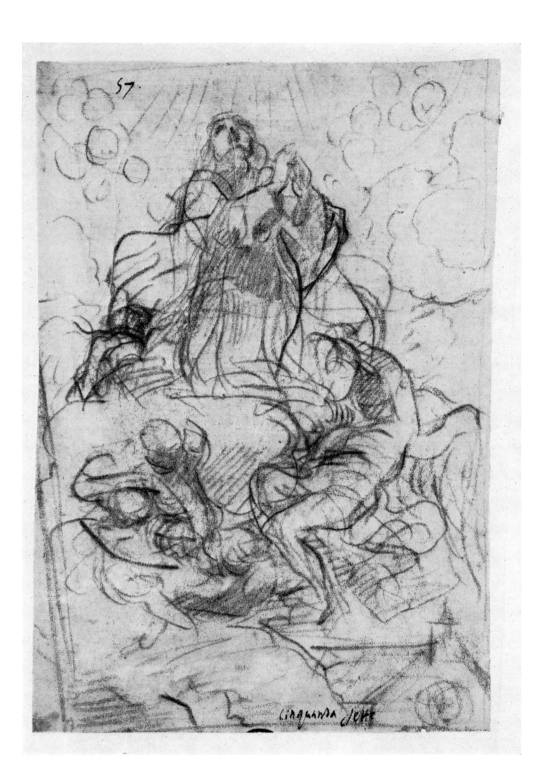

57.

Cinquanta dott

On the front, bottom right, numerals in
pen and brown ink: *92*
Bottom centre – a stamp: *Status Montium*
On the back, a note in pencil by the left
edge of the sheet: *guilielmo borgogn(one)*
Red chalk, heightened with white, on
grey-brown paper, 419 × 273 mm. Oil
stains. On the back there are strips of an
old mount still adhering to the left edge
Inv. No. FP 8171 recto
1932 Inventory: Studies. Unknown
Unpublished

Carefully executed studies of a sainted nun, kneeling on clouds.
For the designs for the whole composition and the painting, see
Cat. no. 27.
At the bottom on the left a study of the head of an angel gazing
upwards: it is the head of the angel who appears, roughly
sketched, below the clouds that support the kneeling saint in
Cat. no. 27, the design for the whole composition. This angel is
drawn in more detail and is easier to recognize in the other
drawings in Düsseldorf and Rome referred to in Cat. no. 27.
The style of the present drawing suggests a date in the late
1660s or in the 1670s.

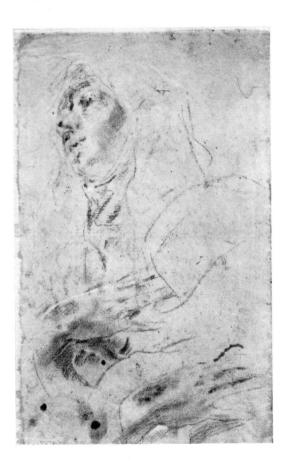

On the verso: Studies in black chalk heightened with white for the
face, upper part of the body and hands of the saint. These studies
show the saint turning to the left and already in the attitude in which
she appears in the painting referred to in Cat. no. 27

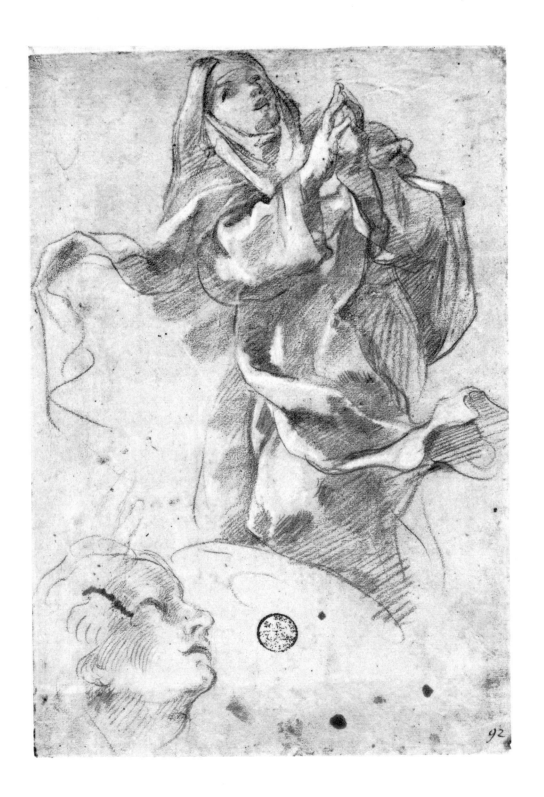

92

Red chalk, construction lines in black chalk. 347 × 256 mm.
Inv. No. FP 11786 recto
1932 Inventory: Studies. Unknown
Unpublished

Design for the composition of Guglielmo Cortese's altarpiece *Madonna and Child with four Saints* in the Altimani Chapel in the Roman Church SS. Trinità dei Pellegrini (first chapel on the left). The painting was carried out in about 1677 (cf. Salvagnini, pp. 177–78, pl. lxii). At the feet of the Madonna the artist has shown San Carlo Borromeo on the left and Saints Dominic, Felix and Philip on the right.

This design, which is clearly an early one, shows the figures still nude. San Carlo Borromeo is still shown kneeling, whereas in the painting he is standing. In the group of saints on the right the figure of Dominic kneeling in the foreground corresponds with the figure in the painting, and Felix also appears in both, behind Dominic, on the extreme right edge of the picture. Philip, who in this sketch is drawn twice, kneeling behind Dominic, in the painting stands in the background to the left of Felix. Anna Matteoli has recently published another design for the painting, partially overdrawn with the pen and wash (Florence, Gabinetto Disegni e Stampe degli Uffizi, Inv. No. 25625S) but she has incorrectly attributed it to the Florentine painter Simone Pignoni (1614–98) (cf. A. Matteoli, 'Le vite di artisti dei secoli xvii–xviii di Giovanni Camillo Sagrestani' in Commentari, vol. xxii, p. 216, fig. 9). Even in this second sketch, in which the figures are now clothed, San Carlo Borromeo is still shown kneeling. As well as individual studies in crayon of Jesus as a boy (Inv. No. FP 8192 and FP 8195) and of the face of St Dominic (Inv. No. FP 7858 verso, see Cat. no. 31) the Düsseldorf Print Room also has another design for part of the painting (see Cat. no. 30).

On the verso: In the lower part of the sheet (at right angles) there is a design for the same painting, showing the right half. As in the design in the Uffizi, the figures are now shown clothed. Above it is a study of a seated woman, probably for the figure of Mary in the painting *Christ in the house of Mary and Martha* (see Cat. no. 32), but drawn in reverse. Red chalk

On the back of the old backing sheet –
note in pencil: *guil. borgognon(e)*
Red chalk on paper which was once light
beige, 343 × 235 mm.
There is a small piece missing from the
top left corner. The sheet is laid down on
an old mount
Inv. No. FP 8092
1932 Inventory: Adoration. Borgognone
Unpublished

Design for part of the altarpiece *Mary with Child and four
Saints* in the Roman church SS. Trinita dei Pellegrini (see Cat.
no. 29). Unlike the version in the painting and in the design for
the whole composition (Cat. no. 29), in this drawing Mary and
the Infant Christ are turned towards Carlo Borromeo. He is
only drawn in outline but is shown in the same posture as in
the painting.
For further studies for this altarpiece see Cat. no. 29.

6

Bottom right – numerals in pencil: *120*
Top left – stamp: *Status Montium*
On the back, bottom left, a note in pencil:
g. borgognone
Red chalk heightened with white, on
blue-green paper, squared in black chalk,
380 × 270 mm.
Left bottom corner missing. Oil stains
Inv. No. FP 7858 recto
1932 Inventory: Study. Unknown
Bibliography: Graf, 'Guglielmo Cortese's
paintings of the Assumption of the Virgin',
p. 31, Cat. no. 21, fig. 39

The design has been worked out very carefully and is squared for copying; it must therefore belong to the final stage of drawing prior to painting. Bearing in mind the considerable differences between the drawing and the paintings on this theme by Cortese known to us, in Castelgandolfo and Ariccia (cf. Cat. no. 20), it does not seem very likely that this sketch has any connection with either of them (Graf, *op. cit.*, figs. 16 and 23). There are also stylistic grounds against such a connection. The style of drawing is much more delicate than in those chalk studies which can with certainty be related to these two paintings of Guglielmo, carried out in the early and middle 1660s (cf. Graf, *op. cit.*, Cat. nos. 1–4, 6–8, 10–20, with ill.). In the present drawing the chalk has been gently rubbed away on the contour lines and in the shaded parts, and the modelling is very delicate and continuous, quite unlike that in the studies just mentioned. On the other hand the drawing is closely related in style to Cortese's studies for the last altarpiece by him listed by Pascoli, *Christ with Mary and Martha* (see Cat. nos. 32–4). Since the verso has studies for Guglielmo Cortese's altarpiece in the Roman church SS. Trinità dei Pellegrini, which must have been carried out around 1677 (cf. Salvagnini, pp. 177–78, pl. lxii), the evidence based on style is given added support. The design for an Assumption of the Virgin must therefore have been produced in the second half of the 1670s. Guglielmo Cortese died in 1679. It is possible that he was not able to complete the painting which he was planning; in any case it is not mentioned by his biographer. There is a detailed study of the Virgin kneeling on clouds in the Düsseldorf Print Room (Inv. No. FP 8186 recto, cf. Graf, *op. cit.*, p. 31, fig. 40).

On the verso: Two studies in black chalk and pastel for the face of St Dominic in Cortese's altarpiece in SS. Trinità dei Pellegrini, Rome (see Cat. nos. 29–30)

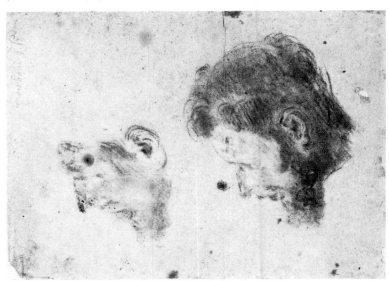

#7858

Numerals in pen and brown ink – bottom right: *46*
Top left – stamp: *Status Montium*
Red chalk, heightened with white, on blue-green paper, 382 × 258 mm. Small paint marks
Inv. No. FP 7903 recto
1932 Inventory: Study. Unknown
Bibliography: Graf, 'Christ in the House of Mary and Martha', p. 358, Cat. no. 8, pl. 14

For the painting see Cat. no. 33.
Study of a youthful figure of Mary. The attitude of Mary, her delicate youthful countenance, her hands crossed above her knee – Guglielmo has drawn the right hand again in the upper part of the sheet – these correspond with the figure in the finished picture. There Mary is shown with loosely flowing hair and a dress with wide billowing sleeves with many folds, which emphasize Mary's passionate surrender to the Word of Christ. Whereas Guglielmo Cortese drew his designs for compositions partly with the pen and wash, or the brush only, and partly in red chalk on white or beige paper, for individual studies, above all in the earlier years, he used brownish paper. In later years, on the other hand, he seems generally to have preferred blue or blue-green paper, as this study shows. This change in the choice of coloured paper coincides with a more tender, delicate and continuously modelled style of drawing and an acute sensitivity to the colouring of his studies. What distinguishes these late studies of Guglielmo from those of other artists of the Roman *Seicento* is a painterly softness combined with very precise modelling, a harmonious line and, above all, the tenderness and spirituality in the expression of his figures.

On the verso: Study of the figure of Mary in the same technique as on the recto, but less carefully worked out (Graf, *op. cit.*, Cat. no. 8 pl. 15)

Top left, numerals in pen and brown ink
(upside down): *133*
Top right – stamp: *Status Montium*
On the back, a note in pencil: *G.
borgognone*
Black chalk on blue green paper, 382 ×
258 mm.
Paint marks and water stains
Inv. No. FP 8108 recto
1932 Inventory: Studies. Borgognone
Bibliography: Graf, 'Christ in the House of
Mary and Martha', p. 358, Cat. no. 3, pl. 5

Study for Guglielmo Cortese's altarpiece *Christ at the House of Mary and Martha.* This was originally intended as an altar painting for the Roman church S. Marta al Collegio Romano, but after the dissolution of the monastery (1873) the picture was transferred to the convent of SS. Quattro Coronati in Rome, where it was rediscovered by Robert Salvagnini (cf. Salvagnini, pp. 180–83, pl. lxiii). According to *Pascoli* (vol. i, p. 151) the painting was the last work of Guglielmo Cortese. In the painting Christ is sitting in the centre and is turning towards Martha, who has just approached and is pointing to Mary seated at Christ's feet listening absorbed and looking up at him (see Cat. no. 32). The gestures of Christ and Martha illustrate the words: 'Lord, dost thou not care that my sister has left me to serve alone? Bid her therefore that she help me.' But Christ answered and said: 'Martha, Martha, thou art careful and troubled about many things, but one thing is needful and Mary hath chosen that good part, which shall not be taken away from her' (Luke 10, 40–2).

The present study, which follows other studies (cf. Graf, *op. cit.,* Cat. nos. 1 and 2 with ill.), shows Christ already in the same attitude as in the painting. Guglielmo is here primarily interested in the arrangement of the robe over the lap and legs and has made a careful study of this. The face, the upper part of the body, the hands and feet of Christ have on the other hand merely been indicated in rapid strokes and are worked out in detail in further studies (cf. Graf, *op. cit.,* Cat. nos. 4 and 5 with ill.). For other studies for the painting see Cat. nos. 32 and 34.

On the verso: Studies in black chalk heightened with white of Martha's face for the same painting, together with plant studies (Graf, *op. cit.,* Cat. no. 3, pl. 6)

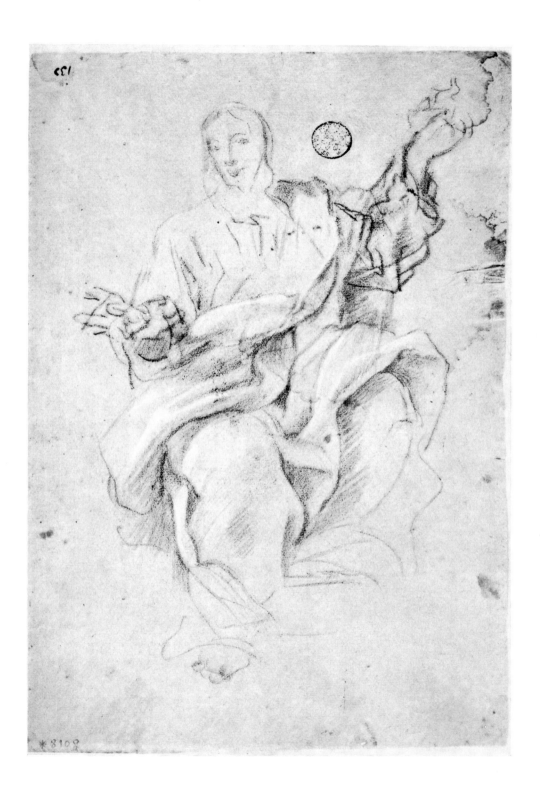

In pen and brown ink, bottom left, a note (upside down): *Del borgognione,* above that – stamp: *Status Montium*
Bottom right – numerals: *100*
Red chalk, heightened with white, on blue-green paper, 418 × 248 mm.
Oil stains
Inv. No. FP 8181 recto
1932 Inventory: Studies. Borgognone
Bibliography: Graf, 'Christ in the house of Mary and Martha,' p. 358, Cat no. 5, pl. 9

For the painting see Cat. no. 33.
On this sheet Guglielmo Cortese has drawn the slender, youthful face of Christ twice in almost the same attitude and with a scarcely varied expression. Top right, a study for the right hand of Christ, a variation of that actually used in the painting, and below this a study of the left hand of Christ pointing upwards. The study of another hand, drawn only in outline, does not seem to have been used for the painting. See also Cat. no. 32.

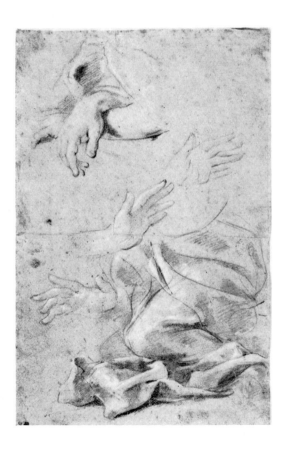

On the verso: Studies of hands, in red chalk heightened with white, for the figure of Mary. Studies of hands for Christ and Martha and a study of Mary's dress, in black chalk heightened with white (Graf, *op. cit.,* Cat. no. 5, pl. 10)

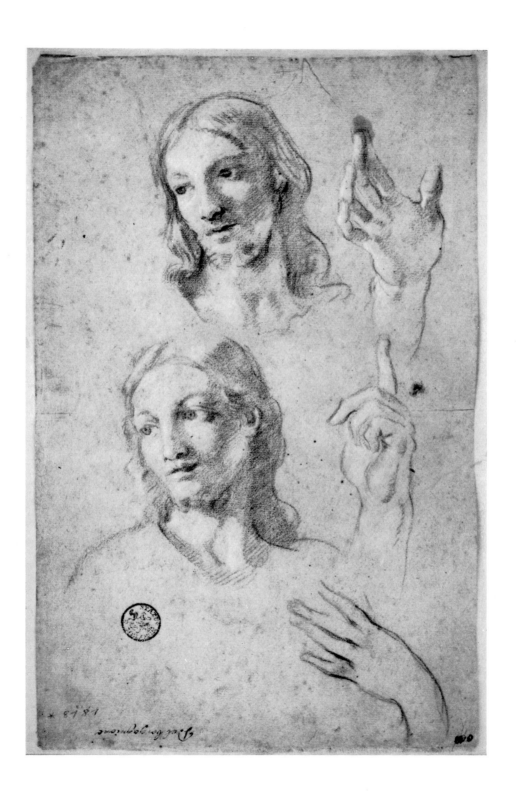

Pietro da Cortona

(Pietro Berrettini)
Painter and architect
Born Cortona, 1596; died Rome, 1669
Cat. nos. 35–40

On the verso, a stamp: *FP*
Black chalk on beige paper, 377 × 247 mm.
Inv. No. FP 358 recto
Krahe, *Inv. II*, fol. 18 verso, No. 75:
Etude de quelques Soldats Romains, 14 × 9 Pouces, as Pietro da Cortona
1932 Inventory: Soldiers in a landscape.
Pietro da Cortona
Bibliography: Cat. *Roman Drawings*, under no. 608; Cat. Exh. *Düsseldorf 1964*, no. 33, pl. 7

Design for a painting by Pietro da Cortona, engraved by C. Bloemart. The painting, *Alexander the Great storming the City of Petra Sogdianae*, was traced only a few years ago (Rome, Palazzo del Vicariato, cf. C. Pietrangeli in *Bolletino dei Musei Comunali di Roma*, vol. vii, 1960, p. 14 ff.).

The painting belongs to a series of commissions which Pietro da Cortona carried out in the early twenties for his first important patron, Marcello Sacchetti (cf. Haskell, pp. 38–9). Sacchetti, whose splendidly painted portrait by Pietro da Cortona is in the Galleria Nazionale in the Villa Borghese, had recommended Pietro da Cortona to his close friend, Pope Urban VIII, who was later to involve the artist in many very important works of painting and architecture.

This study is part of a design for the above painting and shows two officers on the right, who in the painting are urging on the soldiers standing lower left to storm the city, while here, as in the painting, the soldiers standing in the foreground to the left are trumpeting the advance. The steep cliff face is only suggested in the design, but in the painting other soldiers are shown climbing it.

The design for the whole painting is in Windsor (Cat. *Roman drawings*, no. 608, pl. 17). There is a version on the same theme but with variations in the composition in Holkham Hall, Coll. Earl of Leicester. A design by Ludovico Gimignani (1643–97) on the same theme, which is very closely dependent on Pietro da Cortona's composition, is in the possession of the Berlin Print Room (Inv. No. *KdZ* 22377; cf. Cat. Dreyer, no. 100, pl. 45). Peter Dreyer has established the site as Petra, given as Pera by earlier writers.

On the verso: Study in the same technique for the façade of S. Maria della Pace, Rome

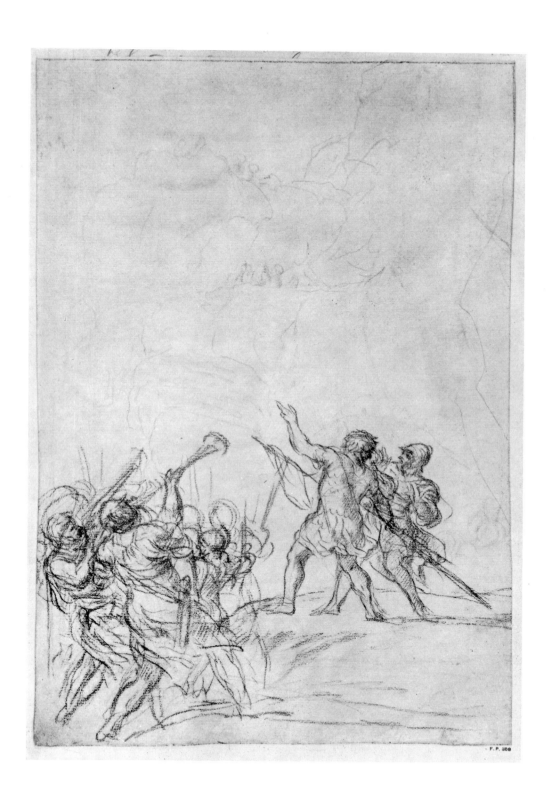

Pietro da Cortona

THE VIRGIN AND CHILD WITH ST JOHN THE BAPTIST AND POPE STEPHEN

On the verso, a stamp: *FP*
Pen and brown ink, with brown and grey
wash, heightened with white, on beige
paper, 270 × 238 mm.
Top left corner restored
Inv. No. FP 737
Krahe, *Inv. II*, fol. 23 recto, No. 12: *La
Ste Vierge sur un Thrône avec deux Saints
a genoux*, *10 × 9 Pouces*, as Francesco
Romanelli
1932 Inventory: Conversatione. Romanelli
Bibliography: Cat. Exh. *Düsseldorf 1969*,
no. 47, fig. 33; K. Noehles, *La Chiesa dei
SS. Luca e Martina nell'opera di Pietro
da Cortona*, Rome, 1970, p. 19, fig. 4.

The drawing, still attributed by Krahe to Francesco Romanelli
(1610–62), was recognized by Eckhard Schaar as by Pietro da
Cortona. The careful execution and the painterly qualities in it
suggest that it is a *modello*, which would have been submitted to
the patron. Schaar drew attention to the relationship between
the composition and that of Pietro da Cortona's painting *The
Madonna with Saints John the Baptist, Peter, Catherine and
Felix of Cantalice* (Milan, Brera; cf. *Briganti*, p. 194, fig. 119)
of c. 1630–31; its iconographic relationship, however, he felt
was to the painting of 1626–28: *The Madonna with Saints
James, Francis, John the Baptist and Pope Stephen* (Cortona,
S. Agostino; cf. *Briganti*, pp. 176–77, fig. 60). In spite of the
absence in this drawing of St James and St Francis, and in spite
of the difference in the architecture behind Mary, Karl Noehles
relates the design directly to the altarpiece in Cortona. If this
is a correct assumption, then the drawing must represent
an early design for this painting, after which the patron
demanded the inclusion of Saints James and Francis.

On the recto, numerals in pen and black ink (at right angles); on the left: *16*, on the right: *sedeci*
On the verso of the mount, a note in lead pencil: *p: da Cortona* and a stamp: *FP*
Black chalk, heightened with white, on grey-brown paper, 207 × 316 mm
The sheet is laid down on an old mount
Inv. No. FP 7902
1932 Inventory: Study. Pietro da Cortona
Bibliography: Cat. Exh. *Düsseldorf 1969*, no. 49, fig. 50

As Eckhard Schaar has recognized, this study is related to the figure of Apollo in the ceiling fresco of the Sala di Giove in the Palazzo Pitti in Florence.
The Grand Duke Ferdinand II de' Medici (1610–70) commissioned Pietro da Cortona to decorate five rooms on the first floor of his palace with ceiling and lunette frescoes. The iconographic plan had been prepared by Francesco Rondinelli, the Grand Duke's librarian: the virtues for which a prince should strive from his childhood to old age were to be illustrated by exemplary scenes taken from classical mythology, with reference to the constellations depicted above (cf. Briganti, pp. 225–27).
Pietro da Cortona decorated the rooms of Venus, Jupiter and Mars from 1641 onwards, with periods of interruptions. In 1647 he returned to Rome to decorate the cupola of S. Maria in Vallicella (see Cat. no. 39). His pupil Ciro Ferri (1634–89) completed the cycle in the Apollo and Saturn Rooms – for the most part from designs by his master.
In the ceiling fresco of the Jupiter Room, decorated in 1643–46 (Briganti, fig. 220), the youthful prince is shown as he is led by Hercules and Fortuna to Jupiter, who is about to crown him. The centre of the picture is occupied by the figure of Apollo flying down and pointing out to the prince the constellation of the Great Bear, which never sets and appears here as the symbol of steadfastness.
Apollo is shown in the present study more or less horizontal, whereas in the fresco he is soaring downwards diagonally, as Pietro da Cortona drew him in a design in the Uffizi (Inv. No. 11747 F, cf. Campbell, Cat. no. 55, fig. 40), which must be later than the Düsseldorf study.
Unlike Briganti and Schaar, Campbell considers the flying figure to represent Ganymede, not Apollo.

7

Numerals in pen and black ink, top right:
73
Bottom right: *Settantatré*
On the mount, Krahe's numerals in lead
pencil: *50*
Pen and dark brown ink over black chalk
on beige paper, 86 × 133 mm.
The sheet is laid down on an old mount
Inv. No. FP 387
Krahe, *Inv. II*, fol. 18 recto, No. 50:
Castor & Pollux cintrés en Plafond, 3 × 5
Pouces
1932 Inventory: Pietro da Cortona
Unpublished

Malcolm Campbell kindly confirmed the attribution of the drawing to Pietro da Cortona, which was also suggested by Karl Noehles and Eckhard Schaar (notes on the mount). It is a design for one of the lunettes in the Jupiter Room of the Palazzo Pitti in Florence (Briganti, fig. 224). For the iconography see Cat. no. 37. Because of the exceptional power of the draughtsmanship the design, in spite of its small format, has great dynamism. The form seems to have been arrived at only during the actual process of drawing. Although the composition has already been established, the design contains several variations from the finished fresco. In the fresco the two Dioscuri, Castor and Pollux, together with their horses, are more widely separated in order to achieve greater spatial clarity, thereby avoiding the overlapping of figures and horses that occurs in this design.

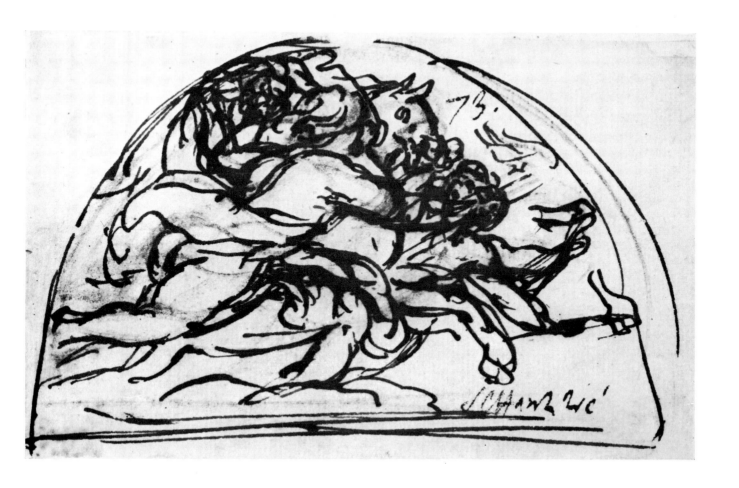

Bottom left, numerals in pen and brown ink: *510*
Bottom centre, part of a stamp: *Status Montium*
On the recto of the mount, numerals: *K. No 1* in pen and brown ink
On the verso of the mount, a note in lead pencil: *pietro da Cortona* and a stamp: *FP*
Black chalk, heightened with white, on blue-green paper, 347 × 251 mm.
The sheet is fastened down along its upper edge on an old mount
Inv. No. FP 355
Krahe, *Inv. II*, fol. 16 verso, No. 1: *Le Pere éternel dans la gloire, 10 × 11 Pouces*, as Pietro da Cortona
1932 Inventory: God the Father. Lanfranco
Bibliography: Cat. Exh. *Düsseldorf 1964*, no. 34, pl. 8, and Cat. Exh. *Düsseldorf 1969*, no. 48

Study for the figure of God the Father, enthroned on clouds, in the cupola fresco of S. Maria in Vallicella, Rome (repr. Briganti, fig. 246). The designs and cartoons for the dome were made between October 1647 and the spring of 1648. The scaffolding for the painting of the frescoes was up by 17 May 1648. The cupola fresco was unveiled in May 1651 (cf. Briganti, pp. 248–49).
The theme of the cupola fresco is the Holy Trinity in Glory and the Glorification of the implements of Christ's Passion. The powerful outward-reaching movement of God the Father has already been evolved in the present study. There are only slight variations in the position of the head and the arrangement of the legs in the final version. On both sides of the central figures of Christ and God the Father in the fresco there is a multitude of figures from the Old and New Testament. There is a large-scale study for this area of the fresco in the Albertina, Vienna (Inv. No. 14127, cf. Knab, *I grandi disegni*, p. 60, fig. 31).

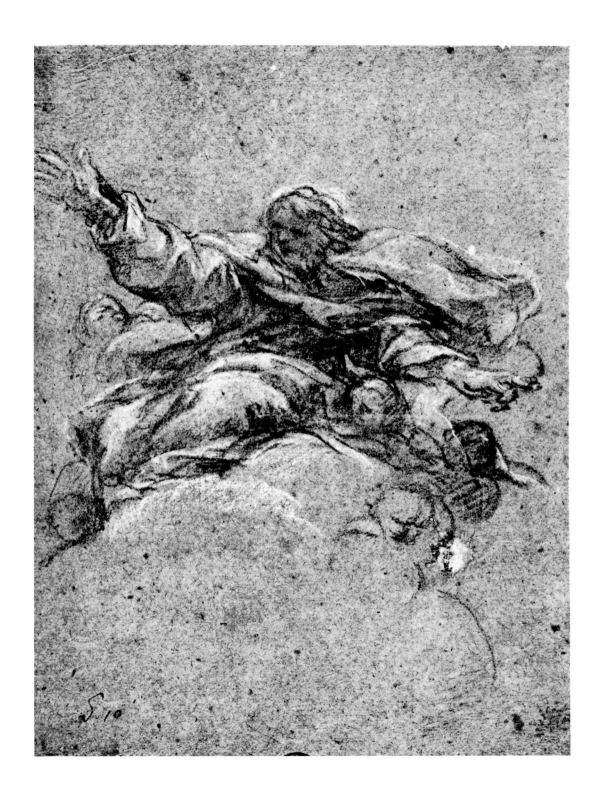

Note in lead pencil, bottom right: *p: da Cortona*
Numerals in pen and black ink, top centre: *146*
Bottom centre: *cento quarantasei*
On the verso, a stamp: *FP*
Black chalk and traces of red chalk, heightened with white, on grey-brown paper, the sketch at the top left in lead pencil, 260 × 395 mm.
Corners bevelled. Paint marks. The sheet is fastened down along the left edge on an old mount
Inv. No. FP 427
1932 Inventory: Seated saint. Pietro da Cortona
Bibliography: Cat. Exh. *Düsseldorf 1964*, no. 35; H. J. Schmidt, 'Italienische Handzeichnungen des Barock der Sammlung Lambert Krahe in Düsseldorf' in *Pantheon*, vol. xxv, 1967, p. 116, fig. 6

Study for the prophet in the fresco on the pendentive above the south-eastern dome pillar in S. Maria in Vallicella, Rome (repr. Briganti, fig. 246). The prophets Isaiah, Jeremiah, Daniel and Ezekiel are painted in the four pendentives. As Briganti demonstrated (p. 261), the scaffolding below the pendentives was put up in November 1659. Already by May 1660 Pietro da Cortona had received a final payment for the frescoes in the pendentives.

The present sheet shows the prophet looking up at Christ and God the Father, who are painted above him in the cupola. In the top left-hand corner there is a slight sketch of the same figure. Two further studies for this figure are in the Louvre (Inv. No. 537, Briganti, p. 316, pl. 288, fig. 68, and W. Vitzthum, 'Dessins de Pietro da Cortona pour la Chiesa Nuova à Rome' in *L'Oeil*, no. 83, November 1961, pp. 62 ff. repr. in colour) and in the British Museum (Briganti, p. 305, fig. 276). The Düsseldorf study seems to have preceded the other two, as it is less carefully worked out and shows greater variations from the finished version in the fresco. See also Cat. no. 39.

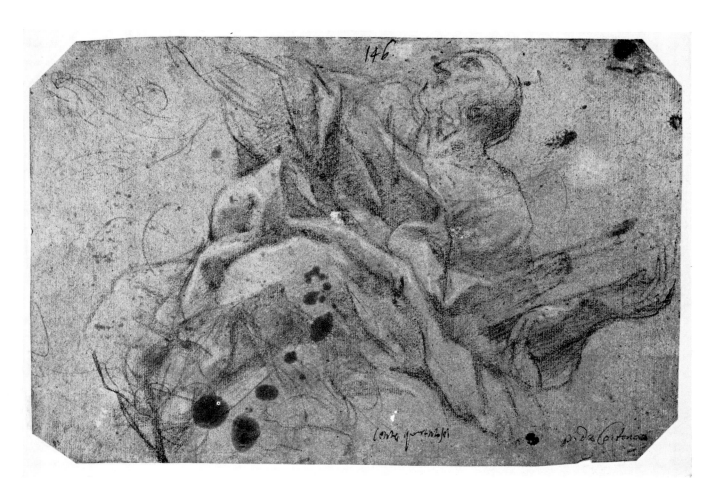

146.

conte p...ntaki p. da Cortona

Gaspard Dughet

Painter
Born Rome, 1615; died Rome, 1675
Cat. nos. 41–9

On the verso of the mount, a note in lead pencil: *Gasp. Poussin*
Brush and brown ink, with brown wash and heightened with white, in part over black chalk, 275 × 392 mm.
Top right corner has been repaired. The sheet is fastened down along its upper edge on an old mount
Inv. No. FP 4691
1932 Inventory: Landscape. Gasp. Dughet
Unpublished

The study may have been from nature. The motif – a rocky cliff overhung with bushes and an isolated crag on the right – has been captured exactly and its precise formation reproduced. The play of light on the cracks and crevices has been shown by the use of wash applied in varying thicknesses and by heightening with white.

In its lightness and accuracy of observation this fine study resembles the famous landscape study at Oxford (Ashmolean Museum, cf. Roli, no. 160, repr.), which Dughet used in his fresco *The Punishment of the Priests of Baal*, painted in S. Martino ai Monti in Rome around 1647–51 (cf. Shearman, p. 326 f., fig. 39; Ann B. Sutherland, 'The decoration of S. Martino ai Monti' in *Burlington Magazine*, vol. cvi, 1964, p. 58 ff.).

On the mount, numerals in pen and brown ink: *97* and *24*
On the verso of the mount, a note in black chalk: *gasp. poussin;* and a stamp: *Status Montium*
Brush and tempera over traces of red chalk on beige paper, the colour flaked in places, 227 × 271 mm.
The sheet is laid down on an old mount
Inv. No. FP 8049
1932 Inventory: Study. Dughet
Unpublished

This study shows a view through an *arco naturale* overgrown with bushes to the distant silhouette of Soracte. Dughet included a similar fissure in the rocks in one of his frescoes in San Martino ai Monti in Rome (first fresco in the left aisle). These frescoes, for which Pietro Testa painted the figures, were executed between 1648 and 1651.
It is probable that this unusual colour study by Dughet was carried out in connection with the fresco. The motif of the *arco naturale* was also depicted in landscapes by Poussin, Claude and Salvator Rosa.

In pen and brown ink: bottom centre, a
note *Cosciou;* bottom right, numerals: *180;*
top right, a stamp: *Status Montium*
On the verso a note in lead pencil:
Cosciou d'après Salvator Rosa; below that
5 florin. Numerals in pen and brown ink:
A. N. 26; and (crossed through): *65.*
Stamp: *FP*
Black chalk, heightened with white, on
paper originally green but now grey-
yellow, 600 × 420 mm.
The sheet is laid on Japanese paper
Inv. No. FP 4740
1932 Inventory: Landscape. Gasp. Dughet
Bibliography: Cat. Budde, no. 712, pl.
120; Sutton, 1962, p. 28, fig. 23;
Shearman, p. 326; Cat. Exh. *Bologna
1962*, no. 226, repr.; Cat. Exh. *Düssel-
dorf 1964*, no. 38, pl. 42; Cat. Exh.
Düsseldorf 1969, No. 114, fig. 89;
Chiarini, 1969, p. 750 ff.; Rosenberg, p.
85 with col. pl.

On Mount Horeb the Angel is saying to Elijah: ' "Go forth,
and stand upon the mount before the Lord." And behold, the
Lord passed by, and a great and strong wind rent the
mountains, and brake in pieces the rocks before the Lord'
(I Kings 19, 11 ff.).
Design for the painting in the National Gallery (No. 1159, Cat.
M. Davies, French School, 1957, p. 88). Another, almost
identical version of the painting was in the Kurfürstliche
Gemäldegalerie in Düsseldorf (cf. N. de Pigage, *La Galerie
Electorale de Düsseldorf ou catalogue raisonné figuré de ces
tableaux*, Basle, 1788, no. 142, pl. xii) and came by inheritance
into the possession of the Bavarian royal house in 1805. It is
now in the Alte Pinakothek in Munich (Inv. No. 2231,
184 × 138 cm.).
Waagen (*Treasures of art in Great Britain*, vol. iii, 1845, p. 179)
had already identified the subject-matter of the London
painting correctly – and thereby also that of the present sheet.
The suggestions published since then have been: *Matthew and
the Angel* (Budde), *The Calling of Abraham* (Shearman and
Arcangeli) and *Landscape with Moses and the Angel* (Davies,
Sutton, Schaar and Rosenberg).
The scene follows the Biblical story very closely. The Angel is
standing on Mount Horeb near Elijah, coming out of his cave,
and is pointing up at the figure of God appearing in Heaven.
From the top of the hill, where a giant storm-lashed tree has
crashed down, there is a view over a widespread, restless
coastline. A powerful 'romantic' pathos pervades this chalk
drawing, majestic even in its size. Arcangeli has dated it
about 1658–60. Amongst Dughet's paintings which approach it
most closely in style *The Storm* in Denis Mahon's Collection
comes to mind, and this is also related in its subject-matter.
A variant of this painting is in the National Gallery (No. 36).
The note *Cosciou* relates to Jan Joost van Cossiau (around
1660–1732), who painted in the same manner as Dughet, and
to whom other drawings by Dughet in the Düsseldorf Print
Room have been wrongly attributed (see also Cat. no. 44). This
note was probably first entered on the sheet after the
Kunstakademie had taken over Krahe's collection (1778).

In pen and brown ink, a note bottom
left: *Cosciou*
Numerals, bottom right: *181*
Top left, a stamp: *Status Montium*
On the verso a note in black chalk:
Cosciou après Salvator Rosa; and below
this: *5 florin.* Numerals in pen and brown
ink: *A. N. 26* and (crossed through): *62*
Black chalk, heightened with white, on
paper originally coloured green, now
grey-green, 600 × 433 mm.
Pieces missing along the top edge have
been repaired. Water stains
Inv. No. FP 4722
Krahe, *Inv. II*, fol. 120 verso, No. 19:
Arbre d'après Nature, 21 × 11 Pouces,
as Guaspre Poussin (Dughet)
1932 Inventory: Landscape. Gasp. Dughet
Bibliography: Cat. Budde, no. 713, pl. 121

A masterly study, astounding in its impression of immediacy.
The sensitive perception of light and atmosphere would seem
to reflect the influence of Claude, though the drawing differs in
its 'heroic' character from the latter's conception of such a scene.

8

45
Gaspard Dughet, after Nicolas Poussin
LANDSCAPE WITH ST MATTHEW AND THE ANGEL

Bottom right, in pen and brown ink:
IR (?) and numerals: *172*
Bottom left, a stamp: *Status Montium*
On the verso of the mount, a stamp: *FP*
Black chalk, traces of heightening with
white on grey-green paper, 425 × 590 mm.
Oil stains. The sheet is laid down on an
old mount
Inv. No. FP 4443
1932 Inventory: Heroic landscape. Nic.
Poussin
Bibliography: Cat. Budde, no. 708, pl. 119
as 'Nicolas Poussin (?)'; Friedländer/
Blunt, vol. iv, p. 52; Cat. Exh. *Düsseldorf
1964*, no. 42; Blunt, *The paintings of
Nicolas Poussin*, under no. 87

A drawing by Gaspard Dughet based on Nicolas Poussin's painting *Landscape with St Matthew and the Angel* painted around 1643, probably for Cardinal Francesco Barberini (Berlin, Staatliche Museen, repr. Blunt, *The paintings of Poussin. Plates*, pl. 150).

As Eckhard Schaar has already observed, it is typical of Dughet's preoccupation as a landscape painter that he has sketched the foreground of Poussin's painting, with the two figures, in outline only. In contrast, the wide river scene with details from the Tiber valley near Aqua Acetosa has been re-created in depth. Claude Lorrain has also used this motif in several drawings, of which the sheet in Cleveland (Museum of Art, Inv. No. 28. 15 recto; cf. M. Roethlisberger, *Claude Lorrain, drawings*, 2 vols., Berkeley and Los Angeles, 1968, Cat. no. 591, repr.) was probably drawn at about the same time as Poussin painted his picture.

Although he followed Poussin's painting very exactly, Dughet also made alterations in his copy. The river bank on the extreme left slopes more steeply and is higher. The tree on the right on the far bank has been moved forward a little from the picture's edge so that now the ridge of the Sabine hills is visible on the right of the tree as well as the left.

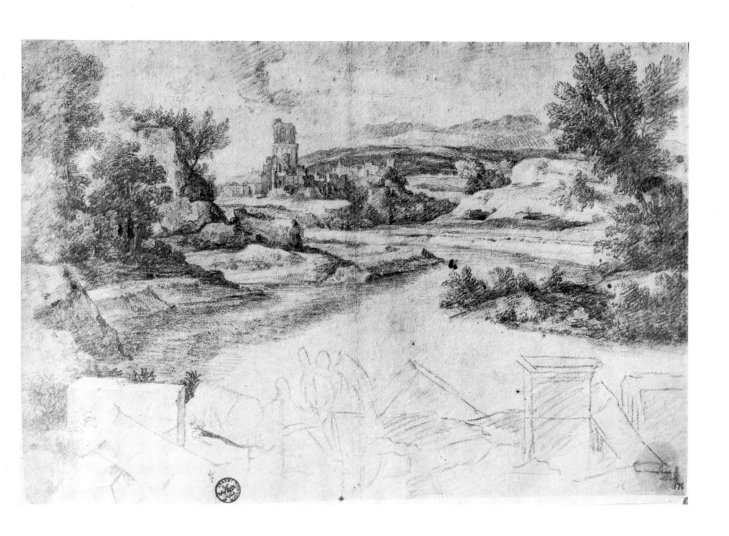

Bottom centre, a stamp: *Status Montium*
Brush, black and grey Indian ink over
lead pencil, traces of white heightening,
on brownish paper, 270 × 410 mm.
The four corners of the sheet have been
repaired
Inv. No. FP 4713 recto
1932 Inventory: Landscape. Gasp.
Dughet
Unpublished

The severe composition of landscape and architecture is
reminiscent of Poussin's landscapes of the later 1640s. The
feeling of this landscape, at peace with itself, flooded with light,
is closely related to Dughet's painting *Landscape with a Lake
and Buildings* (Brocklesby Park, Coll. Earl of Yarborough, cf.
Arcangeli in Cat. Exh. *Bologna 1962*, no. 110, repr.).
Arcangeli considers this painting to have been carried out
around 1651–52, a date which may also be assigned to the
present landscape.

On the verso; by another artist: Cavalry battle, in black chalk

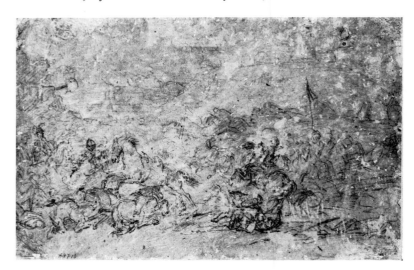

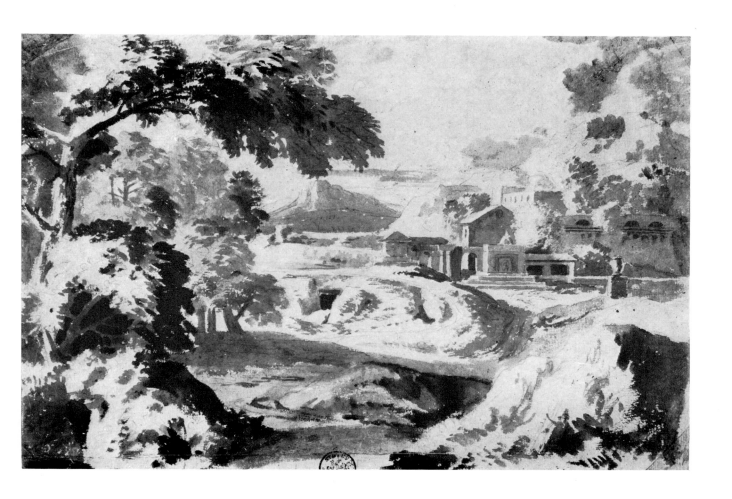

Bottom centre, in pen and brown ink:
300; and stamp: *Status Montium*
Lead pencil on yellowish paper, 224 ×
160 mm.
Inv. No. FP 4697 recto
1932 Inventory: Landscape. Gasp. Dughet
Bibliography: Cat. Budde, no. 730; M.
Chiarini, *I disegni italiani di paesaggio dal
1600 al 1750*, p. 56, pl. 102

The scenery, with the towering mountains, recalls Dughet's *Landscape with Pyramus and Thisbe* (Liverpool, Walker Art Gallery, cf. Cat. Exh. *Bologna 1962*, no. 114, repr.). The style of the drawing, which has not been linked directly with any particular painting, suggests a date around 1660.

On the verso: A landscape in the same technique with figures. Soracte in the background

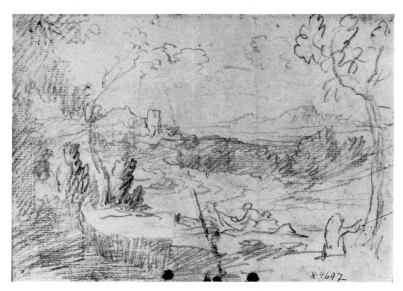

3.04

Top right, numerals in brown ink: *160*
Bottom left, a stamp: *Status Montium*
Black chalk and traces of white heightening
on blue-green paper, 271 × 422 mm.
Inv. No. FP 4707
1932 Inventory: Vedute. Gasp. Dughet
Bibliography: Cat. Budde, no. 727, pl.
127; Arcangeli in Cat. Exh. *Bologna 1962*,
no. 228 with ill.; Cat. Exh. *Düsseldorf
1964*, no. 40; Cat. Exh. *Düsseldorf 1969*,
no. 116, fig. 90

The hill-side, rising in terraces overgrown with bushes and trees, is crowned by classical ruins. The composition shows a landscape opening to the right but bordered on the left by a building which is drawn in more detail, in front of a wall pierced by an arch. The abrupt ending of the composition suggests it was drawn from nature. Yet the natural features have been rearranged as they were drawn to stress their relative value and effect on each other. In this way, by a strict observation of the geometric relations of the horizontal and vertical elements and a calculated division between light and shade, the artist has achieved a boldly conceived yet closely knit composition. This bold simplification of natural features and buildings is reminiscent of Cézanne's later works. Arcangeli dates the drawing in Dughet's last decade, around 1665–70.

160

Brush, Indian ink and tempera on
brownish paper, 310 × 422 mm.
The sheet is laid down on an old mount
Inv. No. FP 4719
1932 Inventory: Landscape. Gasp. Dughet
Unpublished

On the lake, a boat with three men in it. On the far shore under
the magnificent trees, two men standing and one seated. In the
far distance, classical buildings and a high obelisk. The tree-
tops shimmer in the light. The peaceful, Arcadian landscape,
treated as if it were a painting, has a great beauty and an
astonishing range of tonal values. A second landscape drawing
in the Düsseldorf Print Room (Inv. No. FP 4715) is very similar
in subject, handling and technique. The Albertina has a similar
scene, akin to this in both conception and style, *Christ and
three Disciples in a hilly Landscape* (Inv. No. 24253; cf. E.
Knab, 'Observations about Claude, Angeluccio, Dughet and
Poussin' in *Master Drawings,* vol. ix, 1971, no. 4, pp. 367–83,
pl. 24b). Like the Viennese sheet our landscape probably dates
from Dughet's late period.

Giovanni Battista Gaulli, called il Baciccio

Painter
Born Genoa, 1639; died Rome, 1709
Cat. nos. 50–72

50
Giovanni Battista Gaulli
DESIGN FOR THE DECORATION OF A WINDOW NICHE

Numerals in pen and brown ink, bottom right: *130*
Krahe's numerals in lead pencil on the right border of the sheet: *33;* below these, the numerals of the Kunstakademie, Düsseldorf, in lead pencil: *2674*
Centre left, a stamp: *Status Montium*
Pen and brown ink over black chalk, with grey wash and white heightening on greenish-brown paper, 415 × 268 mm.
Water stains and paint marks
Inv. No. FP 1972
Krahe, *Inv. II*, fol. 103 verso, No. 33: *6 Plafonds historiés de L'apocalysse, 10* × *15 Pouces,* as G. B. Gaulli
1932 Inventory: Architectural drawing. Gaulli
Bibliography: Cat. Exh. *Düsseldorf 1969,* no. 86, fig. 74; Macandrew/Graf, p. 243

The sheet was identified by Eckhard Schaar as a design for the decoration of a window niche in the nave of the Jesuit church Il Gesù in Rome. The contract between the Jesuit General, Padre Gian Paolo Oliva, and Giovanni Battista Gaulli – for the decoration of the cupola, the pendentives and the vaulting in the nave, clerestory and choir of the church but not for the vaulting of the apse – was signed by Gaulli on 21 August 1672. Amongst other things the contract specified: '*Inoltre* (Gaulli) *promette e si obliga di dipingere parimente di sua mano e far indorare tutto il voltone e volte della Chiesa, comprese le finestre e finestroni . . .*' (cf. P. Tacchi Venturi, 'Le convenzioni tra Giovanni Battista Gaulli e il Generale dei Gesuiti Gian Paolo Oliva per le pitture della Cupola e della Volta del Tempio Farnesiano' in *Roma,* vol. xii, 1935, p. 149).
Gaulli was therefore responsible for the decoration of the whole area of the vaulting above the main cornice. The drawing is clearly an early idea for decorating one of the window niches in the clerestory of the nave. It differs from the work as executed in so far as it preserves to some extent the original shape of the niches, which used to form a triangular apex immediately above the windows, as we may see in the picture of the interior of the church painted in 1641 by Andrea Sacchi and Jan Miel (Galleria Nazionale, Rome: Enggas, fig. 74). The drawing shows the apex cut off and replaced by a broken cornice, on which allegorical female figures recline, on each side of a shell ornament. A pair of putti perch on the architrave of the window holding on to the festoons that hang from the shell above. Above this carefully considered design comes a rough sketch for the decoration of the vault of the nave below the ceiling painting. It shows that at this stage in the planning of his work Gaulli was proposing to place tondi with figures above the window niches. But in the work as executed the niches were made much higher, so that there was no room between them and the ceiling painting for the tondi (see Enggass, fig. 73). The windows, as finally reconstructed, were each given a double pediment, on which a pair of putti sits holding garlands, and the openings are flanked by allegorical female figures. The figures, ornaments and frames were carried out in stucco from Gaulli's designs by a team of sculptors, among whom the most notable were Antonio Raggi (1624–86) and Leonardo Retti (active 1670–1709).

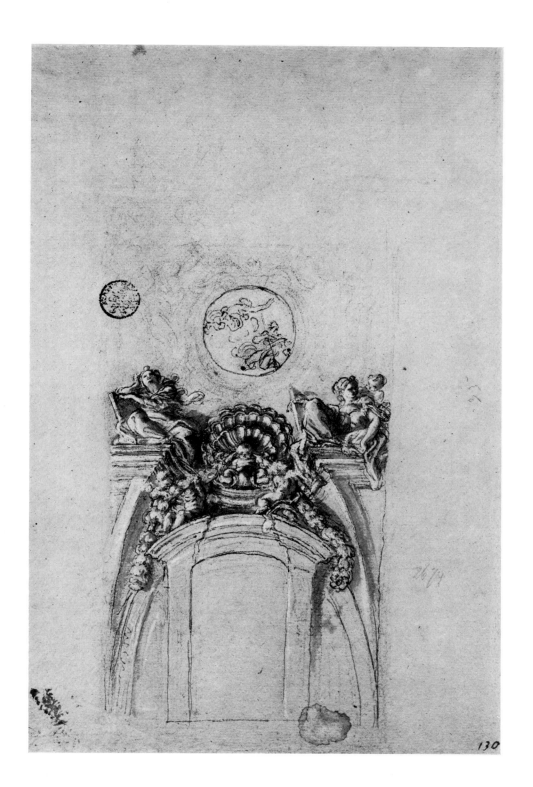

130

Bottom left, a stamp: *Status Montium*
Pen and black ink over black chalk, with
grey-brown wash, heightened with white
on brown-green paper, 328 × 253 mm.
Paint marks top centre and right
Inv. No. FP 1884
Bibliography: Cat. Budde, no. 304, pl. 45;
Lanckoronska, p. 19 ff., fig. 22; Brugnoli,
1956, p. 31, n. 1; Cat. Exh. *Düsseldorf
1964*, no. 54; Enggass, p. 71, fig. 98;
Cat. Exh. *Düsseldorf 1969*, no. 85; A. T.
Lurie, 'A bozzetto for the four Prophets
by Gaulli' in *Bulletin of the Cleveland
Museum of Art*, April 1971, p. 103, fig. 11;
A. T. Lurie, 'A short note on Baciccio's
pendentives in the Gesù à propos a new
bozzetto in Cleveland' in *Burlington
Magazine*, vol. cxiv, 1972, p. 170, fig. 43;
Macandrew/Graf, p. 253.

Gaulli's study for the fresco in the pendentive over the south-western pillar in the crossing of the Gesù church in Rome. In the other three pendentives Gaulli depicted the Four Prophets of Israel, the Four Doctors of the Latin Church and the Four Lawgivers and Leaders of Israel. These frescoes were painted in the years 1675–76. The present design must at the latest have been made in 1675 and probably belongs to the earliest plans for the fresco, as the latter varies considerably from the design (cf. Enggass, fig. 60, and Lurie, 1972, p. 170). With its nervous handling this drawing is a characteristic example of Gaulli's style of drawing during the middle 1670s. Another of Gaulli's designs in the Düsseldorf Print Room relates to the pendentive *The Four Prophets* (Inv. No. FP 1876; Cat. Exh. *Düsseldorf 1969*, no. 85, fig. 72), for which there also exists a design in the Munich Print Room (Inv. No. 2639), recently published by Hugh Macandrew (*op. cit.*, p. 121, under no. 7).

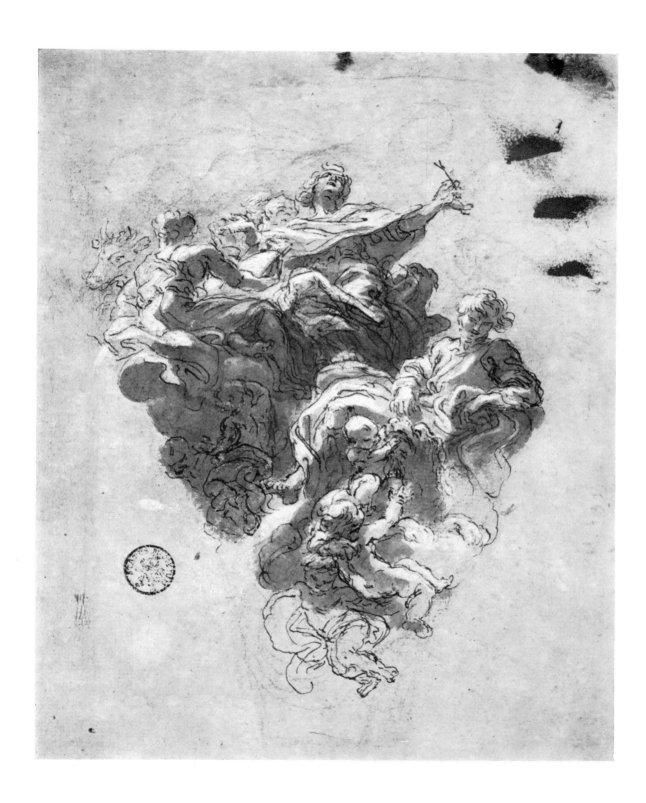

9

Bottom centre, Krahe's numerals in lead pencil: *33;* on the right, numerals of the Kunstakademie in lead pencil: *2673*
Top left, a stamp: *Status Montium*
On the verso, a stamp: *FP*; and numerals in brown ink: *A. K. N. 34* (with the numeral crossed through) and *33*
Pen and brown ink over traces of black chalk, with brown wash and white heightening, on greenish brown paper, 250 × 397 mm.
Inv. No. FP 1883
Krahe, *Inv. II*, fol. 103 verso, No. 33: *6 Plafonds historiés de L'apocalysse, 10 × 15 Pouces*, as G. B. Gaulli
1932 Inventory: Madonna. Gaulli
Bibliography: Cat. Budde, no. 306, pl. 45; Lanckoronska, pp. 19–22, 51–2, fig. 28; Canestra Chiovenda, 1959, p. 22, fig. 8; Cat. Exh. *Düsseldorf 1964*, no. 50; Macandrew/Graf, p. 253–54

Karolina Lanckoronska sees in this detail of a ceiling design by Gaulli a study for the decorations in the dome of Il Gesù, which were then altered before painting was carried out. Schaar agrees with her on this. Beata Canestra Chiovenda, on the other hand, thinks that the design is a study for the decoration of the cupola of the Roman church S. Agnese in the Piazza Navona.
The decoration of the cupola of S. Agnese was entrusted to Ciro Ferri (1634–89). The contract between the patron, Prince G. B. Pamphili, and Ferri is dated 11.9.1670. It was stipulated that the fresco should be finished not later than June 1674. Ferri died in 1689 without having finished it. It must have been at this juncture at the latest that Gaulli, who had already painted the frescoes in the church's pendentives in 1666–72, attempted to obtain the commission to paint the cupola. As shown by a *bozzetto* by Gaulli for a part of the projected fresco in the Thomas Brian Collection, London (cf. Chiovenda, fig. 2) and a *bozzetto* by him for the whole fresco, which I discovered recently, Gaulli's intentions were never directed towards completing Ferri's work, but he planned to paint the entire fresco in the cupola again from the start. The patron, however, decided to let Ferri's pupil Corbellini finish painting his fresco. The idea that this drawing is connected with the cupola decoration in S. Agnese is supported by the choice of saints shown in it. In the centre Agnes, the name saint of the church, appears; to her right is Cecilia, recognizable by her attribute, the organ. Rudolf Preimesberger has been kind enough to point out to me that the saint next to Cecilia would seem to be Emerentiana. Amongst the male saints on the left he recognizes Sebastian, Alexius and Eustachius. The figures shown in the drawing are thus saints to whom altars in the church are dedicated.
The present design, however, cannot – for stylistic reasons – have been drawn as late as 1689, the year of Ferri's death or soon after that, but has to be dated, as a comparison with Cat. no. 51 would show, as early as about 1675. Presumably therefore Gaulli, observing the slow progress of his rival, had already begun to work on his plans for S. Agnese before 1689, doubtless in the hope that he would be allowed to take over the commission.

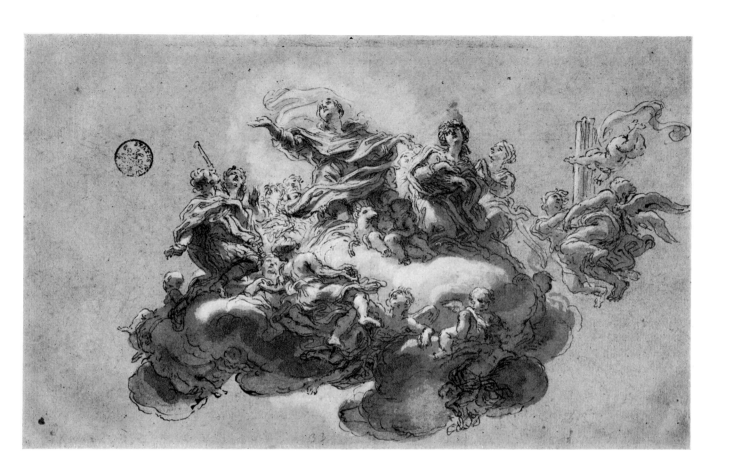

Krahe's numerals in lead pencil on the
old mount: *51*
Black chalk, heightened with white, on
grey-brown paper, squared in black chalk,
326 × 237 mm.
Laid down on an old mount
Inv. No. FP 1926
Krahe, *Inv. II*, fol. 104 recto, No. 51:
Venus arrêtant Adonis, 9 × 12 Pouces, as
G. B. Gaulli
Bibliography: R. E. Spear, 'Baciccio's
Venus and Adonis. A Postscript' in
Burlington Magazine, vol. cx, 1968, p. 38,
fig. 50; Cat. Exh. *Düsseldorf 1969*, no. 87

A design for Gaulli's painting – from which it differs in details –
in the Collection of the Marquess of Exeter, Burghley House.
There is another design in Windsor (cf. Cat. *Roman Drawings*,
no. 155, pl. 50) which shows almost the same composition as
the Düsseldorf sheet, but has been gone over with pen and
wash. Other studies for the painting by Gaulli in the Düsseldorf
Print Room are Inv. No. FP 11200 verso (cf. Cat. Exh. *Oberlin*,
p. 92, no. 33 with ill.) and Cat. no. 54.
Another design by Gaulli in Düsseldorf (Inv. No. FP 1925)
relates to the painting *Death of Adonis* in Oberlin, Allan
Memorial Art Museum. As Richard E. Spear has shown, the two
paintings were made as companion pieces around 1685 (cf.
Spear, 'Baciccio's pendant paintings of Venus and Adonis' in
AMAM Bulletin, vol. xxiii, pp. 98–112 with ill.).
Though in the design in Windsor, drawn on white paper, all
the details are established more clearly through the use of pen
and wash, yet the charm of the present sheet lies precisely in
the softness of the drawing on the tinted paper which, together
with a restrained use of white heightening, creates a warm,
sunlit atmosphere.
Spear ('Baciccio's pendant paintings,' *op. cit.*, p. 110 f.) drew
attention to paintings by P. P. Rubens and his pupils which
could have given Gaulli inspiration for the composition of his
Adonis bidding Farewell to Venus. A direct or indirect connexion
also seems to exist with Johann Carl Loth's (1632–98) painting
Joseph and Potiphar's Wife (Graz, Alte Galerie am Landes-
museum, cf. G. Ewald, *Johann Carl Loth*, Amsterdam 1965, pl.
14): the pose of Potiphar's wife, although she is turned sideways
is almost identical with that of the Venus in Gaulli's painting.

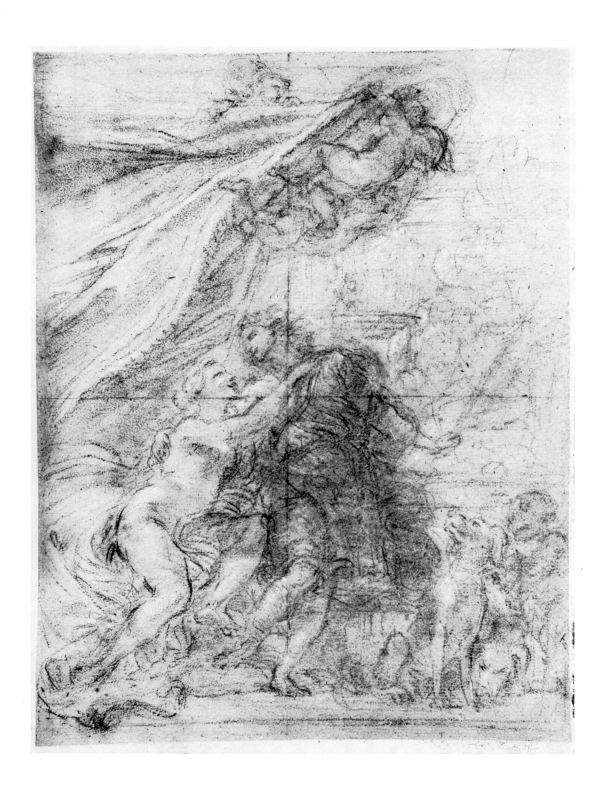

Giovanni Battista Gaulli
STUDY FOR ADONIS

Numerals in pen and brown ink, bottom right: *105*
Bottom left, a stamp: *Status Montium*
Pen and brown ink over black chalk, with white heightening and grey wash, on grey-brown paper. Bottom right, a drapery study in black chalk, 422 × 270 mm.
Oil stains
Inv. No. FP 11107 recto
1932 Inventory: Corrado
Unpublished

Final study for the figure of Adonis in the painting *Adonis bidding Farewell to Venus* (see Cat. no. 53). In the painting Adonis, shown in the act of leaving, is bending down to Venus, who is attempting to restrain him from going hunting. His attitude in this study corresponds to that in the painting, where his left arm, outstretched, is holding a lance. The right arm has not been drawn in this study, as it is largely hidden by the figure of Venus in the painting.
The impression of fleeting movement between his turning to Venus and his simultaneous departure is conveyed with masterly skill. No less beautiful is the play of light on the drapery, which in its dramatic motion reflects the motion of his feelings.

On the verso: Detail study for the sleeve of Adonis's left arm. Black chalk, heightened with white

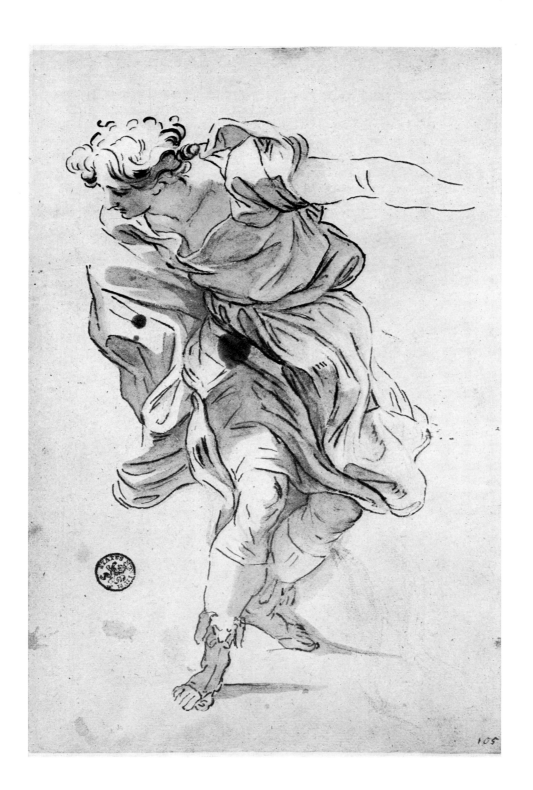

105

Bottom right, numerals in pen and brown ink: *187*
Bottom left, a stamp: *Status Montium*
Black chalk, strengthened in places with pen and brown ink, grey and brown wash. Squared in black chalk, 425 × 284 mm.
Inv. No. FP 11184
1932 Inventory: Corrado
Bibliography: Macandrew/Graf, p. 249

Final study for two of the guests in the painting *Christ in the House of Simon* (Burghley House, Exeter Collection, Enggass, p. 122, fig. 44). The painting depicts the discussion between Christ and Simon about the woman, a sinner, who had anointed His feet during the meal. When Christ says to the sinner 'Thy sins are forgiven', the guests react with every sign of astonishment and ask one another 'Who is this that forgiveth sins also?' The two men studied in the present sheet, who in the painting are sitting on the right of the table, are also turning to each other in astonishment, and the front one is pointing to the left, where in the painting the sinner is kneeling at Christ's feet.
In this drawing as in other studies by him, Gaulli has here and there applied the grey washes in several layers, and has dissolved the brown ink of the pen strokes with the wet brush in certain places and so achieved richly modulated painterly effects.
The painting was probably executed around 1680–85. Other studies for this painting in the Düsseldorf Print Room are Inv. No. FP 11279 (see Cat. no. 56) and FP 11144 (study for the woman in the background of the painting on the far right).

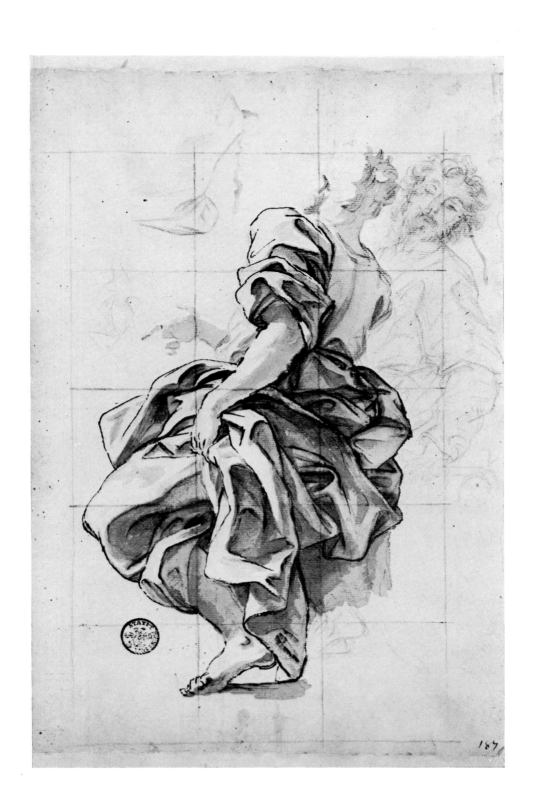

187

Bottom right, numerals in pen and brown ink: *46*
Top left, a stamp: *Status Montium*
Black chalk, in places strengthened with pen and brown ink, with grey and brown wash. Squared in black chalk, 286 × 435 mm.
Brown ink stains
Inv. No. FP 11279 recto
1932 Inventory: Corrado
Bibliography: Macandrew/Graf, p. 249

For the painting, see Cat. no. 55.
The beautiful study in the top part of the sheet relates to the figure of a servant who, in the painting, is entering behind the table at which the guests are seated. The chalk study below this shows the old man who, in the painting, is leaning with his right hand on the table. In the right half of the sheet Gaulli has repeated this study on a larger scale and has given the old man the attitude in which he is shown in the painting.

On the verso: 3 studies in black chalk for the old man and a very slight rough sketch for the servant girl, who in the painting is bringing in fruit

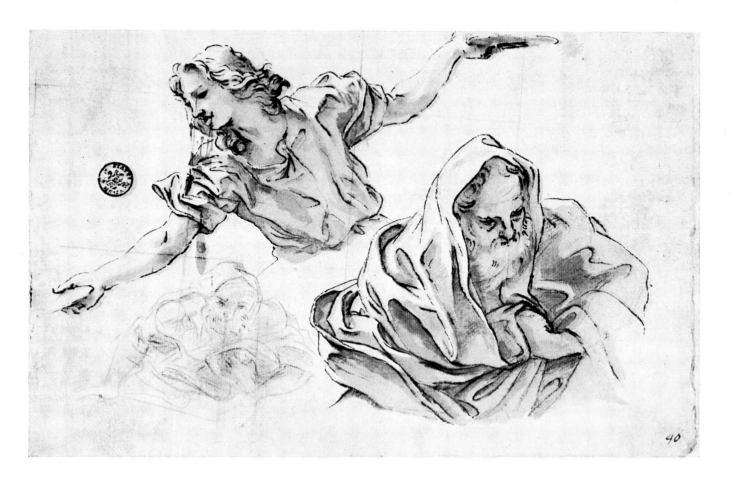

46

Bottom right, numerals in lead pencil by the Kunstakademie Düsseldorf: *2676*
Centre right, a stamp: *Status Montium*
On the verso, bottom right, numerals in brown ink: *A. K. No. 33* and the stamp: *FP*
Pen and brown ink over traces of black chalk, with grey and brown wash, on yellowish grey paper, 256 × 370 mm.
Inv. No. FP 1885
Krahe, *Inv. II*, fol. 103 verso, No. 33: *6 Plafonds historiés de L'apocalysse 10 × 15 Pouces*, as Gaulli
1932 Inventory: Elevation of the Cross. Gaulli
Bibliography: Cat. Budde, no. 308, pl. 46; Lanckoronska, pp. 19–22, 51–2, fig. 25; Cat. Exh. *Düsseldorf 1964*, no. 51; Canestra Chiovenda, 1966, pp. 176–77, fig. 7; Cat. Dreyer, under no. 81; Macandrew/Graf, pp. 253–54

Design for the decoration of the cupola in the vestibule of the Baptismal Chapel (first chapel on the left) in St Peter's, Rome. Christ is shown soaring upward. His right hand is raised in blessing, His left points at the Cross supported by flying angels. From the wound in His side flow two streams, not just of blood, as has previously been written, but of blood and water. Gaulli doubtless knew Bernini's *Allegory of the Blood of Christ* as represented in the drawing in the Teyler Museum, Haarlem (Inv. No. D. 10) or anyhow as represented in the engraving after the drawing by Francesco Spierre (see J. Q. van Regteren Altena and P. W. Ward-Jackson, *Drawings from the Teyler Museum*, Exhibition catalogue, London, Victoria and Albert Museum, 1970, no. 99, repr.). Bernini's design, which according to the inscription on the plate refers to the notion of Redemption through the Blood of Christ, may be regarded as the inspiration of Gaulli's picture. Beata Canestra Chiovenda was the first correctly to point out that our drawing and the

two sheets Cat. nos. 58 and 59 should not be related to Gaulli's decoration of the dome of the Gesù church – as Lanckoronska and Schaar had supposed – but formed part of the plans for the mosaics of the cupola mentioned above.
Gaulli had received the commission for this work from Pope Clement X Altieri (1670–76). Chiovenda (pp. 176–77) has published an important note by the Swedish architect Nicodemus Tessin the Younger. During his second visit to Rome in 1686–87 Tessin visited Gaulli in his studio. Amongst Gaulli's works which he admired there he mentioned a wooden model for one of the oval cupolas of St Peter's. He admired the beauty of the painting and of the composition as well as the skill with which the wooden model had been fashioned.
Frank R. DiFederico has recently published important documents on this project of Gaulli's ('Documentation for Francesco Trevisani's decorations for the Vestibule of the Baptismal Chapel in St Peter's' in *Storia dell'Arte*, no. 6, 1970, pp. 156, 163–64). Under pressure from Pope Clement XI Albani (1700–21) Gaulli showed the Rev. Fabbrica di San Pietro his designs only in July 1708 and was asked to transfer these to cartoons for the mosaic work in the cupola (DiFederico, p. 162, Doc. 1). By February 1709 the preparations were so far advanced that it was decided to put up the scaffolding (Doc. 2). Gaulli died on 2 April 1709. The Rev. Fabbrica di San Pietro decided in September 1709, despite the wishes of Gaulli's heirs, not to have Gaulli's designs carried out by his pupils, but to pay the heirs 1200 scudi, about a quarter of the total amount agreed with Gaulli for the work involved in the designs (Doc. 4). This decision was upheld again in May 1710 (Doc. 5), and Francesco Trevisani received the commission to decorate the cupola, pendentives and half-lunettes of the Vestibule of the Baptismal Chapel from his own designs.
In addition to the present drawing, from which Gaulli also had painted an oil sketch, attributed to Gaulli by Eckhard Schaar and so far unpublished (Kunstmuseum, Düsseldorf, Inv. No. 2523), and the two drawings Cat. nos. 58 and 59, there are other studies for the decoration of the cupola in Düsseldorf, Oxford and Berlin (see Macandrew/Graf, pp. 254–55, Cat. no. 15, pl. 12; no. 16, pl. 13; no. 16a, fig. 16 and nos. 16b–c; Cat. Dreyer, nos. 80–2, pls. 42–3).
The present sheet seems to belong still to the second half of the 1680s and must accordingly represent an early stage in Gaulli's plans. Cat. no. 59 has a rough sketch for the present drawing on its verso. On the verso of Cat. no. 58, on the other hand, there is probably an alternative to the present composition, showing God the Father with the dead Christ in clouds. The Berlin drawing (*KdZ* 15280, Cat. Dreyer no. 80, pl. 42), in which Christ is depicted standing on clouds, with

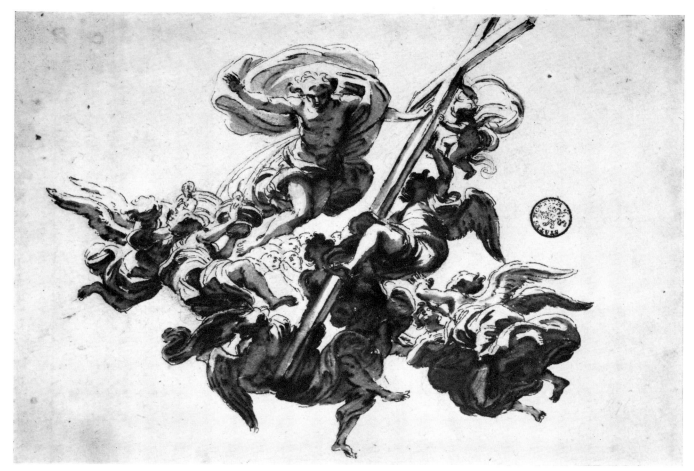

blood and water streaming from the wound in His side, is yet another variant of the design for the central scene in the planning for the decoration of this cupola. A similar conception of the subject, with Christ standing on clouds, is shown in a design for a cupola in the British Museum (Inv. No. 1946–7–13–758, left half, and 1946–7–13–757, right half). On each side of Christ there are groups of saints on clouds, similar to the saints in Cat. nos. 58 and 59. As the style of this drawing is that of the 1670s, it may be a very early design for the decoration of the Cupola in the Baptismal Chapel. The decoration of the cupola executed from Trevisani's designs was described in a passage – referred to by DiFederico (p. 155) – by Sindone and Martinetti, *Della sacrosanta basilica*, 1750, pp. 213–14, as follows: '*Poiche in essa conservasi il Sacro Fonte Battesimale, cosi nella Cupola e negli altri ornamenti e Quadri tutti espressi in musaico, si rappresentano fatti e misterj*

allusivi a questo gran Sacramento. Intorno all'occhio della Cupola si leggono queste parole: Qui crediderit baptizatus fuerit, salvus erit (Marcus 16, 16). Quindi nel convesso di questa mole si rappresenta il triplice Battesimi di Acqua, di Sangue e di Desiderio.'
Il Battesimo di Sangue is also the theme of Gaulli's design Cat. no. 59, while Cat. no. 58 shows Baptism by water. If Gaulli, in keeping with the iconography of Trevisani's cupola designs, also planned to have a picture representing the *Battesimo di Desiderio*, no design for this has so far been discovered or identified, unless one considers this theme is depicted in the right-hand group of saints in Cat. no. 58.
After the death of Gaulli, Maratta's pupil Michelangelo Ricciolini (1654–1715) was also involved in the project for the decoration of the cupola. His design is in the Berlin Print Room (see Cat. Dreyer, no. 150, pl. 80).

Top left, a stamp: *Status Montium*
Pen and brown ink over traces of black
chalk, with grey wash, heightened with
white, on yellowish brown paper, 223 ×
404 mm.
Inv. No. FP 1882 recto
Krahe, *Inv. II*, fol. 103 verso, No. 33:
*6 Plafonds historiés de L'Apocalysse, 10 × 15
Pouces*, as Gaulli
1932 Inventory: Saints in glory. Gaulli
Bibliography: Cat. Budde, no. 303, pl. 42;
Lanckoronska, pp. 19–22, 51–2, fig. 26;
Cat. Exh. *Düsseldorf 1964*, no. 48;
Canestra Chiovenda, 1966, pp. 176–77,
fig. 7; Cat. Dreyer, under nos. 81–2;
Macandrew/Graf, pp. 253–54

Design by Gaulli for a mosaic in the cupola of the Vestibule
of the Baptismal Chapel of St Peter's, Rome (cf. Cat. nos. 57
and 59). The saints are facing to their right, where at this stage
of the planning the figure of Christ floating, surrounded by
angels, was to have appeared (Cat. no. 57). The water shown
there being caught by angels as it streamed from the wound in
Christ's side is held here by an angel in a bowl, while a second
angel pours it from a jug over the saints. The scene represents
Baptism as Redemption through water.

On the verso: In black chalk, rough sketches for the composition in
Cat. no. 57

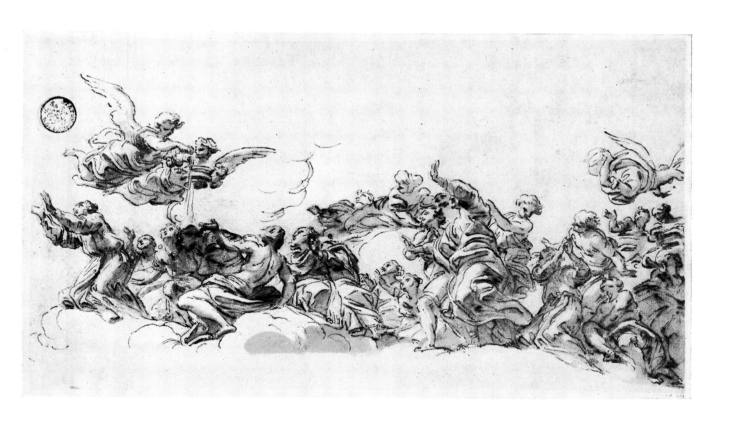

59
Giovanni Battista Gaulli
MARTYRS AND ANGELS ON CLOUDS

Top left, a stamp: *Status Montium*
Pen and brown ink, over traces of black
chalk, with grey wash, heightened with
white, on yellowish brown paper, 213 ×
371 mm.
Paint marks and oil stains
Inv. No. FP 1881 recto
Krahe, *Inv. II*, fol. 103 verso, No. 33:
*6 Plafonds historiés de L'apocalysse, 10 ×
15 Pouces*, as Gaulli
1932 Inventory: Martyrs in glory. Gaulli
Bibliography: Cat. Budde, no. 307, pl.
43; Lanckoronska, pp. 19–22, 51–2,
fig. 27; Cat. Exh. *Düsseldorf 1964*, no. 49,
pl. 15; Canestra Chiovenda, 1966, pp. 176–
77, fig. 7; Cat. Dreyer under no. 81;
Macandrew/Graf, pp. 253–54.

Design for a mosaic in the cupola of the
Vestibule of the Baptismal Chapel in St Peter's, Rome, planned by Gaulli but
carried out by Francesco Trevisani from his own designs (cf.
Cat. nos. 57 and 58).
The martyred saints are facing to their left, where at this stage
in the planning the figure of Christ floating, surrounded by
angels, was to have appeared (Cat. no. 57). As in Cat. no. 58,
an angel is shown carrying a bowl. It contains the blood from
the wound in Christ's side, which a second angel with a jug is
pouring over the martyrs. This scene represents Baptism as
Redemption through Blood.
Another study by Gaulli for this part of the decoration of the
cupola is the Berlin drawing *KdZ* No. 20997 (Cat. Dreyer, no.
82, pl. 43).

On the verso: In black chalk, God the Father and the dead Christ
shown on clouds surrounded by angels

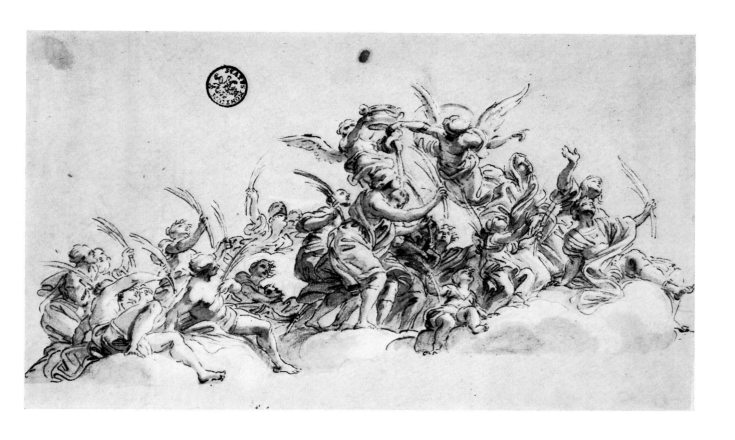

10

Bottom right, numerals in pen and brown
ink: *II*
Black chalk on yellowish paper, 248 ×
350 mm.
Missing piece on the left top corner
restored. Water stains
Inv. No. FP 10259 recto
1932 Inventory: Unknown artist
Unpublished

Design for a painting by Gaulli which has not been identified.
On the left side of the composition there is a female figure
surrounded by other figures and carrying a torch and a mirror,
as can be seen more clearly in the detailed study for the
figure in the same collection (Inv. No. FP 11209 recto).
Presumably this figure represents Ceres, as she wears a wreath
of ears of corn. The design has subsequently been held to
represent an allegory of summer or autumn. Compare Carlo
Maratta's designs in the Uffizi and in the Devonshire Collec-
tion, Chatsworth, for a lost painting of the same subject, which
show a very similar composition (see F. H. Dowley, 'A few
drawings by Carlo Maratta' in *Master Drawings*, vol. iv, 1966,
pp. 424-26, pl. 39a).
Bacchus, also surrounded by a number of figures, is on the right
and, turning away, is raising a cup. A figure lying at his feet
can be identified as Silenus (see Cat no. 62). A second design in
the Düsseldorf Print Room (Inv. No. FP 11209 verso) relates
only to the right-hand group. The composition is the same,
though Bacchus as the central figure is now shown holding the
Thyrsus staff. In this variant a youth is kneeling in the fore-
ground to the right, and behind him Amor, gazing up at
Apollo, holds a bow and arrow. Gaulli has made detailed studies
of Bacchus, the youth and the boy Amor on another sheet (see
Cat. no. 61). The style of these drawings suggests a date around
1690. It is possible that these studies are part of the
preparations for a larger decoration, probably illustrating the
four seasons, because the British Museum has also got a drawing
by Gaulli (Inv. No. 1959–3–7–8) of a boy beating a tambourine
with putti on clouds which may well belong to the same project,
judging from the subject, the handling and the technique.
Hugh Macandrew (Macandrew/Graf, Cat. no. 20) groups
together a second series of Gaulli's drawings in Oxford, Paris,
Berlin and Chicago, which because of their subject-matter seem
to belong to a similar project, but may have been made later.
He dates this second group in the late 1690s.

On the verso: Three studies for a coat of arms, the left one, crowned
by a cardinal's hat, in black chalk. One of these studies has been gone
over with the pen. The ink has soaked through to the recto

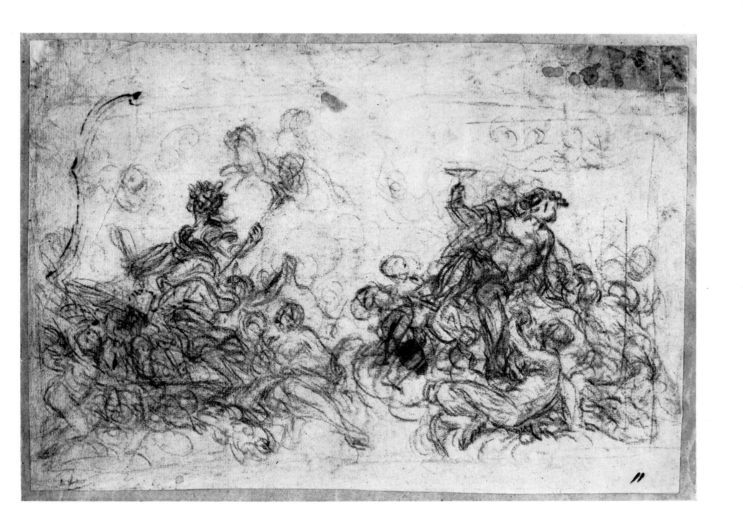

Top right, numerals in pen and brown
ink: *171*
Top centre, a stamp: *Status Montium*
Pen and brown ink over black chalk, with
grey and brown wash, 283 × 430 mm.
Squared in black chalk. The sheet has
been cut in two
Inv. No. FP 11161 (left half) and FP
11287 (right half)
1932 Inventory: Corrado
Unpublished

Studies for Bacchus, the boy Cupid with bow and arrows and
a youth kneeling with fruit. The Düsseldorf Print Room has a
design by Gaulli for the composition of a scene incorporating
the figures here studied separately (Inv. No. FP 11209 verso,
see also Cat. no. 60). It also has another sheet of studies by
Gaulli containing an almost identical study for Bacchus (Inv.
No. FP 11162, left half, and FP 11285, right half).

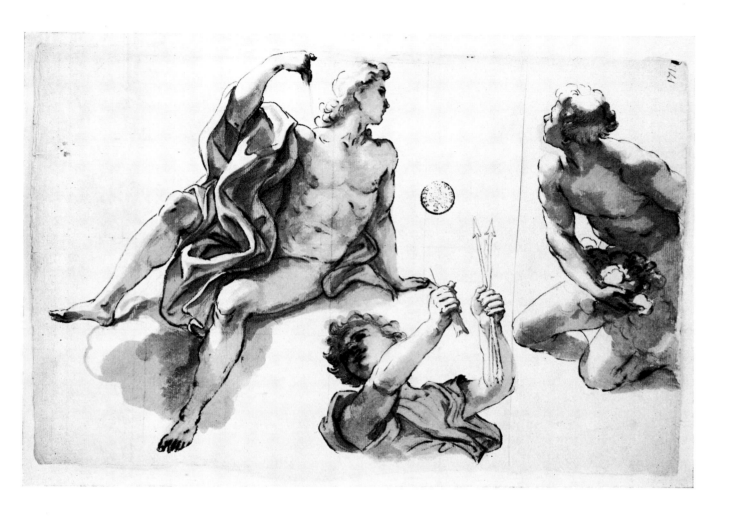

Giovanni Battista Gaulli
STUDY FOR A BACCHANTE

Numerals in pen and brown ink, bottom right: *83*
Top right, a stamp: *Status Montium*
Pen and brown ink over black chalk, with grey and brown wash. Squared in black chalk, 284 × 427 mm.
Bottom right, a brown ink stain
Inv. No. FP 11231 recto
1932 Inventory: Corrado
Unpublished

The Bacchante corresponds with the figure with ram's legs reclining at the feet of Bacchus in the drawing in Cat. no. 60, which is a design for an unidentified painting.
The Print Room of the Staatliche Museen in Berlin has a study for this figure in the same technique (*KdZ* No. 15281 recto). There the Bacchante is holding a pair of scales, the sign of the Zodiac for Autumn.
A second drawing in Berlin shows an allegorical figure of Winter (*KdZ* No. 22345; Cat. Dreyer, no. 9). This study is almost certainly connected with the project discussed in Cat. nos. 60-1.

On the verso: in black chalk a rough sketch for a figure of St Joseph in the painting *The Holy Family with St Elizabeth and the Infant John* (Vienna, Czernin Collection, cf. Enggass, pp. 99, 159, fig. 128)

63
Giovanni Battista Gaulli
THE MYSTICAL MARRIAGE OF ST CATHERINE

Bottom right, numerals in pen and brown ink: *33*
Bottom left, in lead pencil: *1 fl* (Florin)
Black chalk, 322 × 236 mm.
Small tear, bottom right
Inv. No. FP 10222
1932 Inventory: Unknown artist
Unpublished

Design for a painting in a private collection in Genoa (cf. P. Torriti, *Tesori di Strada Nuova, La Via Aurea dei Genovesi*, Genoa 1970, pp. 43–6, fig. 46). This drawing does not represent the final stage in Gaulli's preparations for the painting; his final studies, although first drawn in in chalk, were usually re-worked in pen and wash. In this drawing, where the pentimenti centre mainly round St Catherine's head, the Virgin's head is shown full face. In a second study, also in the Düsseldorf Print Room (Inv. No. FP 1919), Gaulli found the solution that he used for the picture. Here, as in the painting, the upper part of the Virgin's body and her face are in profile, and the child is shown full-face, gazing up at Mary, held in her left arm and sitting on her left knee. Torriti (*op. cit.*), dates the painting around 1675–80. But the style of the drawing suggests a date around 1690 or later.

Mary Newcome, on a visit to the Düsseldorf Print Room, first saw the connexion between the drawing and the painting, which was then unknown to me.

Bottom right, numerals in pen and brown ink: *183*
Bottom left, a stamp: *Status Montium*
Pen and brown ink over black chalk with grey wash. Squared in black chalk, 429 × 284 mm.
Ink stains and paint marks
Inv. No. FP 11143
1932 Inventory: Corrado
Bibliography: D. Graf, 'Two paintings by Giovanni Battista Gaulli, called il Baciccio, and some related drawings' in *Burlington Magazine*, vol. cxiii, 1971, pp. 650–57, Cat. no. 19, fig. 23

Study for the figure of Joseph in Gaulli's painting *Joseph makes himself known to his Brethren* (Ajaccio, Musée Fesch, Graf, *op. cit.*, fig. 5). In designing this figure, as in composing the whole picture (which was painted about 1690), Gaulli was inspired by the etching of the subject (Graf., *op. cit.*, fig. 6) that Pier Francesco Mola made from his own painting in the Palazzo del Quirinale (cf. Cocke, p. 58, no. 49, pl. 60). In his rhythmical arrangement of the figures, in the eloquent gestures and dramatic movements expressing devotion and stupefaction, Gaulli surpasses Mola's version of the subject.
Gaulli probably painted the picture as a pendant to a second scene from Joseph's history, *Joseph telling his Dreams* (Graf, *op. cit.*, fig. 4), which is also in the Musée Fesch. The paintings were first attributed to Gaulli by Michel Laclotte. For other studies by Gaulli for the two paintings see Graf, *op. cit.*, Cat. nos. 1–18 and Macandrew/Graf, Cat. nos. 1 and 1a–i.

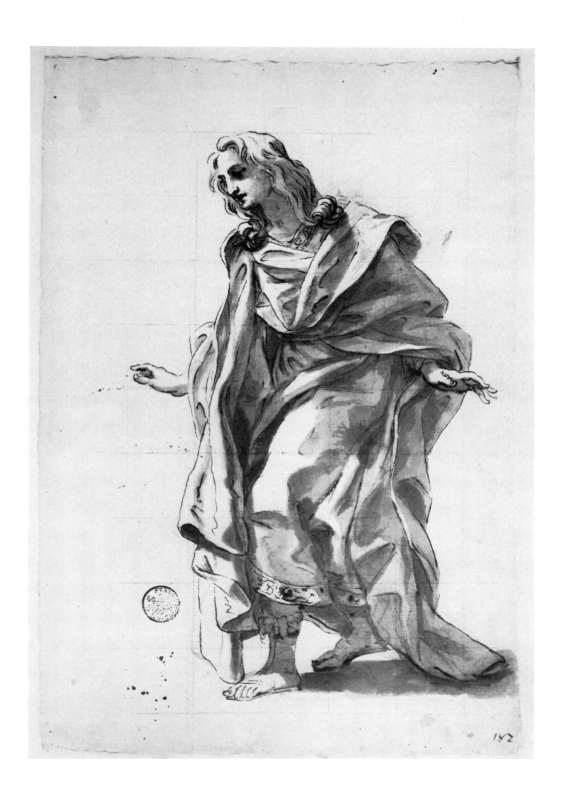

182

Bottom right, numerals in pen and brown ink: *127*
Centre left, a stamp: *Status Montium*
Pen and brown ink over black chalk, with white heightening, on yellowish grey paper, 424 × 270 mm.
Inv. No. FP 11178 recto
1932 Inventory: Corrado
Unpublished

Final study for the figure of Mary in Gaulli's *bozzetto* for *St Agnes in Glory* (London, Thomas Brian Collection, Cat. Exh. *Oberlin*, no. 18 with ill.).

When the painting of the cupola of S. Agnese was left unfinished on the death of Ciro Ferri (1689), Gaulli attempted to obtain the commission to repaint the cupola from his own designs (see Cat. no. 52). The *bozzetto* in the Thomas Brian Collection is a part of his scheme and relates to the central figures in the projected fresco. Agnes, guided by John the Baptist, is being received by Christ and God the Father, who are enthroned on a bank of clouds. Below Christ the Virgin Mary appears as interceder in the pose in which she is shown in the present study, turning with an encouraging gesture to Agnes and at the same time pointing to Christ, who is holding in His hands the crown intended for Agnes.

Other studies in the Düsseldorf Print Room for the *bozzetto* are Inv. No. FP 11268 recto (studies for God the Father, cf. Cat. Exh. *Oberlin*, no. 40 with ill.) and FP 11264 recto (study for Christ).

A study for the figure of St Agnes is in the Louvre (Inv. No. 9506; Canestra Chiovenda, 1959, p. 22, fig. 6).

On the verso: Outline sketch for the figure of Mary without her clothes, in brown ink over black chalk

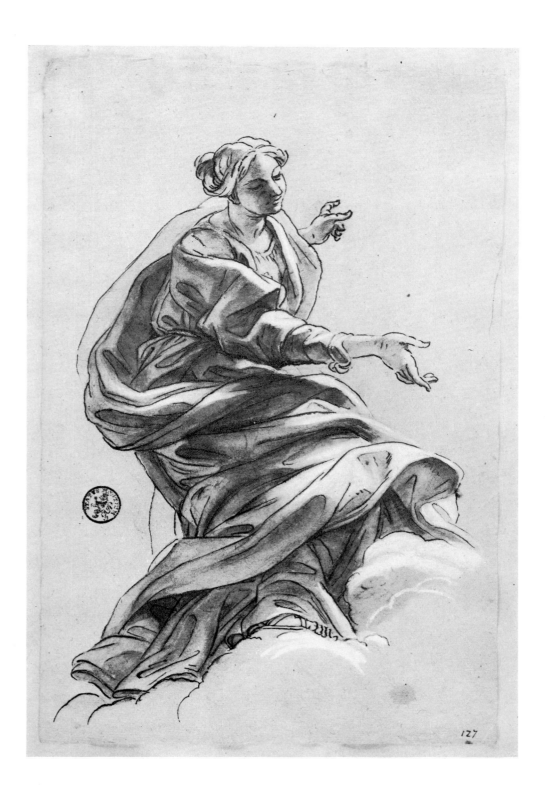

127

Numerals in pen and brown ink, bottom right: *227*
Bottom centre, a stamp: *Status Montium*
Pen and brown ink, over black chalk, with grey wash. Squared in black chalk, 438 × 293 mm.
Inv. No. FP 11130
1932 Inventory: Corrado
Unpublished

Study for an armed female figure and a putto, standing on clouds. She is probably an allegory of Fortitude. It is possible that the drawing is a detail of the design for the ceiling fresco planned by Gaulli for the Sala del Maggior Consiglio of the Palazzo Ducale in Genoa. Gaulli had received the commission on the recommendation of Cardinal G. B. Spinola and had done the necessary preparatory work when he travelled to Genoa in 1693 to submit the designs. As Gaulli's estimate was not accepted, he returned to Rome, where his biographer Carlo Giuseppe Ratti, during his stay in Rome (about 1756-66), saw the *bozzetto* for this ceiling project in the studio of the painter after his death and described it: '*Era quivi espressa in atto di trionfo la Liguria seduta sopra un arco baleno, entro la cui circonferenza leggevasi a caratteri d'oro il motto Libertas. Accanto alla Liguria stavano in varj maestosi attegiamenti le principali Virtù sue indivisibili compagne. E a' piedi d'essa il tempo in atto di sviluppare da un panno, ond'era avvolta La Verita, che compariva con un sole in mano, da' raggi del quale abbagliati, ed atterriti alcuni mostri (cioè i vizj piu pregiudiziali alla Libertà) precipitosamente fuggivano*' (Soprani/Ratti, vol. ii, p. 83).

Among the numerous drawings by Gaulli in the Düsseldorf Print Room that are probably related to this project (see also Cat. no. 67) there is a second study in black chalk for the figure of Fortitude, though it is only a rough sketch (Inv. No. FP 11258 verso). In this drawing another female figure kneels at her feet. Below her float some other figures, hastily drawn and difficult to recognize, and a sketch for a sea beast with feet like snakes, probably one of the *mostri* mentioned by Ratti or a river god; there is also a detailed study for this creature (Inv. No. FP 11266).

For Gaulli's decoration designs for this ceiling project, see Schaar, pp. 53–66 with ill., and Newcome, Cat. nos. 113–14 with ill.

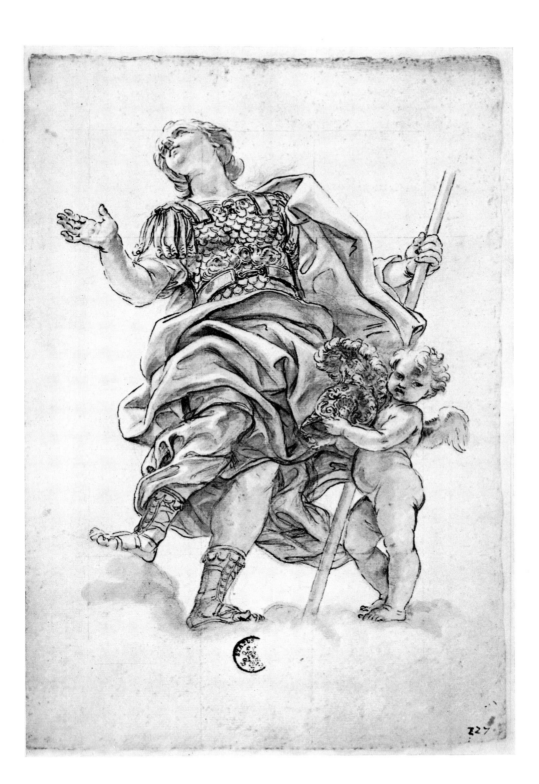

67
Giovanni Battista Gaulli
STUDY OF A WARRIOR FLYING DOWN FROM THE SKY

Numerals in pen and brown ink, bottom right: *215*
Bottom centre, a stamp: *Status Montium*
Pen and brown ink over black chalk, with grey wash. Squared in black chalk, 432 × 284 mm.
Brown ink stains
Inv. No. FP 1012 recto
1932 Inventory: Gaulli
Unpublished

This study for a warrior flying down from the sky, holding a laurel wreath in his right hand, is probably related to Gaulli's plans for painting the Sala del Maggior Consiglio in the Palazzo Ducale in Genoa. The commission came to nothing, but Gaulli had prepared for the project with drawings and a *bozzetto* for the ceiling picture (see Cat. no. 66). In 1700 the decoration of the Sala del Maggior Consiglio was transferred to Marc Antonio Franceschini, who began the work in 1702 and finished it in less than two years with the help of Francesco Antonio Melloni and Luigi Quaini. The painting was destroyed by fire in 1777. (See Torriti, p. 423 ff.)

On the verso: Rough sketch in black chalk for the figure shown on the recto

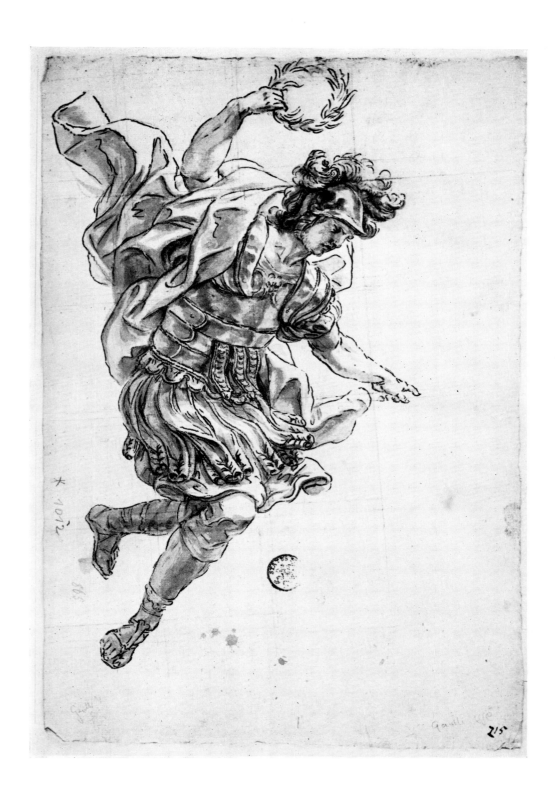

11

Bottom right, numerals in pen and brown ink: *121*
Top left, a stamp: *Status Montium;* and Krahe's numerals in lead pencil: *61*
Pen and brown ink over black chalk, 271 × 411 mm.
Inv. No. FP 1946
Krahe, *Inv. II*, fol. 104, No. 61: *7 ornemens pour Plafonds, 10 × 15 Pouces,* as Gaulli
1932 Inventory: Gaulli
Unpublished

Krahe entered this sheet in his inventory together with six other drawings as designs for ceiling pictures. It is possible that this design for a sea battle was made in connexion with Gaulli's plans for the painting of the Sala del Maggior Consiglio in the Palazzo Ducale in Genoa. In technique and handling the drawing is closely related to other designs by Gaulli in the Düsseldorf Print Room which are identified by Eckhard Schaar as having been made for this project (cf. Schaar, pp. 53–66). After the failure of the negotiations with Gaulli (1693) the painting of the Sala Grande was entrusted to Marc Antonio Franceschini in 1700 and was subsequently destroyed. Ratti's comprehensive description of Franceschini's paintings (Soprani/Ratti, vol. ii, pp. 336–39) gives an impression of the scope and iconographic programme of the decorations. Among the paintings he mentions is one of a sea battle against Alphonso, King of Aragon, (p. 337) and another of the Genoese against the Pisans (p. 338).

It is hardly possible to ascertain to what extent Gaulli was bound by the same iconographic programme as Franceschini. It can, however, be assumed that Gaulli would not have painted only the ceiling picture for which Ratti saw and described the *bozzetto* in Gaulli's studio (see Cat. no. 66), but that the decoration of the whole room must have been offered him. It goes without saying that, in a lavish scheme designed to celebrate the renown of both Genoa and Liguria, the victorious sea battles of the Genoese would not have been omitted. Piero Torriti (pp. 423–28, figs. 13–5) has published a cartoon by Franceschini for the battle of Meloria against Pisa, a picture mentioned by Soprani-Ratti, p. 337. The cartoon is in the Accademia Ligustica di Belle Arti, Genoa. A scene very like the one shown in the drawing before us occupies the left half of the cartoon. Gaulli's design is presumably therefore connected with a picture of the same subject planned by him for the Palazzo Ducale, and it probably shows only a part of the projected painting.

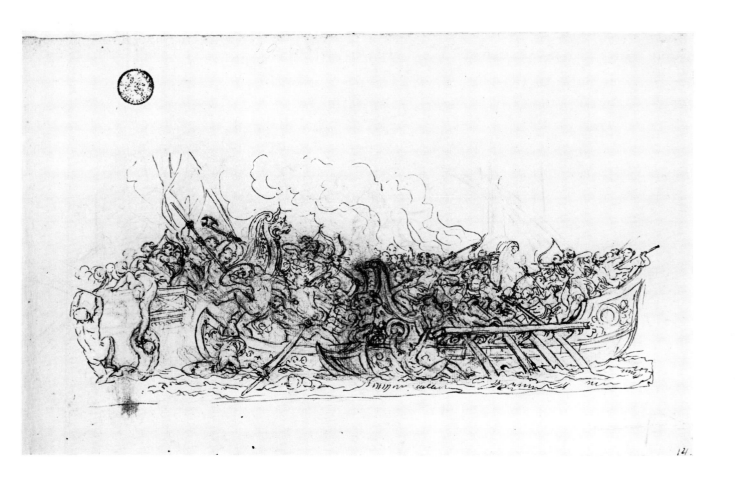

121.

Bottom right, numerals in pen and brown ink: *60*
Black chalk, 292 × 434 mm.
Brown ink stains. The sheet has been cut in two
Inv. No. FP 11159 recto (left half) and FP 11246 recto (right half)
1932 Inventory: Corrado
Bibliography: Macandrew/Graf, p. 248, Cat. no. 4v, a

The altarpiece was painted by Gaulli between 1697 and 1698 for the church of S. Maria Maddalena in Rome at the request of the Torri family (cf. Enggass, p. 144, fig. 122).
On the left, two studies for the figure of St Nicholas, on the right the Virgin and some angels.
In the painting Mary is sitting on clouds at Christ's feet. She is pointing her right hand at Christ and turning to the saint, who in the painting is shown kneeling to the left in the foreground, to hand him the scapulary. The pose of Mary in this study already corresponds to a large extent with the painting.
The type, pose and set of the head of Nicholas were transferred unaltered to the painting, though there he is kneeling with both his knees on a step and is holding his arms stretched out sideways, as is shown in the outline sketch on the verso of the present sheet. In the left-hand study on the recto the arrangement of the saint's draperies has already been sketched in outline. For other studies for the altarpiece see Macandrew/Graf, Cat. nos. 4v and 4b–e.
There is a drawing copied from Gaulli's altarpiece and attributed by Peter Dreyer to G. B. Lenardi (1656–1704) in the Print Room of the Staatliche Museen in Berlin (Inv. No. *KdZ* 16480).

On the verso: Outline sketch for the figure of St Nicholas kneeling, in pen and brown ink over traces of black chalk

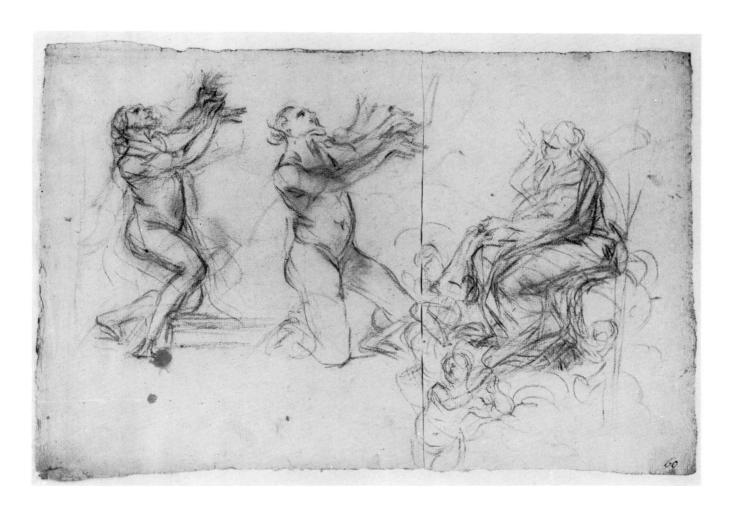

60

Black chalk, 288 × 434 mm.
The sheet has been cut in two –
presumably in the Kunstakademie in
Düsseldorf. Paintmarks along the upper
edge
Inv. No. FP 11166 recto (left half) and
FP 11222 recto (right half)
1932 Inventory: Corrado
Unpublished

Studies for the figure of Elizabeth and two of her serving-women in Gaulli's painting *The Birth of John the Baptist* (Enggass, p. 149, fig. 123), Rome, S. Maria in Campitelli. The painting shows in the background on the right Elizabeth on her bed, leaning forward with clasped hands and gazing up at the Dove of the Holy Ghost appearing surrounded by angels. In the painting one of the two servant-women is standing at the foot of the couch, the other below her. In the present study, on the other hand, Elizabeth is lying sunk back on the cushions with an expression of exhaustion or surrender, and the two serving-women are standing behind her couch.

Another sheet in the Düsseldorf Print Room, likewise cut in two (Inv. Nos. FP 11157 and FP 11199) has on the recto two studies in chalk, pen and brown ink for the woman in the right of the foreground in the painting, who is grasping the hand of the boy John, and on the verso there is a study for Zacharias in black chalk.

The altarpiece was executed around 1698, probably commissioned by the Altieri family.

The painting of the same subject in the Accademia di San Luca, Rome, was considered by previous writers to have been intended as a *bozzetto* for the altarpiece (cf. Enggass, p. 149, fig. 124), but Hugh Macandrew (Macandrew/Graf, p. 242) thinks it is a 'reduced variant' of the altarpiece, painted at about the same time. For the numerous drawings made by Gaulli as studies for this second painting, see Macandrew/Graf, Cat. nos. 5 and 5 a–j.

On the verso: Studies for the two servant-women from the recto in the same technique, and a study in pen over chalk for the head of the woman who in the painting is kneeling at the feet of the boy John

Giovanni Battista Gaulli
THE PRESENTATION OF MARY IN THE TEMPLE

Black chalk, 398 × 251 mm.
Stains of brown ink and grey wash
Inv. No. FP 10221 recto
1932 Inventory: Unknown artist
Bibliography: Macandrew/Graf, Cat. no.
17a, fig. 17

Design for a painting which has, however, not yet been identified. In the composition as a whole, as well as in the individual figures, this drawing of Gaulli's comes very close to his altarpiece *The Presentation of Christ in the Temple* painted around 1704 for S. Pietro Martire in Rieti (for the painting in Rieti see Enggass, pp. 102, 134, fig. 139). The relationship of height and breadth is also the same in the altarpiece and the present design.

As well as this, the Düsseldorf Print Room and the Ashmolean Museum in Oxford have a series of other sheets containing studies for details in the composition shown in the drawing before us, some of them even squared (cf. Macandrew/Graf, Cat. nos. 17 and 17 b–d). This means that Gaulli's preparations for a painting based on the present design had already reached their final stage. Therefore either Gaulli painted the picture and it was destroyed or lost, or he was obliged at a very advanced stage in his preparations, to paint a *Presentation of Christ in the Temple* instead of the subject originally intended, *The Presentation of Mary in the Temple.*

On the verso: Study for an angel. Black chalk

Numerals in pen and brown ink, bottom
right: *212*
Bottom left, a stamp: *Status Montium*
Pen and brown ink over black chalk, with
grey wash. Squaring in black chalk,
281 × 434 mm.
The sheet has been cut into three pieces
Inv. No. FP 11168 (left), FP 11172
(centre) and FP 11136 (right) recto
1932: Inventory: Corrado
Bibliography: Macandrew/Graf, Cat. no.
101

Studies for three of the apostles in Gaulli's ceiling fresco *Christ in Glory receiving Franciscan Saints*, Rome, SS. Apostoli. Gaulli painted the ceiling fresco in 1707 at the request of Cardinal Giorgio Cornaro, Bishop of Padua and titular Cardinal of SS. Apostoli (cf. Enggass, pp. 100–01, 142; fig. 134). Pascoli (vol. i, p. 340) reported that Gaulli painted this fresco in only two months.

The apostles in the present study appear in the centre of the fresco below Christ. The study on the left is of the Apostle Andrew. In the fresco his attribute, the x-shaped cross, is beside him. The study in the centre of the sheet depicts Peter. The kneeling apostle on the right cannot be identified.

The Düsseldorf Print Room has thirteen other sheets of studies for Gaulli's ceiling fresco. The Ashmolean Museum, Oxford, and the Print Room of the Staatliche Museen in Berlin each have another sheet (cf. Macandrew/Graf, Cat. nos. 10, 10a–i and k–o).

On the verso: The shoulder, arm and hand of the apostle shown kneeling on the right of the recto have been traced in black chalk

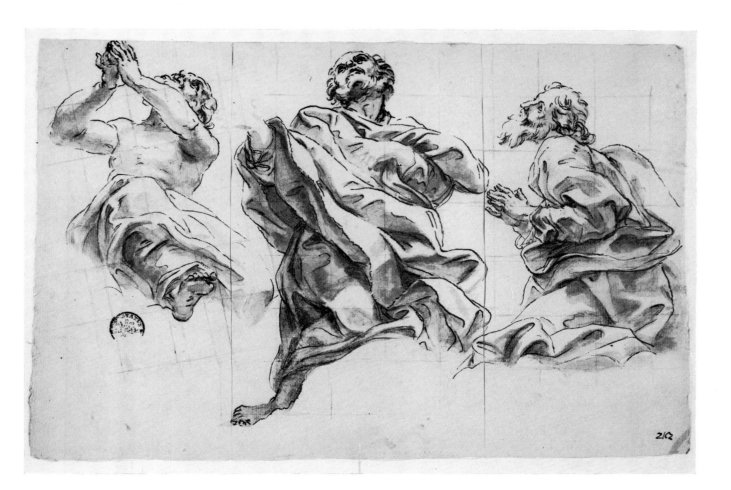

Giovanni Lanfranco

Painter
Born Parma, 1582; died Rome, 1647
Cat. nos. 73–9

73
Giovanni Lanfranco
STUDY FOR AN ANGEL

Top left, numerals in pen and brown ink: *49*
Black chalk, heightened with white, on grey-brown paper. Squared in red chalk, 375 × 261 mm.
Oil stains. The sheet has been torn off irregularly along its upper edge
Inv. No. FP 13716 recto
1932 Inventory: Studies. Unknown artist
Bibliography: E. Schleier, 'Lanfrancos "Elias und der Engel" und der Bilderzyklus der Sakramentskapelle von S. Paolo fuori le mura in Rom' in *Bulletin van het Rijksmuseum,* vol. viii, 1970, p. 17 ff, fig. 17 (recto) and fig. 18 (verso). For the study of the verso, see also E. Schleier in *Burlington Magazine,* vol. civ, 1962, p. 257

Studies for the angel in Lanfranco's painting *The Freeing of St Peter* (Schleier, 1970, fig. 13), formerly in the collection of Monsignore E. Cunial. As Erich Schleier has kindly informed us, the picture, dated by him around 1614–15, was acquired by the Galleria Nazionale in Parma in 1972.
In the present drawing the angel's left hand has been drawn again in the lower right corner. Top right, at right angles, there is an outline sketch and a detailed study for the outstretched right arm of the angel. Along the top border of the sheet there is a drapery study and a study for a hand.
The painting shows considerable *pentimenti,* especially in the figure of the angel. As Schleier (1970, p. 26) has explained in detail, the present study contains elements of the original as well as of the corrected rendering of the angel in the painting and can, therefore, be assigned to a date between the two.

On the verso: In the same technique, study of the head of the angel and a study for one of the myrmidons in Lanfranco's vault fresco *The Crowning of Christ with Thorns* in the Cappella Paganini (first chapel on the right) in S. Maria in Vallicella in Rome

Giovanni Lanfranco
STUDY FOR A MALE FIGURE LOOKING UPWARDS

Bottom right, note in lead pencil:
Lanfranco
Black chalk and traces of white
heightening on brownish paper. Squared
in red chalk, 256 × 208 mm.
Paint marks and oil stains. The sheet is
partially surrounded by a line in pen and
brown ink and is laid down on an old
mount
Inv. No. FP 13718
1932 Inventory: Studies. Lanfrancho
Unpublished
Erich Schleier related this study to the
fresco mentioned (written communication).

Study for one of the male figures in the fresco painted by
Giovanni Lanfranco in 1625–28 in the cupola of S. Andrea
della Valle in Rome. As in Lanfranco's cupola fresco in the
Cappella Buongiovanni in S. Agostino in Rome, the central
figures of the picture are the Virgin in glory, seated on clouds
supported by angels, and Christ, who is shown above her in
the lantern of the dome.

Mary is surrounded by a large number of male and female
saints, and Old Testament patriarchs and prophets, of whom
the most prominent are recognizable by their attributes. Two
rows, one above the other, of angels and putti singing and
playing music follow the saints in the lower part of the fresco.
The present study seems to be of an Old Testament figure who
cannot be identified with certainty. In the fresco he is shown to
the left above Hagar and Ishmael. As the figure in the fresco is
partly hidden by other figures, only as much of him has been
drawn here as will appear in the fresco. His attitude and
appearance correspond with the finished version. The left arm
of this figure has been drawn again, lower left.

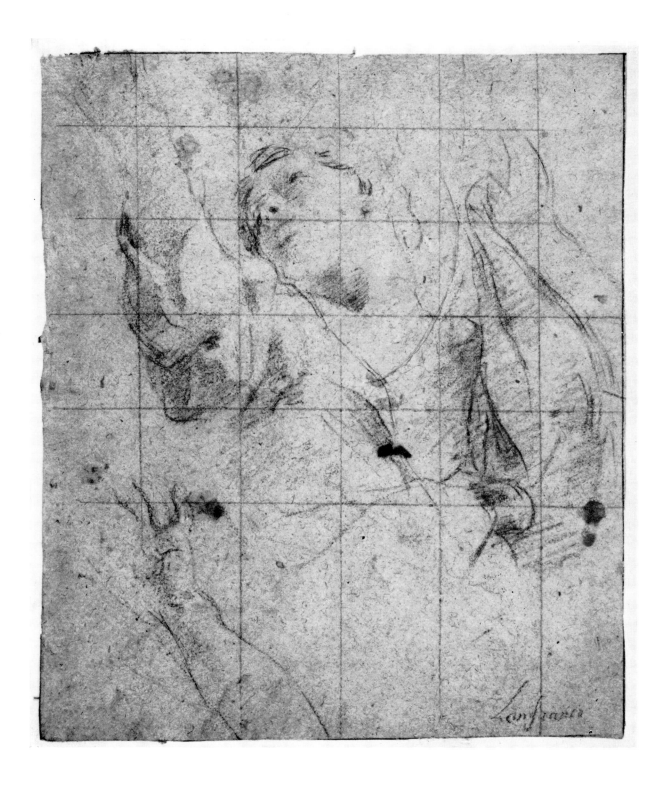

12

75
Giovanni Lanfranco
STUDY FOR A FIGURE OF ST JOHN

On the verso, top centre, a note in lead pencil on a strip adhering from an old mount: *Lanfran[co]*
Black chalk, heightened with white, on yellowish-grey paper, 409 × 280 mm.
Oil stains and paint marks
Inv. No. FP 13685 verso
1932 Inventory: Studies. Lanfrancho
Unpublished
Erich Schleier (written communication) related this study to the painting mentioned

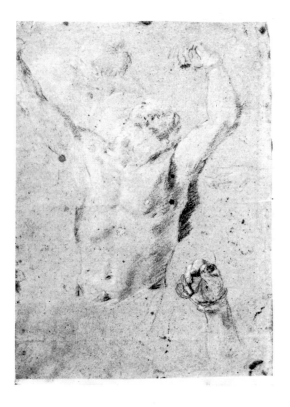

Study for the figure of St John in the painting *St Peter walking on the Sea of Galilee*. The attitude of St John corresponds closely with the painting, where he is shown standing in the boat rocked by the storm. Lower right, a study of John's outstretched left arm.

The painting, one of six altarpieces showing scenes of St Peter's life in St Peter's, Rome, was commissioned by Pope Urban VIII Barberini in 1626 and executed by Lanfranco in 1627–28 (cf. Pollak, vol. ii, pp. 566 ff.). In 1726 the fresco was replaced by a mosaic copy. Only the lower part of the painting has survived and is in the vestibule of the Loggia della Benedizione in St Peter's. The famous painting restated in terms of baroque art the subject of the *Navicella*, Giotto's mosaic. It has been engraved by Nicolas Dorigny – facing the right way, in contrast to the reversed engravings by Louis Gommier, Gerard Audran, Etienne Picart, Francesco Faraone, and Pietro Aquila (there is an impression of Dorigny's print in the Düsseldorf Print Room, Inv. No. FP 5472 D).

There is a design for the painting in both the Louvre (Inv. No. 6312) and the Albertina (Inv. No. 2798) (cf. Bean/Vitzthum, pp. 106–07, figs. 2–3; Roli, no. 38 with ill.; Knab, *I grandi disegni*, no. 76 with col. pl.). A study in chalk for another disciple (Naples, Museo di Capodimonte, Inv. No. 638 recto) was published by E. Schleier (*Burlington Magazine*, 1968, p. 574, fig. 54, with a reproduction of the mosaic copy of the altarpainting: fig. 55).

On the recto: As Erich Schleier recognized (written communication), the studies executed in the same style on the recto of this sheet relate to a Martyrdom of St Bartholomew

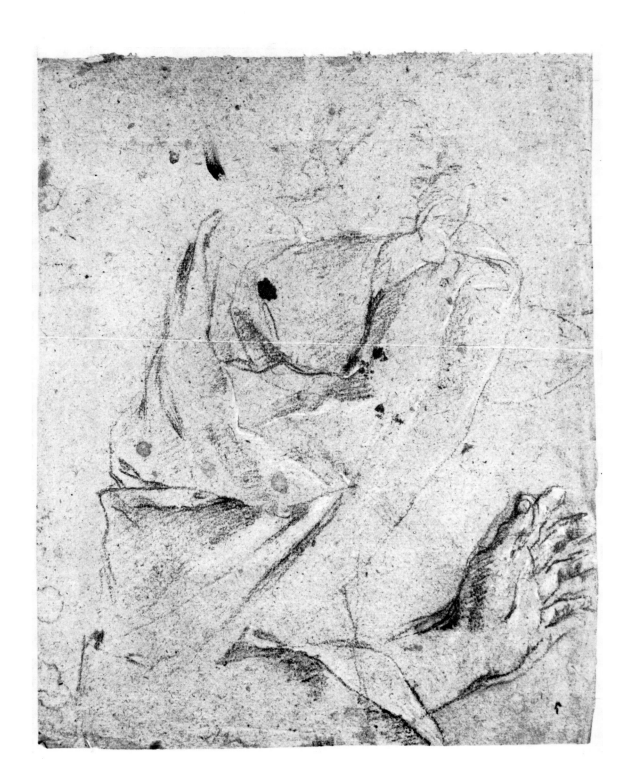

Bottom left, a note in lead pencil:
Lanfranchi
On the verso, numerals in pen and brown
ink: *14*
Black chalk, heightened with white, on
grey-green paper, 407 × 270 mm.
The top corners have been bevelled. Oil
stains and paint marks. On the verso
strips of an old mount adhere to the lower
edge of the sheet
Inv. No. FP 13688 recto
1932 Inventory: Studies. Unknown artist
Unpublished
The relation of this drawing to the
painting mentioned was recognized by
Erich Schleier (written communication)

Study for the figure of Joseph in Lanfranco's painting *The Adoration of the Shepherds* painted in 1631 in S. Maria della Concezione, Rome, in the second chapel on the right (originally fourth chapel on the left). To the left and below Joseph there are detailed studies of drapery and of a hand. This painting was preceded by another version of the same theme (cf. Schleier, 1962, pp. 246–57, fig. 17). Whereas the earlier version, painted during Lanfranco's first stay in Rome 1606–07, reflected the influence of Annibale Caracci's lost *Adoration of the Shepherds*, the painting in S. Maria della Concezione, executed nearly twenty-five years later, comes much closer in conception to Correggio's *Notte* (Dresden, Staatliche Gemäldegalerie).

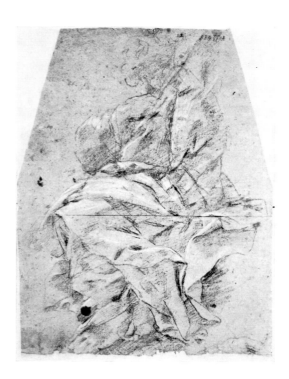

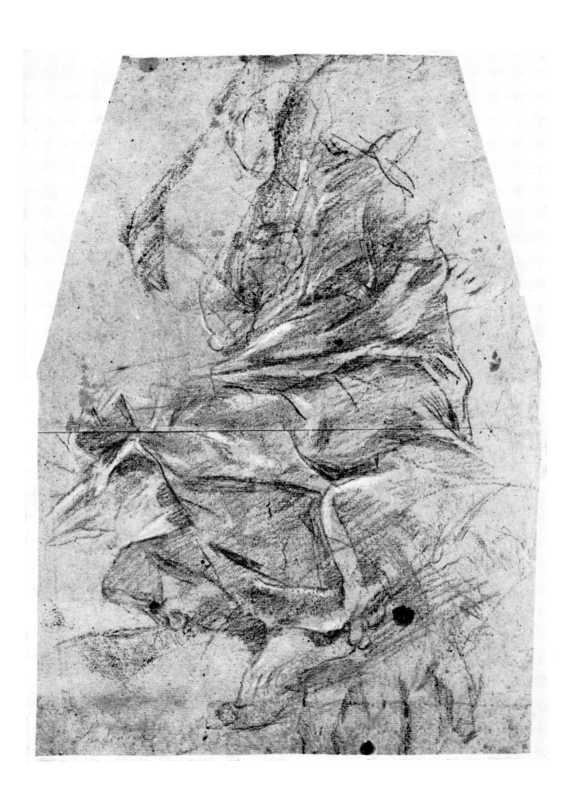

Bottom left on the mount, numerals in pen and brown ink: *67*
On the verso of the mount, a note in lead pencil: *Lanfranchi* and in black chalk: *2 fl(orin)*
Black and brown chalk, heightened with white, on greenish-grey paper, 387 × 243 mm.
The sheet is fastened down by its edges to an old mount
Inv. No. FP 13684
1932 Inventory: Studies. Lanfrancho
Unpublished

Study for a soldier in the lunette fresco *The Crucifixion* painted in 1638 in the choir of the Certosa di S. Martino in Naples. The warrior is seated in the right foreground of the crowded scene. He is looking towards the group which contains St John and the women tending the Mother of Christ, who has fallen in a faint on the ground at the foot of the Cross.

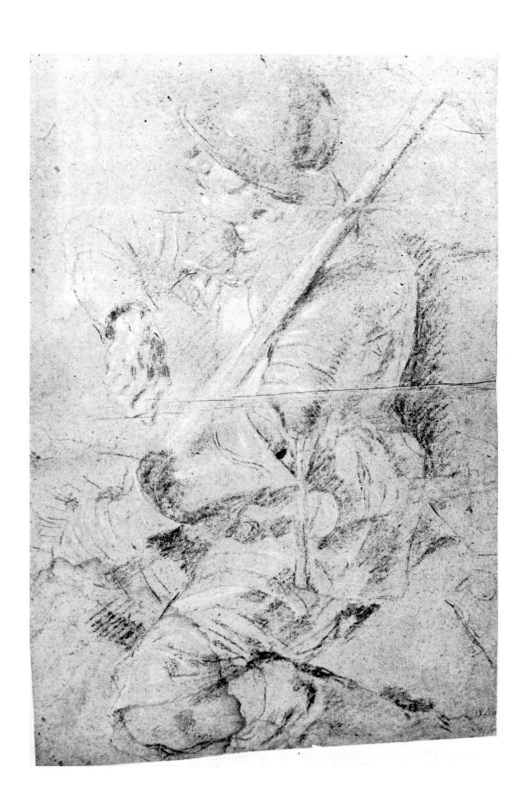

78
Giovanni Lanfranco
STUDY FOR TWO STANDING FEMALE FIGURES

Bottom right, a note in lead pencil:
Lanfran[co]
Black chalk, heightened with white, on yellowish-grey paper, squared in black chalk, 411 × 282 mm.
Bottom right corner torn off. Oil stains. Fastened along left edge of sheet, strips from an old mount
Inv. No. FP 13724 recto
1932 Inventory: Studies. Unknown artist
Unpublished.
We are indebted to Erich Schleier (see note on mount) for the attribution to Lanfranco and for relating the studies on the recto and verso to the fresco in the cupola of the Cappella del Tesoro

Study for two of the female allegorical figures in Lanfranco's fresco in the cupola of the Cappella del Tesoro of S. Gennaro in Naples. Domenichino, who had been working for ten years on the decoration of the chapel, had already begun the cupola fresco when he died in 1641. When Lanfranco was commissioned to decorate the cupola he had the fresco begun by Domenichino removed and in 1643 began painting from his own designs, finishing the fresco in less than two years.
The studies on the recto and verso of the present sheet relate to the female figures standing in the lower zone of the cupola, in front of a painted stone balustrade. The one who is standing on the left in the drawing, is shown in the fresco holding a dish with flames and can, therefore, be identified as *Sapientia*. In the scenic construction of his composition Lanfranco is following Correggio's cupola fresco in Parma Cathedral, in which the apostles are also shown in front of a painted stone balustrade, in the lower zone.

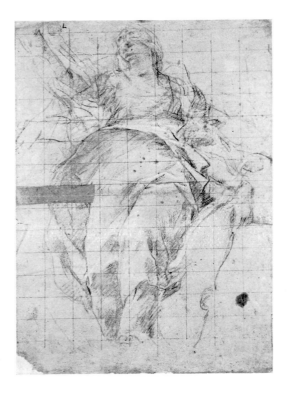

On the verso: Study in the same technique of a woman with a lyre, representing *Harmony*, also drawn for the cupola fresco of the Cappella del Tesoro

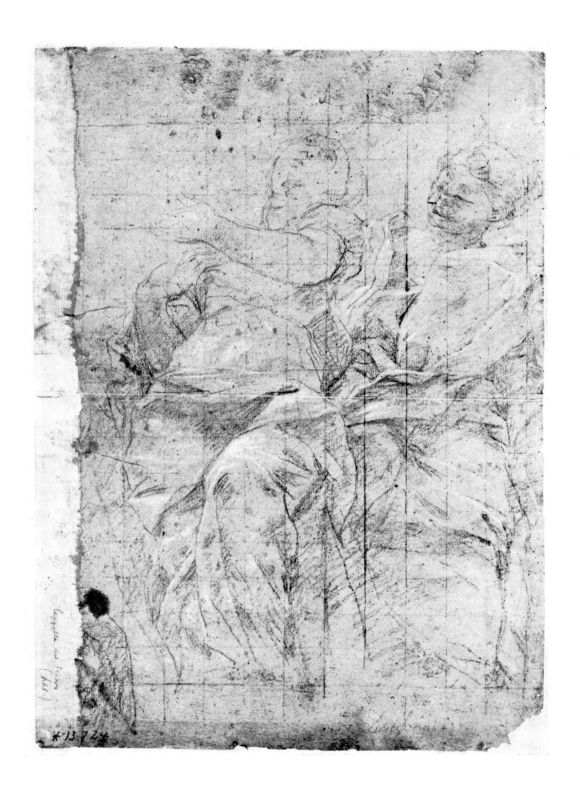

In pen and brown ink, note bottom
centre: *65 JWH*
Numeral, bottom right: *6*
On the verso, notes: in pen and brown
ink, top centre: *Del titian;* in black chalk,
bottom right: *Lanfranchi,* in red chalk,
bottom left: *30 x*
Black, grey and brown chalks, heightened
with white, on greenish-grey paper, 378 ×
269 mm.
Squaring in black chalk. The sheet has
a border on the recto and verso in pen
and brown ink. Oil stains, partly covered
over with white. Pieces missing from the
left edge of the sheet
Inv. No. FP 13679 recto
1932 Inventory: Studies. Unknown artist
Unpublished
The connection with the painting
was recognized by Erich Schleier
(written communication).

Study for the figure of Joseph in a painting *The Angel appearing
to St Joseph*, still unpublished (in the Earl of Leicester's
Collection, Holkham Hall). The painting dates from Lanfranco's
late period in Naples. Above the study for the whole figure there
are two studies in detail for the right hand and the right
forearm of Joseph.

In Lanfranco's painting *A Bishop of the Theatine Order
watching Christ on the Mount of Olives* (Naples, SS. Apostoli),
painted between 1644 and 1646, the figure of Peter is painted
in an almost identical attitude to that of Joseph in the present
study. Designs for this painting in the choir of the Neapolitan
Theatine church are in the Capodimonte Museum, Naples,
and elsewhere. (Cf. Cat. Exh. *Disegni di Lanfranco per la
Chiesa dei Santi Apostoli nel Museo di Capodimonte*, Naples,
1964, Cat. no. 74 recto and verso and no. 75, fig. 16.)

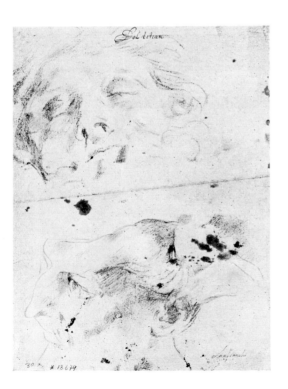

On the verso: Two studies of heads, in black chalk heightened with
white. Schleier relates these to the painting *The Dream of Joseph*, but
it is also possible that the upper study relates to the figure of the
sleeping St John in the Neapolitan picture

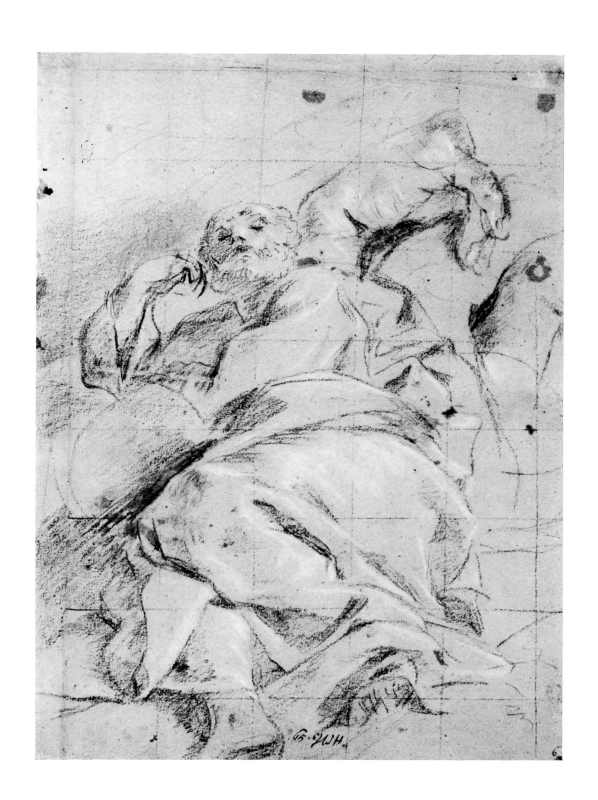

𝓕. 𝓤𝓗.

6

Carlo Maratta

Painter and etcher
Born Camerano, 1625; died Rome, 1713
Cat. nos. 80–101

Carlo Maratta

STUDIES FOR THE PAINTING 'THE ADORATION OF THE MAGI'

Top left, numerals in pen and brown ink:
93
Top centre, a stamp: *Status Montium*
On the verso, a note in lead pencil:
C Maratt(a) and a stamp: *FP*
Red chalk, heightened in white, on deep blue paper, 282 × 427 mm.
Inv. No. FP 8277
1932 Inventory: Study. C. Maratti
Bibliography: *KSM*, no. 188

The altarpiece must have been painted in 1656 (Rome, S. Marco, third chapel on the right, Mezzetti, no. 104). The present sheet contains studies of the male nude for all the figures in the painting except the Infant Christ. On the left a study for the Madonna, who is standing near the left-hand border in the painting, where she is holding the Infant Christ in outstretched arms. In the centre of the sheet there are two studies for the oldest of the kings, who in the painting is kneeling at the feet of the Madonna and is holding out a golden vessel. On the right at the top is a study for the Moorish king, bending forward. Below that, a study for the head and upper body of the third king, who in the painting is partly hidden, and for the head of the Madonna, reversed in the painting. Two other sheets by Maratta in the Düsseldorf Print Room (*KSM*, nos. 189 and 193) also contain studies for this painting.

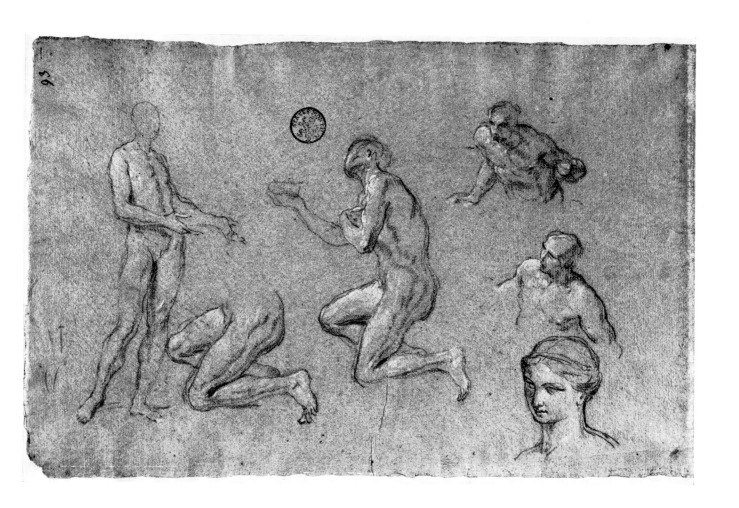

Bottom left, note in lead pencil, gone over in pen: *C Maratti*
Top left, numerals in pen and brown ink: *63*
Bottom centre, a stamp: *Status Montium*
Red chalk, heightened with white, on grey-brown paper, 282 × 425 mm.
Inv. No. FP 8298 recto
1932 Inventory: Figure studies. C. Maratti
Bibliography: *KSM*, no. 195, pl. 44;
Cat. Exh. *Düsseldorf 1969*, no. 55, fig. 58

The painting (Greenville, U.S.A., Bob Jones University; Mezzetti, no. 50, fig. 27) shows the saint kneeling in front of the x-shaped cross. Behind him stand two executioners bare to the waist. On the left a centurion, viewed from behind, can be seen leading more soldiers forward. The painting's composition follows – in reverse – Andrea Sacchi's altarpiece painted for St Peter's (Posse, fig. 17, see Cat. no. 133). The present sheet shows on the left, near a study of drapery, a nude study for the kneeling saint, who in the painting is praying before the Cross. On the right of this there is a nude study of the executioner who in the painting is removing the saint's cloak; also studies for his legs and, on the far right, a study of the nude rear view of the centurion, who is shown here, in contrast to the treatment of the figure in the painting, looking down to the left. On the evidence of the studies, which in style are still very close to Sacchi, the painting must have been made around 1656. A variant of the painting (Mezzetti, no. 49) is in the collection of the Earl of Wemyss. This second version must have been painted during the same period, judging by the studies on the verso of the present sheet.

On the verso: In the same technique, on the left, four studies of the younger of the female spectators in the variant of the painting in the collection of the Earl of Wemyss. On the right, three studies of arms and legs of the saint and a study of the right hand of the same woman spectator

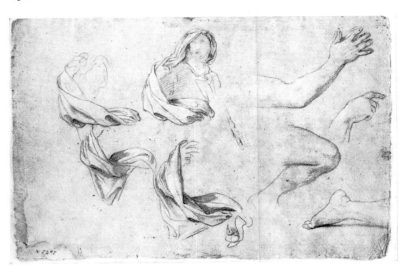

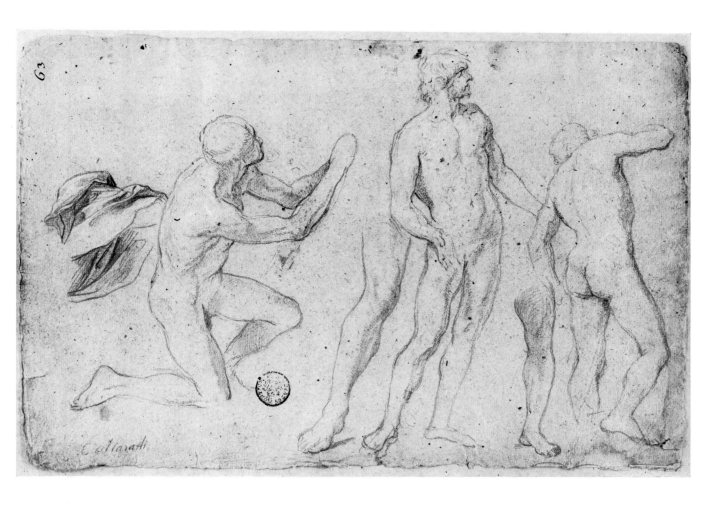

Carlo Maratta
STUDIES OF A NUDE MODEL

Top left, numerals in pen and brown ink:
25
Bottom centre, a stamp: *Status Montium*
On the verso, a stamp: *FP*
Red chalk, heightened with white, on
pale beige paper, 281 × 430 mm.
Inv. No. FP 13021
1932 Inventory: Studies. Unknown
Bibliography: *KSM*, no. 467

The studies on the left half of the sheet show a man standing with his left arm raised, viewed from the front. On the right of the sheet more studies of the nude man, a study of a woman's face, two studies of hands and three studies of drapery. These cannot be identified with any known work of Maratta. The sheet dates from Maratta's early period and the style of the drawing is closely related to that of his teacher Andrea Sacchi. Cf. Cat. no. 135.

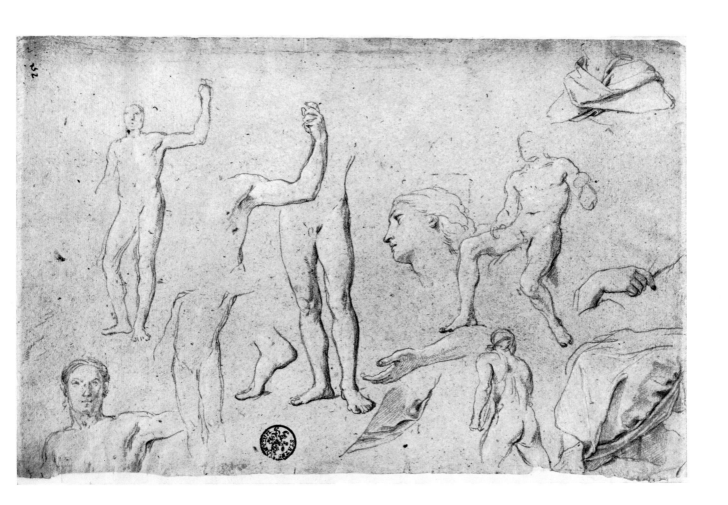

Top right, a note in lead pencil (at right angles): *f. 4* and *C. Maratta* and numerals in pen and brown ink: *74*
Centre left, a stamp: *Status Montium*
On the verso, a note in lead pencil: *C. Maratti*
Red chalk, partly heightened in white, on blue paper, 422 × 274 mm.
Oil stains
Inv. No. FP 8240 recto
1932 Inventory: Studies. C. Maratti
Bibliography: *KSM*, no. 486

The upper part of the sheet has four studies of the figure of a seated youth, possibly St John the Baptist. Below these, at right angles, four studies of John's raised right arm and a hand study. Schaar was unable to relate these studies, made around 1640–60, to any painting by Maratta so far identified.

On the verso: Two studies in the same technique of a male figure, stooping and looking to the right, and a drapery study

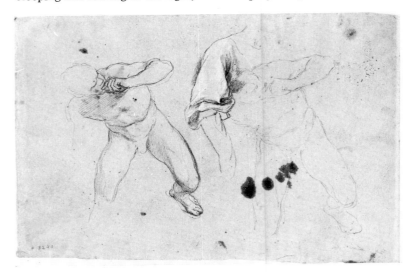

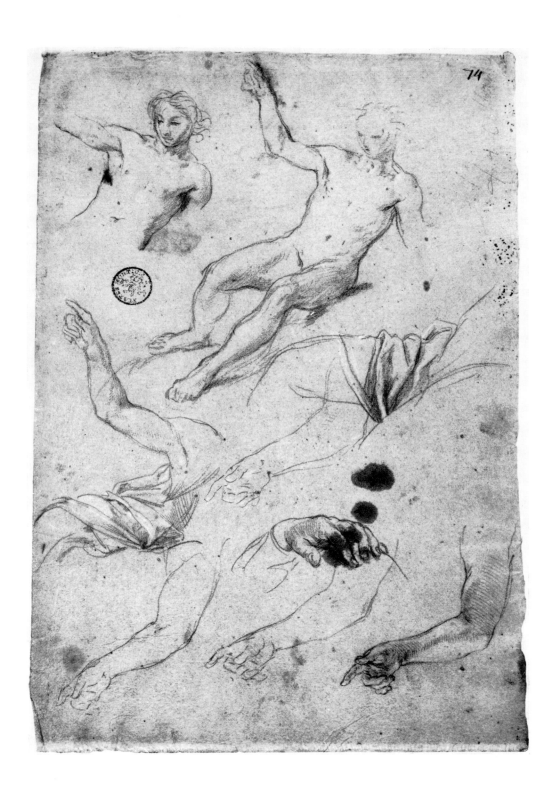

Bottom right, numerals in pen and brown ink: *10;* beside them in lead pencil *59* and a stamp: *Status Montium*
On the verso, a stamp: *FP*
Red chalk on pale beige paper, 244 × 199 mm.
Inv. No. FP 9980
1932 Inventory: Studies. Unknown.
Bibliography: *KSM*, no. 202

Early studies for the painting *The Visitation* executed around 1656 (Rome, S. Maria della Pace, Mezzetti, no. 109, fig. 16).
In the centre of the sheet, a study for Mary and Elizabeth, the chief figures in the picture. Top left, a hastily drawn sketch for Zacharias; bottom left, for the woman carrying a basket, who in the painting appears between Joseph and Mary. The studies not only differ from the painting but also from the Berlin drawing of the complete composition, which in turn shows considerable variations from the version in the painting (cf. *KSM*, p. 94, and Cat. Dreyer, no. 108, pl. 52). Our drawing must, therefore, belong to a very early stage in the plans for the painting. In the latter – exactly opposite to the drawing – Mary is shown in profile, Elizabeth, on the other hand, in three-quarter face, and both women are embracing each other, while, at the same time, they are holding out their left hand to each other. In the painting, Zacharias is holding both his arms outstretched, and the woman with the basket, here shown walking, is viewed from the front.
The Düsseldorf Print Room has, as well as these and the two following sheets in this catalogue, six other drawings for the painting (*KSM*, nos. 201, 203–04 and 206–08). Together with the Berlin design for the whole composition and the studies mentioned by Schaar (*KSM*, p. 94) in Windsor, the British Museum, the Uffizi and formerly in Würzburg, they form an extremely clear picture of the development of the composition, from the sketches of the artist's first ideas to the final version in the painting. See also Cat. nos. 85 and 86.

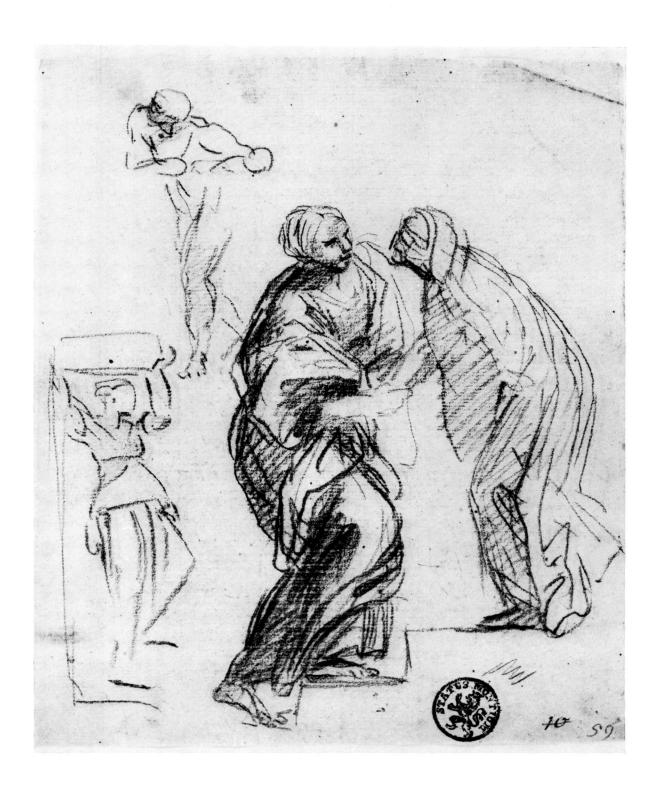

Note in pen and brown ink bottom centre (written on the sheet turned upside down):
Disegni di Maratta No. 4
On the left border, a stamp: *Status Montium*
Black chalk, heightened with white, on brownish-grey paper, 200 × 311 mm.
Piece missing from top border. Oil stains
On the verso an illegible note in pen and brown ink
Inv. No. FP 13760 recto
1932 Inventory: Studies. Unknown artist
Bibliography: *KSM*, no. 205

A broadly sketched study for the figure of Zacharias for the painting *The Visitation* (see Cat. nos. 84 and 86). In this Maratta's chief concern is with the drapery of the cloak. The face and hands have merely been suggested in outline. The right leg of Zacharias is not visible in the painting and has, therefore, been omitted.

On the verso: Study of a leg in the same technique

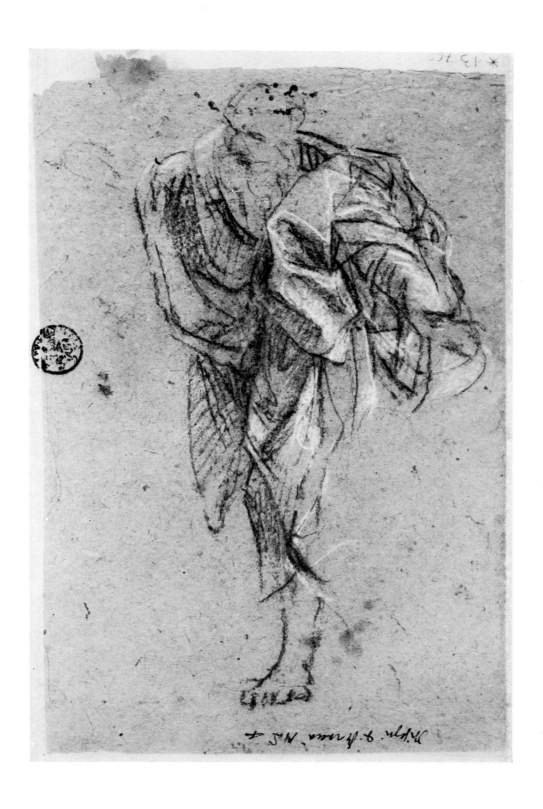

Carlo Maratta
STUDY FOR A FEMALE FIGURE

Top right, numerals in pen and brown
ink: *119*
Bottom left, note in lead: *3 florin*
Centre left, a stamp: *Status Montium*
Note on the verso in black chalk
A.S(acchi), corrected to *C. Maratt[a]*
Black chalk, heightened with white, on
brown paper, 411 × 262 mm.
Oil stains
Inv. No. FP 8997
1932 Inventory: Figure study. Unknown
artist
Bibliography: *KSM*, no. 200

A fully finished study for a kneeling woman originally intended
by Maratta for the right foreground of his painting *The
Visitation* (see Cat. nos. 84 and 85). In her place in the painting
there is a seated woman seen from the front, holding a child on
her lap, accompanied by another woman, whose figure is cut off
by the picture's border so that only her face, seen in profile, is
visible.

The relation of the present drawing to the painting is proved
both by the presence of the study on the verso as well as by
other studies by Maratta in the same style and on the same
paper, which are definitely related to the painting (compare
KSM, no. 208, pl. 38).

It is true, however, that the figure of this woman in an almost
identical attitude can also be be found in Maratta's engraving
The Birth of the Virgin (B.1; impression in the Düsseldorf
Print Room, Inv. No. FP 5572 D), and therefore it is possible
that the present study was made for that composition. A draw-
ing on the same theme attributed to Maratta is in the British
Museum (Inv. No. 1946–7–13–1284) and shows an almost
identical composition.

On the verso: In the same technique broadly sketched study of
Zacharias for the same painting

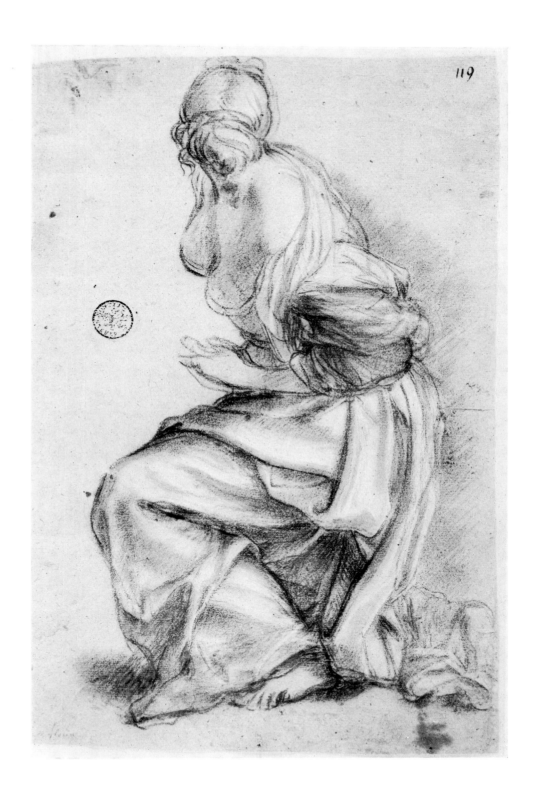

Bottom centre, a stamp: *Status Montium*
Red chalk on yellowish brownish paper.
Squared in lead pencil, 319 × 215 mm.
Inv. No. FP 572
Krahe, *Inv. II*, fol. 30 recto, No. 103:
La Maison de Lorette portée par les Anges,
12 × 8 Pouces, as Andrea Sacchi
1932 Inventory: Veneration of the
Madonna. Andrea Sacchi
Bibliography: Cat. Budde, no. 112, pl.
102 as A. Sacchi; *KSM*, no. 460

The design, attributed by Krahe and Illa Budde to Andrea Sacchi, was recognized by Eckhard Schaar as a work of Carlo Maratta and dated in the 1660s. It is true that to date no painting by Maratta based on this design has been traced, yet Schaar was able to adduce a painting on the same subject by a follower of Maratta (Rome, Ministero dell'Aeronautica, photo G.F.N., E 18372), which depicts the Madonna on the Casa di Loreto, though without the saints. Moreover, Schaar has drawn attention to three drawings by Maratta's pupil Giacinto Calandrucci which treat the same subject and show how popular this subject was in Maratta's circle (Düsseldorf Print Room, Inv. No. FP 1425 and FP 2080; Louvre, Inv. No. 3358, as Maratta). Another variant of the subject is in the Albertina in Vienna, again attributed to Maratta (Inv. No. 1045, cf. *Katalog der Handzeichnungen der Albertina*, vol. iii, no. 779, repr.), but recently published by Eckhart Knab as by Andrea Sacchi (see Knab, *I grandi disegni*, pp. 70–1, fig. 37).

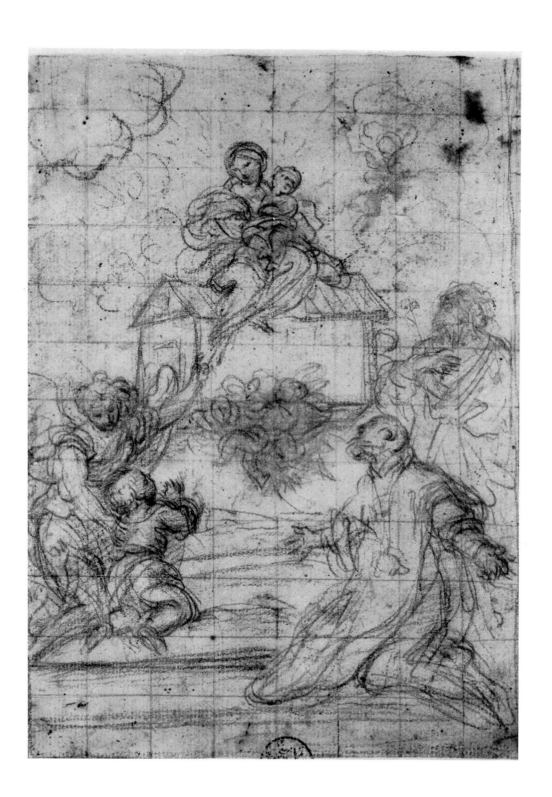

Pen and brown ink on yellowish paper,
305 × 242 mm.
Inv. No. FP 1113
Krahe, *Inv. II*, fol. 33 verso, No. 111:
La Ste Trinité adorée par plusieurs Saints,
9 × 7 Pouces, as Carlo Maratta
1932 Inventory: Saint in clouds. Carlo
Maratta
Bibliography: Cat. Budde, no. 189, pl. 31;
KSM, no. 465, fig. 24

As Pascoli relates (vol. i, p. 200), the Jesuit General Padre Oliva,
when commissioning the vault frescoes of the Roman church Il
Gesù, narrowed his choice to Ciro Ferri, Giacinto Brandi, Carlo
Maratta and, lastly, Giovanni Battista Gaulli, who obtained the
commission (see Cat. nos. 50 and 51).

It is possible that, as Schaar conjectures, this sheet may
represent a design by Maratta for this project. If this is the
case, then this design must have been made between the
accession to office of Padre Oliva (1661) and the giving of the
commission to Gaulli (1671).

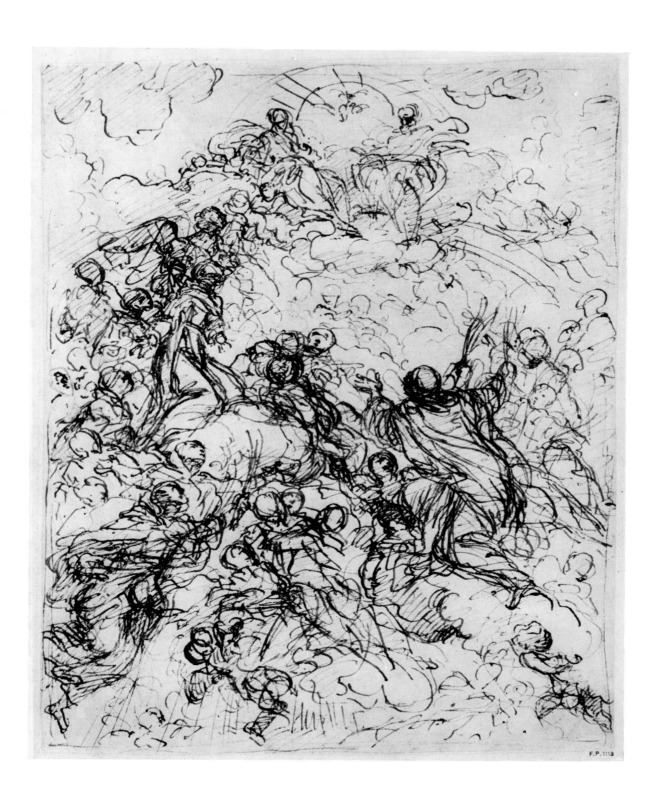

F.P. 1113

89
Carlo Maratta
STUDIES FOR A FIGURE OF ST CARLO BORROMEO (?)

Numerals in pen and brown ink, bottom centre: *13*
Top left, a stamp: *Status Montium*
On the verso, a note in black chalk:
C. Maratta and stamp: *FP*
Red chalk, heightened with white, on blue-grey paper, 413 × 269 mm.
Inv. No. FP 13105
1932 Inventory: Studies. C. Maratti
Bibliography: *KSM*, no. 522

A fully completed study, and below it the sleeve of the right fore-arm drawn again. The saint is shown as though seated at a table, though the artist has not drawn it in. On the left the side of a folding chair is suggested. The sheet appears to have been drawn in the 1670s. No related painting has been identified.

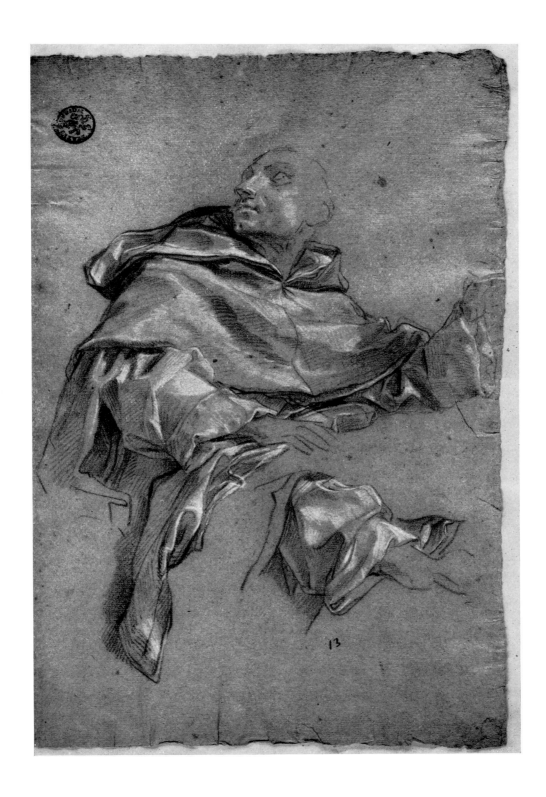

13

14

Carlo Maratta
STUDIES FOR THE FIGURE OF A PENITENT MAGDALENE

Bottom right, numerals in pen and brown ink: *52*
Top right, a stamp: *Status Montium*
On the verso, a note in lead pencil: *C. Maratt(a)* and a stamp: *FP*
Partly in red and partly in black chalk, heightened with white, on green paper, 427 × 282 mm.
Inv. No. FP 13819
1932 Inventory: Studies. C. Maratti
Bibliography: *KSM,* no. 527

Studies for a half-length figure of the penitent Magdalen. Top, study of the head, shoulder and supporting right arm. Below, in black chalk, two studies of drapery and a book which the saint, gazing upward, is holding open on her lap. Below this a study for the lower part of the picture, already framed with the rectangular border-line of the painting. On the right edge of the sheet a detailed study of drapery in black chalk.

The studies have not been linked to a painting by Maratta. In style they are related to Maratta's drawings for his altarpiece *The Death of St Francis Xavier* (Rome, Il Gesù; *KSM,* nos. 286–92, and E. Schaar, 'Carlo Marattas "Tod des Hl. Franz Xaver" ' in *Festschrift Hans Kauffmann,* Berlin, 1968, pp. 247–64 with ills.) painted in 1674–79, and they should be dated in about the same period.

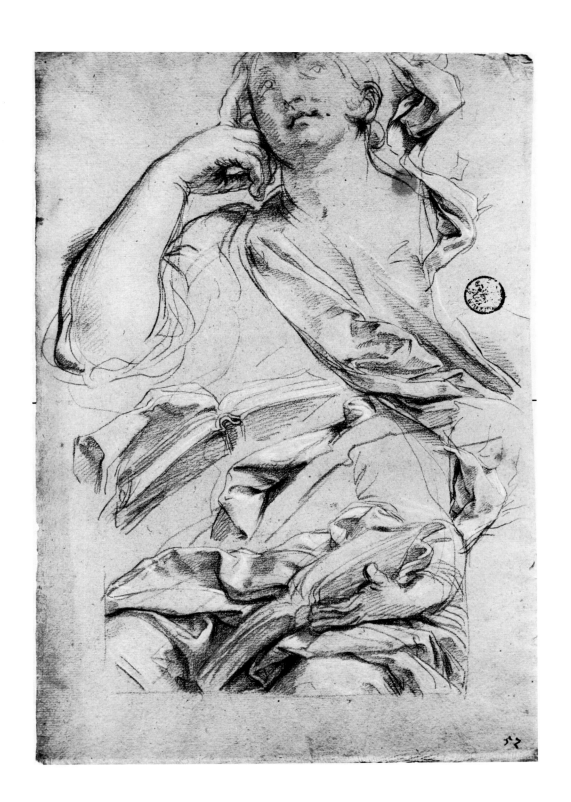

Bottom right, numerals in lead pencil: *218*
Top right, a stamp: *Status Montium*
Pen and brown ink over red chalk on
blue-green paper, 354 × 264 mm.
The top has been cut and the four corners
bevelled. A strip 77 mm. deep has been
added at the bottom to enlarge the sheet
Inv. No. FP 1112
Krahe, *Inv. II*, fol. 35 verso, No. 211:
*Plafond de la Salle Altieri, 13 × 10
Pouces* as Carlo Maratta
1932 Inventory: Allegory. Carlo Maratta
Bibliography: Cat. Budde, no. 155, pl. 28;
Mezzetti, p. 339 under no. 118; Cat.
Exh. *Düsseldorf 1964*, no. 86; *KSM*,
no. 258

Design for the ceiling fresco painted by Maratta in 1674–77 in
the *salone* of the Palazzo Altieri in Rome (Mezzetti, no. 118,
repr. Voss, p. 346).
The figure of Clementia is the central character in the ceiling
fresco, in allusion to the name of the patron, Pope Clement X
Altieri (1670–76). She is shown enthroned on clouds, in her
left hand holding the sceptre of *Providentia*, divine providence,
and in her right an olive branch above the globe.
The top part of this design has had about a third cut away. It
is possible to identify Clementia's lap at the top edge, with the
globe to the left. As in the fresco, the figures below Clementia
are, from left to right, personifications of Prudentia (Wisdom),
shown here as Pallas Athene, Justitia (Justice), Abundantia
(Plenty) and Fortitudo (Strength), shown here in the form of a
standing warrior. The latter is equipped with the attributes of
Hercules, a club and a lion's skin, and is holding the standard of
the Church in his left hand. Don Gasparo Altieri, the nephew
of the Pope and a gonfalonier, is portrayed in this figure. At
the bottom, below the personifications of these four virtues,
putti have been sketched in to symbolize the four seasons of
the year.
The iconographic programme of this important work by
Maratta is described by Giovan Pietro Bellori, the leading
art critic and biographer of the period (see Bellori, pp. 91–2).
Two *bozzetti* for the fresco have been preserved in the Palazzo
Altieri (Mezzetti, no. 119, fig. 34).
The Düsseldorf Print Room has twenty sheets of studies for
individual figures in the fresco (*KSM*, nos. 256–57, 259–76).
Another sheet is in the Collection of Janos Scholz, New York
(cf. F. H. Dowley, 'A few drawings by Carlo Maratta' in *Master
Drawings*, vol. iv, 1966, p. 423, pl. 37).

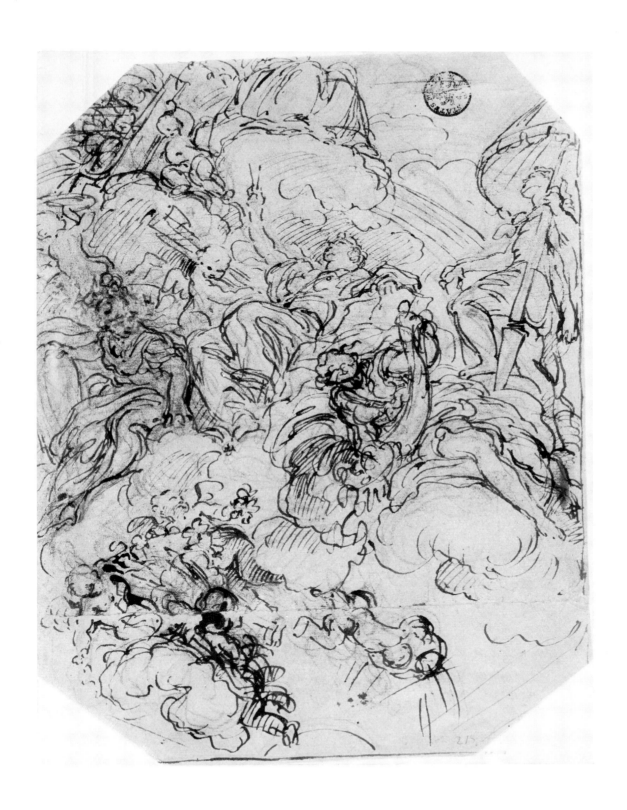

Red chalk, pen and black ink on beige
paper, 162 × 201 mm.
The sheet is laid down on old cardboard
Inv. No. FP 1258
Krahe, *Inv. II*, fol. 35 verso, No. 201:
*Daphnée poursuivie par Appollon, 6 × 9
Pouces* as Carlo Maratta
1932 Inventory: Apollo and Daphne. Carlo
Maratta
Bibliography: I. Budde, 'Originalentwürfe
für italienische Gemälde des Barock in
den Zeichnungensammlungen der
Staatlichen Kunstakademie zu Düsseldorf'
in *Zeitschrift für Bildende Kunst*, 1927–28,
p. 36 with ill.; Cat. Budde, no. 167, pl.
27; Mezzetti, p. 320 under no. 18; *KSM*,
no. 325

In answer to his daughter's prayer when she is pursued by
Apollo, the river god Peneus changes her into a laurel tree
(Ovid, *Metamorphoses* I, 452–565).
This is clearly an early design for the painting by Maratta
carried out in 1681 (Brussels, Musées Royaux des Beaux-Arts,
Mezzetti, no. 18, repr. Voss, p. 344). Only the figures of Apollo
and Daphne resemble the final version of the composition. The
water nymph, shown to the far right in the drawing, appears in
the foreground to the left in the painting, while the river god
is in the background in the painting, on the right beneath
a group of trees, where a wood nymph is also lying. A painting
of the same subject attributed to Maratta is in the Collection
of the Earl of Leicester at Holkham.
See also Cat. no. 93.

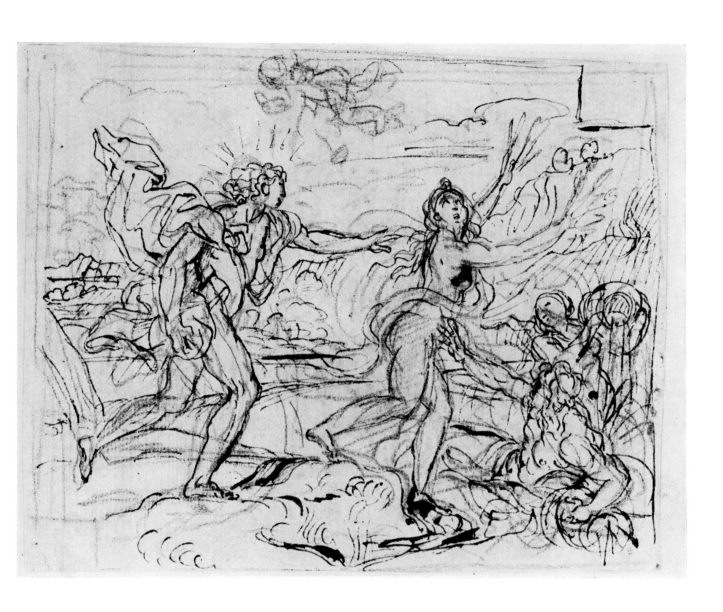

Top right, numerals in pen and brown ink:
81
Top left, a stamp: *Status Montium*
Red chalk, heightened with white, on
green paper, 420 × 272 mm.
Oil stains
Inv. No. FP 7311
1932 Inventory: Nude study. Unknown
artist
Bibliography: *KSM*, no. 327, pl. 2.

For the painting, see Cat. no. 92. The drawing belongs to a
sequence of eleven sheets in the Düsseldorf Print Room, used
by Maratta in his preparations for the painting (*KSM*,
nos. 325–35).

In contrast to the studies in *KSM*, no. 326, where the wood
nymph still has her face turned to the left, in the present study,
as in the painting, she is looking to the right. The head
crowned with leaves and the classical profile of her face,
reminiscent of Poussin, are carefully worked out. The right
contour of her body is sketched in as far as the hips; the
position of the arms, and of the legs (stretching, as in the
painting, to the right) is illustrated in another study in the
Düsseldorf Print Room (*KSM*, no. 328).

There are other studies for the painting in the British Museum
(cf. Mezzetti, no. 18, fig. 39, and W. Vitzthum, *Il barocco a
Roma*, 1971, p. 86, col. pl. xxxi).

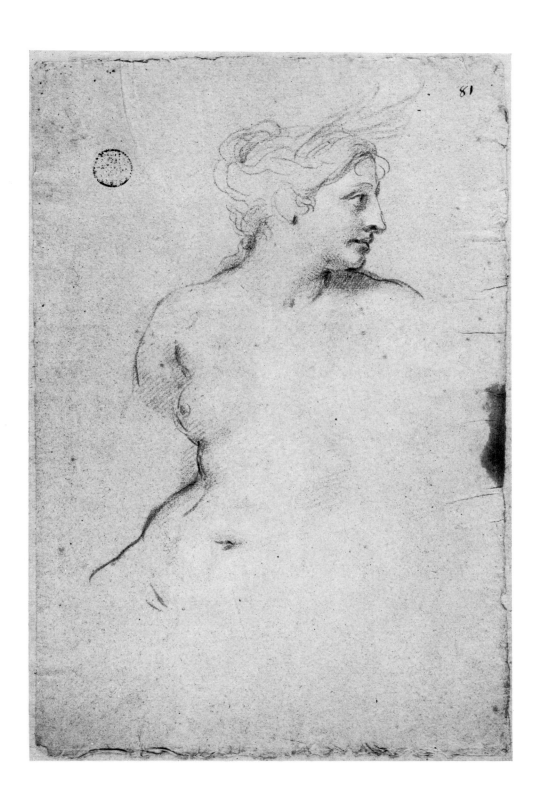

81

On the verso, a stamp: *FP*
Red chalk, heightened with white, on
blue paper, 365 × 269 mm.
Piece missing on top edge of sheet has
been repaired
Inv. No. FP 2155
1932 Inventory: Studies. Calandrucci
Bibliography: *KSM*, no. 304, pl. 80;
Cat. Exh. *Düsseldorf 1969*, no. 61, fig. 54

Design for one of the pendentives in the Cappella della
Presentazione in St. Peter's, Rome. It shows the Prophet
Balaam who, with his right arm outstretched, is gazing up at
the Star of Jacob: 'There shall come a Star out of Jacob, And
a Sceptre shall rise out of Israel' (Numbers 24, 17). This text
may be taken to refer to the supremacy of David as much as to
the coming of the Messiah.

In 1677 Maratta received the commission to draw designs for
the four pendentives and the six half lunettes in the chapel,
which were carried out in mosaic by Fabio Cristofani and
Giuseppe Conti before 1695. The subjects, drawn from the Old
Testament are typologically related to the cupola mosaic, *The
Miracle of the Immaculate Conception of the Virgin Mary*. This
mosaic was not designed and carried out until between 1695
and 1708.

There are twenty-two other sheets of studies and designs in the
Düsseldorf Print Room for the scenes in the four pendentives
and in four of the six half lunettes (*KSM*, pp. 116–17 and nos.
297–303, 305–19).

Since the drawing *KSM* no. 302 has another study of the
prophet Balaam on the recto and a study for the picture
Apollo and Daphne on the verso (see Cat. nos. 92 and 93), it
may be assumed that the preparatory drawings for the mosaics
were made at about the same time as those for the picture,
which was completed in 1681. There are further studies for the
figure of Balaam: *KSM*, no. 303; Cat. *Roman drawings*, no. 298
and a sheet which passed through the hands of Colnaghi's in
1949.

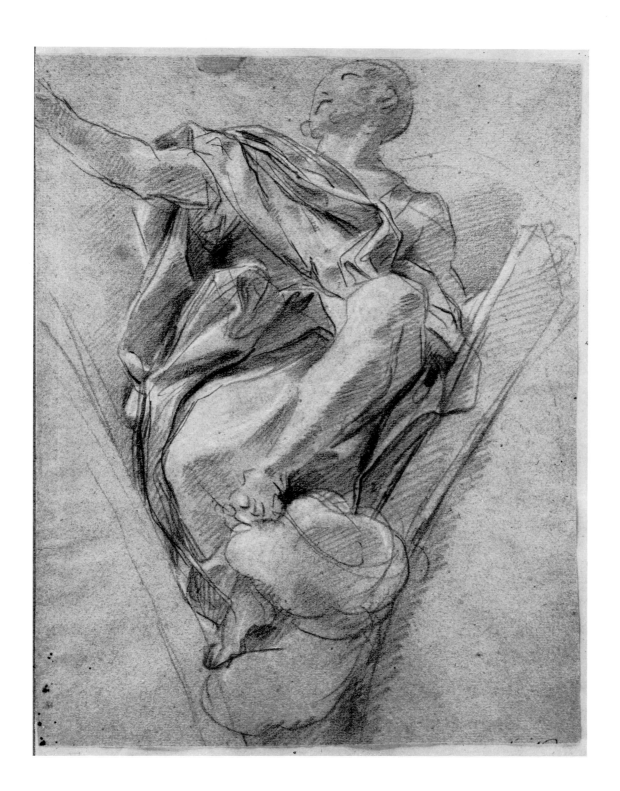

95
Carlo Maratta

ST JOHN THE EVANGELIST CONVERSING WITH ST GREGORY, ST JOHN CHRYSOSTOM AND ST AUGUSTINE ABOUT THE IMMACULATE CONCEPTION

Pen and brown ink over black and red chalk, partly with brown wash, on yellowish paper, 366 × 198 mm.
Several missing pieces restored. Top enclosed in a semi-circle
Inv. No. FP 1131
Krahe, *Inv. II*, fol. 33 recto, No. 92: *La Ste Vierge avec des Saints, 15 × 10 Pouces*, as Carlo Maratta
1932 Inventory: Scene with saints. Carlo Maratta
Bibliography: Cat. Budde, no. 168, pl. 30; F. H. Dowley, 1957, p. 172 ff., fig. 12; Cat. Exh. *Düsseldorf 1964*, no. 104; *KSM*, no. 342, pl. 85

Design for the altar painting completed in 1686 for the Cappella Cybo in S. Maria del Popolo, Rome (Mezzetti, no. 110; repr. Dowley, 1957, fig. 9). The history of the planning of this painting can be followed by means of numerous designs for the whole composition and individual studies and has been described in detail by Dowley (*op. cit.*) and Schaar (*KSM*, p. 126).
The disposition of the figures in the drawing before us corresponds to a considerable extent with the work as executed, which was based, as far as the composition is concerned, on a design in the Academia de San Fernando in Madrid (Cat. Alcaide, no. 23). Mary is shown turning to the left in the present sheet, which is a variation from the painting. The table shown here, at which Gregory is seated writing, has been omitted from the painting, where the saint is viewed from the front. Augustine, seated to the left in the foreground, is gazing upward in the painting. John Chrysostom, who in our drawing is shown in alternative positions on the right as well as on the left of Gregory, in the painting is seated to the left of Gregory, but without his mitre. By abandoning the table in the painting, the artist has achieved a greater feeling of space in the composition, so that the figures of St John and the Fathers of the Church gain in effectiveness.

On the lower border of the sheet, a stamp:
Status Montium
On the mount, numerals in pen and
brown ink: *75;* below that in lead pencil:
122
On the verso of the mount a note in lead
pencil: *C Maratta;* and a stamp: *FP*
Pen and brown ink, 265 × 186 mm.
The sheet is fastened to an old mount at
the corners
Inv. No. FP 1182
1932 Inventory: Bible scene. Carlo
Maratta
Bibliography: F. H. Dowley, 1957, p. 174,
fig. 17; Cat. *Roman drawings*, p. 56;
Cat. Exh. *Düsseldorf 1964*, no. 105, pl.
30; Cat. Alcaide, p. 8 under no. 9; *KSM*,
no. 350, pl. 87

Design for the painting carried out by Maratta in 1686–87 in
S. Maria di Montesanto, Rome, third chapel on the left
(Mezzetti, no. 108; Dowley, 1957, fig. 14).
The drawing represents an early idea in the history of the
painting's origin. The same composition is used again in other
studies carried out in chalk, in Windsor (Cat. *Roman drawings*,
no. 284, pl. 55) and Madrid (Cat. Alcaide, no. 9). On the other
hand two further studies, also in Windsor (Cat. *Roman drawings*,
no. 283, pl. 54) and Madrid (Cat Alcaide, no. 8), show Mary on
a throne, while St Francis is standing and St James is seated
(Windsor) or alternatively kneeling (Madrid). A third design in
Madrid (Cat. Alcaide, no. 10) approaches the finished painting
most closely, with Mary standing higher to the left of the
picture. At her feet St Francis is kneeling to the right and St
James is behind him, his gaze meeting that of the Child.
Another design is mentioned in Cat. *Roman drawings* under
no. 286 as having been at Sotheby's in 1928. There are figure
studies of both James and the Madonna at Windsor (Cat.
Roman drawings, no. 285) and Oxford (Cat. Parker, vol. ii,
no. 903).

97
Carlo Maratta
STUDY FOR A PORTRAIT

Top right, numeral in pen and brown ink: *3*
Top left, a stamp: *Status Montium*
On the verso a note in lead pencil: *C. Maratti;* and a stamp: *FP*
Black chalk, heightened with white, on grey-green paper, 428 × 280 mm.
Very small pieces missing along the right edge of the sheet
Inv. No. FP 10699
1932 Inventory: Studies. C. Maratta
Bibliography: *KSM*, no. 532

In the centre of the sheet there is a study for a half-length portrait of a man facing left. The head and face of the sitter have been sketched in outline only, but the bust is drawn more firmly. The sitter seems to be holding a letter. The edges of the composition have already been drawn in. Above and below this there are studies of putti. No portrait based on the study has so far been identified. The drawing may be dated in the 1680s.

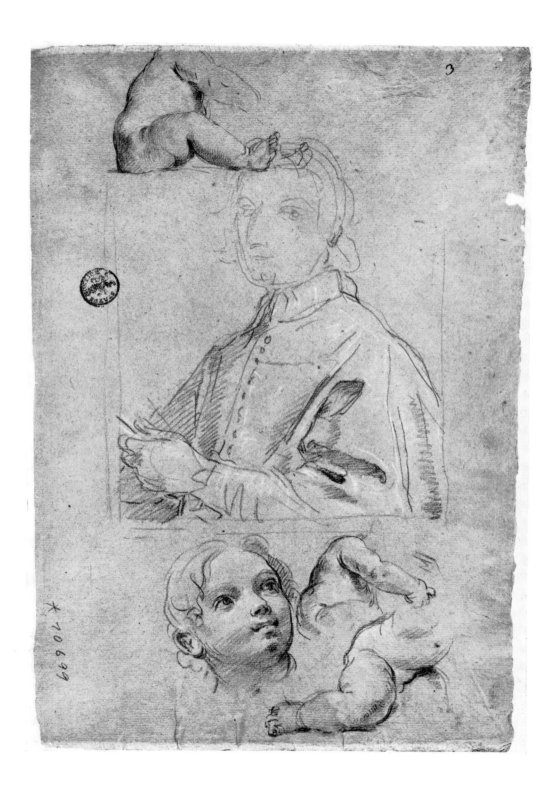

3

15

Bottom right, a note in pen and brown ink: *C Maratti*
Bottom left, a stamp: *Status Montium*
On the verso of the mount a note in lead pencil: *Maratt(a)* and a stamp: *FP*
Black and red chalk, heightened with white, on greenish grey paper, 258 × 239 mm.
The sheet is laid down on an old mount
Inv. No. FP 8312
1932 Inventory: Figure studies. C. Maratti
Bibliography: Cat. Exh. *Düsseldorf 1964*, no. 106; H. Voss, 'Eine Kompositions-zeichnung Marattis zur "Taufe Christi" in der Peterskirche' in *Albertina Studien*, vol. ii, 1964, pp. 110–12, fig. 1; *KSM*, no. 396

Study for the painting *The Baptism of Christ*, completed by Carlo Maratta in 1696 for the high altar of the Baptismal Chapel of St Peter's, but now in the Roman church S. Maria degli Angeli and replaced in St Peter's by a mosaic copy (Mezzetti, no. 106, repr. Voss, p. 342). The exceptionally careful execution of the drawing and the great attraction of its delicate shading led Voss (*Albertina Studien*, p. 112) and Schaar to conjecture that this may have been a presentation sheet for the patron or a repetition by the artist himself.
The Düsseldorf Print Room has ten other sheets of studies for the painting (*KSM*, nos. 386–95). For the history of the planning of the altarpieces of the Baptismal Chapel in St Peter's and the studies for them in Budapest, Madrid and Holkham see F. H. Dowley, 1965; E. Schaar, 'Carlo Maratti and his pupils in the Baptismal Chapel of Saint Peter's' in *Art Bulletin*, vol. xlviii, 1966, pp. 414–15, and *KSM*, p. 137.

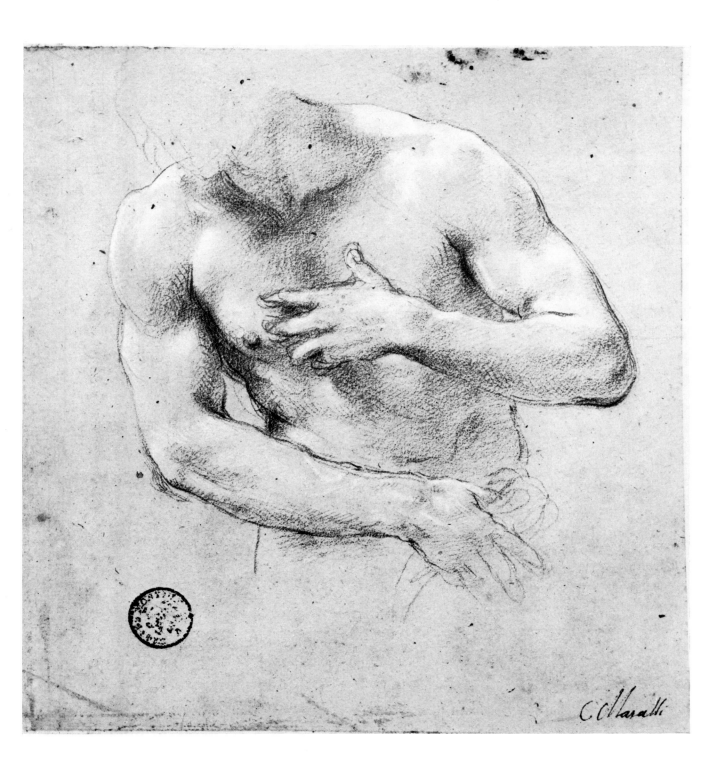

C. Maratti

Bottom right in lead pencil, a note: *C
Maratti* and the numerals: *4*
Bottom centre, a stamp: *Status Montium*
On the verso of the mount a note in lead
pencil: *C Maratti*
Pen and brown ink on yellowish paper,
170 × 235 mm.
The sheet is laid down on an old mount
Inv. No. FP 1201
1932 Inventory: Allegorical scene. Carlo
Maratta
Bibliography: *KSM*, no. 454, fig. 21

Design for a plate for a thesis dedicated to Pope Innocent XII
Pamphili (1691–1700), engraved by Robert van Oudenaarde in
1698 (impression in the Düsseldorf Print Room, Inv. No. FP
16610 D). The disposition of the figures and their poses are
already very much the same as in the engraving. But there the
structure of the throne behind the figure of the Pope is
noticeably larger, so that only its lower part is visible. Also the
figures are larger in the engraving, and, instead of the steps
below the feet of the Pope, a high platform is shown, as already
adumbrated in the drawing. In front of this, in both the
drawing and the engraving, the fallen figure of Heresy is shown.
Schaar connects with this thesis engraving a drawing by
Maratta in the Berlin Print Room published by Ursula Schlegel
as a design for a title-page (Inv. No. *KdZ* 17426; U. Schlegel,
'Bernardo Cametti' in *Jahrbuch der Berliner Museen*, vol. v,
1963, p. 172, fig. 50).
A composition by Maratta, closely related to the present
drawing, is Inv. No. FP 1213, *KSM*, no. 634 in the Düsseldorf
Print Room. Whether it too should be related to the thesis is
not quite sure, because the enthroned figure, corresponding to
the figure of the Pope, seems to be holding a sword in his raised
right hand.

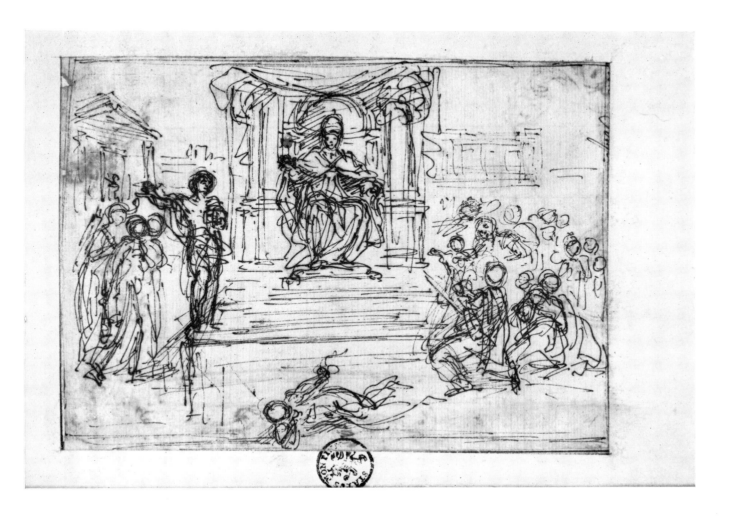

Carlo Maratta
STUDY FOR APOLLO IN THE PAINTING 'MARATTA AND THE MARCHESE NICCOLO MARIA PALLAVICINI'

In pen and brown ink, a note bottom left:
C Maratti and top right, numerals: *80*
Bottom centre, a stamp: *Status Montium*
On the verso of the mount, a stamp: *FP*
Black chalk, heightened with white, on
grey-green paper, 402 × 270 mm.
The sheet is laid down on an old mount
Inv. No. FP 8290
1932 Inventory: Study. C. Maratti
Bibliography: *KSM*, no. 407, pl. 103

For the painting see Cat. no. 101.
A carefully drawn study for the figure of Apollo, which already corresponds with the painting except for a small variation in the position of the right forearm. To the left of Apollo a study for the left hand of the Marchese, which is repeated to the right of Apollo. In addition there are studies of Pallavicini's right hand, of the drapery covering his right wrist and of Apollo's left foot.

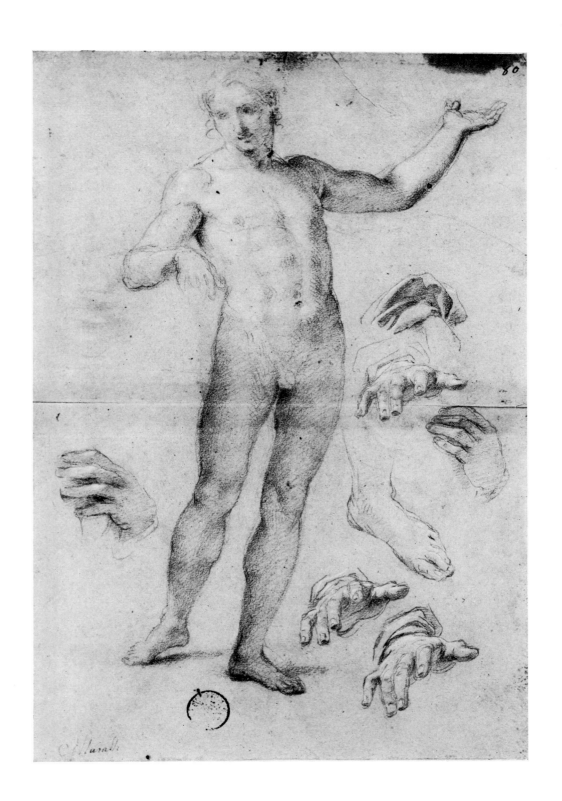

On the verso of the mount a stamp: *FP*
Black chalk, heightened with white, on
brown paper, 278 × 247 mm.
The sheet is laid down on an old mount
Inv. No. FP 1110
Krahe, *Inv. II*, fol. 31 recto, No. 3: *Le
même* (Portrait de l'Auteur) *en grand age,
11 × 9 Pouces* as Maratta
1932 Inventory: Self portrait. Carlo
Maratta
Bibliography: Cat. Budde, no. 191, pl.
34; *KSM*, no. 411, pl. 105 and col. illus.
on cover (detail); Cat. Exh. *Düsseldorf
1969,* no. 62, fig. 63

Study for the last known self-portrait of Maratta. It is for the
double portrait painted in 1706 of Maratta and the Marchese
Niccolò Maria Pallavicini (Stourton, Stourhead House,
National Trust, Mezzetti, no. 158).
In this large painting Maratta is seated on the right with his
crayon, in the process of portraying the Marchese, his friend
and patron. The latter is standing on the left, in profile, and his
attention is being drawn by Apollo (see Cat. no. 100) to the
Temple of Virtue visible in the distance. Behind Maratta, the
Muses.
Among the seven other study sheets for this painting in the
Düsseldorf Print Room (*KSM*, no. 404–10), there is a
portrait study of Pallavicini, inscribed: '*Il vero Rittratto del
Signore Marchese Palavicini fatto dal Cavalier Carlo Maratti
dipintore celeberrimo 1706*' (*KSM*, no. 410, pl. 104).
A design in the British Museum published by Amelia Mezzetti
('Carlo Maratti: altri contributi' in *Arte Antica e Moderna*, vol.
vi, 1961, pp. 377–87, fig. 182a) tries out a composition which is
still very different from the painting as executed, whereas the
Düsseldorf studies clearly came directly before it. Schaar
(*KSM*, p. 142) mentions a copy of the whole composition in
the Louvre (Inv. No. 3428).
See also Cat. no. 100.

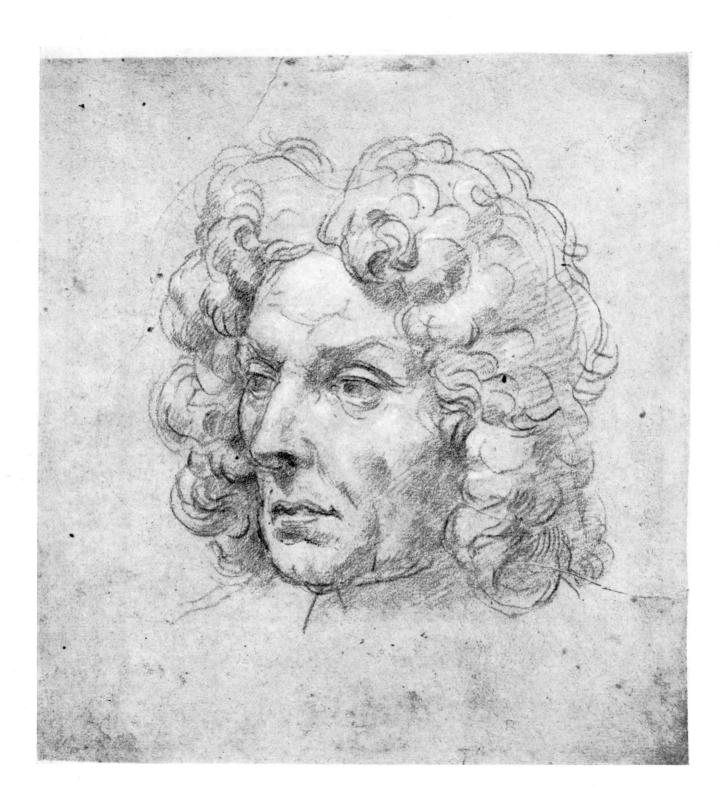

Pier Francesco Mola

Painter and etcher
Born Coldrerio, 1612; died Rome, 1666
Cat. nos. 102–12

Note on the upper edge of the sheet
(turned upside down), in pen and brown
ink: *ancora*
Bottom right, a stamp: *Status Montium*
Pen and brown ink, 144 × 193 mm.
Paint mark. The sheet is fastened down
along its left edge to the same mount as
Cat. no. 103
Inv. No. FP 11594 recto
1932 Inventory: Biblical scene. Unknown
artist
Unpublished

The subject is unidentified and it is not even clear whether the
figures belong to the same composition. In style the drawing
is closely related to Mola's design (Louvre, Inv. No. 8414,
Cocke, pl. 115) for the painting of *The Rest on the Flight into
Egypt* (Leningrad, Hermitage; Cocke, Cat. no. 12, pl. 114).
Cocke dates the painting about 1659.

On the verso: Studies in the same technique for a painting of *Hagar
and Ishmael in the Wilderness* and figure studies in red chalk. Another
design for *Hagar and Ishmael* in the Düsseldorf Print Room (Inv. No.
FP 8059, cf. Cat. Exh. *Düsseldorf 1964*, no. 113; Cocke, *Master
Drawings*, p. 26, pl. 20) was related by Cocke to the painting of the
same theme in the Galleria Colonna in Rome (Cocke, Cat. no. 42,
pl. 93). The studies on the verso of the present sheet may also have
served for this painting

Pier Francesco Mola
REBECCA AND ELIEZER AT THE WELL

Pen and brown ink, with brown wash,
92 × 145 mm.
The sheet has been trimmed irregularly
and, together with Cat. no. 102, laid down
on an old mount
Inv. No. FP 11595
1932 Inventory: Biblical scene. Unknown
artist
Unpublished

Eliezer was sent by Abraham to Abraham's native land to look
for a bride for Isaac. Eliezer rested with his camels by the well
outside the city and waited until the women came to draw
water. When Rebecca had filled her pitcher he asked her: ' "Let
me drink a little water of thy pitcher." She answered: "Drink
my lord", and she hasted and let down her pitcher upon her
hand, and gave him drink' (Genesis I, 24, 17–8).
Mola represented the subject in a painting in the Galleria
Colonna in Rome which he presumably painted for Lorenzo
Onofrio Colonna (cf. Cocke, Cat. no. 41). Judging from the
studies for Rebecca and Eliezer illustrated by Cocke (Venice,
Accademia, Inv. Nos. 747 and 744, Cocke, pls. 96–7), the
composition of the present drawing is not the same as in the
painting, which I was unable to see. Nevertheless the drawing
might have been made with the painting in mind.
Another design by Mola for a Rebecca and Eliezer at the well,
erroneously described as Rachel at the well, is in the Albertina
(Inv. No. 24980; see Knab, *I grandi disegni*, no. 80, with col. pl.)

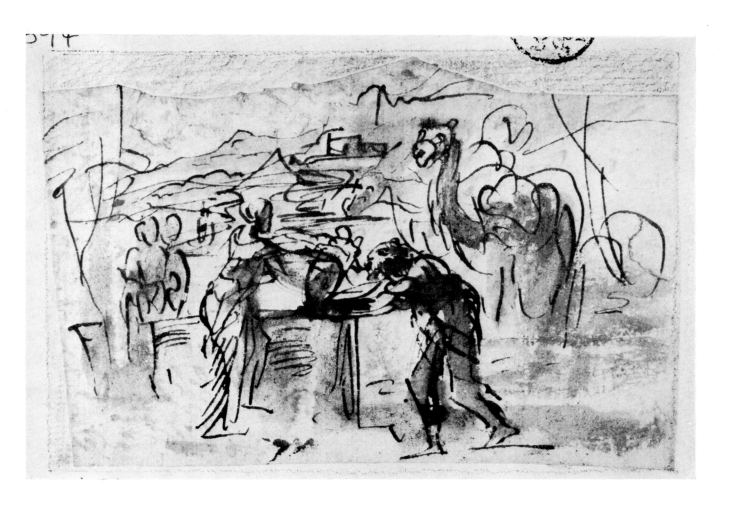

Numerals in pen and brown ink in the centre of the sheet: *111;* and in the same handwriting, bottom centre: *cento e undeci;* bottom right in another hand: *31* Bottom centre, a stamp: *Status Montium* Krahe's numerals in lead pencil on the mount: *74*
Black chalk, heightened with white, on grey-brown paper, 247 × 408 mm.
The sheet is laid down on an old mount
Inv. No. FP 797
Krahe, *Inv. II,* fol. 69 recto, No. 75: *Junon sollicitant Jupiter pour Agamemnon, 9 × 14 Pouces,* as Pier Francesco Mola *1932 Inventory:* Scene from the Odyssey. Mola
Unpublished

While Juno points out the ship of Aeneas to Aeolus, the winds which are intended to wreck Aeneas and his companions have already been let loose by Aeolus (Virgil, *Aeneid* I, 50–86). As part of a cycle representing the four elements, this scene depicts the element of Air.
In 1657–58 Pier Francesco Mola had decorated the Stanza dell'Aria in the Palazzo Pamphili in Valmontone with frescoes, but had not completed the work, so that Pope Innocent X Pamphili had the unfinished frescoes destroyed in 1659 and commissioned Mattia Preti in 1661 to repaint the room (cf. L. Montalto, 'Gli affreschi del Palazzo Pamphili in Valmontone' in *Commentari*, vol. vi, 1955, pp. 267–302).
In contrast to the designs by Mola for the Stanza dell'Aria published by Richard Cocke ('Mola's designs for the Stanza dell'Aria at Valmontone' in *Burlington Magazine*, vol. cx, 1968, pp. 558–65 and Cocke, *Master Drawings*, pp. 25–31), the present drawing is not directly connected with the preparatory work for these frescoes. As, however, the family of the Pamphili claimed descent from Aeneas, the possibility that it was made for a painting intended for the Pamphili family cannot be ruled out. It may be connected with one of the frescoes of unrecorded subjects which Mola painted in the Palace of the Pamphili at Nettuno, according to Pascoli (vol. i, p. 125), and which according to Richard Cocke (Cat. no. L.2.) have not been preserved.
The same subject was painted by Pietro da Cortona, together with other scenes from the Aeneid, in the gallery of the Pamphili palace in the Piazza Navona in Rome in 1651–54 (cf. Briganti, pp. 250–51, fig. 258).

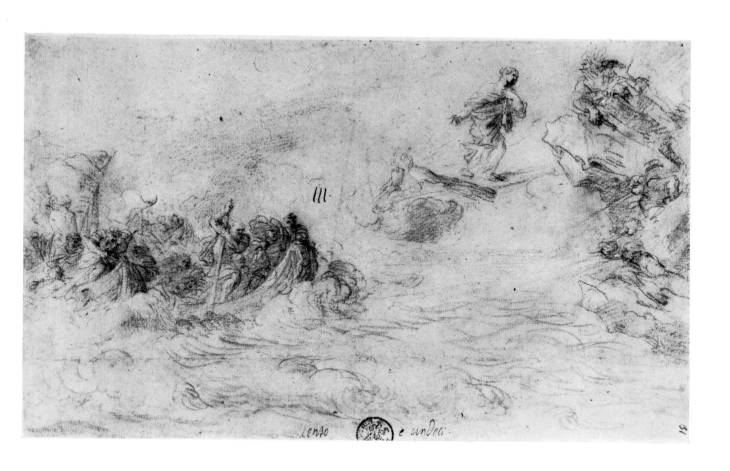

cento e undici

16

On the mount, Krahe's numerals in lead
pencil: *71*
On the border at the bottom, remnant of
a stamp: *Status Montium*
Red chalk, pen, brush and brown ink,
with wash, on pale beige paper, 246 × 172
mm.
A piece missing on the left at the top has
been restored. There are tears and smaller
missing pieces. The sheet is laid down on
an old mount
Inv. No. FP 802
Probably Krahe, *Inv. II*, fol. 69 recto no.
71: *Naissance de Bacchus, 6 × 8 Pouces*, as
Pier Francesco Mola
1932 Inventory: 'Birth of Bacchus'. Mola
Unpublished

If the assumption that this drawing represents the Massacre of
the Innocents is acceptable, it seems very typical of Mola to
present the action not, as is customary, on a stage framed by
buildings but transposed quite arbitrarily into a landscape
setting in tune with his artistic intentions.
He has not shown the massacre of the children but the mourning
of the mothers. In the foreground there are three dead children
and a woman lying bent forward in a position rather like that of
St Bruno in Cat. no. 106. Behind these there is a group of four
more women and a sixth, kneeling on the left below an antique
statue. The figure of the woman kneeling in the centre of the
sheet has been gone over by Mola with the pen to make her
pose clearer and in part to correct it: her right arm, originally
stretched out in a forward position, has been moved to the
right, and the woman seems to be holding up a dead child.
Pain, sorrow and despair are expressed in the attitude and
gestures of the women.
Like Cat. no. 106, this drawing is a splendid example of Mola's
technique with the brush, at once free yet sure. In such
drawings Mola, whose gifts were essentially painterly, is less
concerned with an exact drawing of the figures than with
planning a composition based on the interplay of light and shade.
There is no documentary evidence of a painting by Mola of
this subject nor has one so far been found.

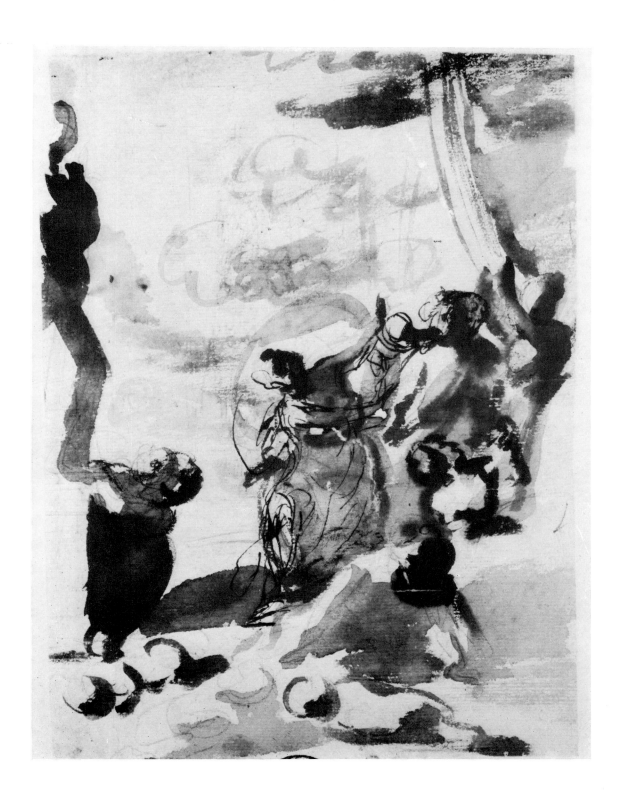

Pier Francesco Mola
STUDY FOR THE FIGURE OF ST BRUNO

Red chalk, brush and brown ink on light
beige paper, 108 × 160 mm.
The sheet is fastened down along its
upper edge on an old mount
Inv. No. FP 822
1932 Inventory: Saint. Mola
Unpublished

Study for the figure of the saint for the painting *The Vision of
St Bruno* (Rome, Incisa Collection, Cocke, Cat. no. 45, pl. 136).
Cocke refers to quite a number of other versions of this
painting, which in his opinion were partly painted by Mola's
studio assistants. In the picture in the Incisa Collection, dated
about 1663–66 by Cocke, the saint is facing to the right.
However, judging by the present study Mola had apparently
originally planned a composition facing in the opposite
direction. Another drawing that belongs to this early stage
in the planning of the picture is a design for the whole
composition in the Hessisches Landesmuseum in Darmstadt,
which is also in the opposite direction to the painting (Inv. No.
AE 1803, Cocke, pl. 133). Cocke mentions two other painted
versions of the subject which, like the present study and the
Darmstadt drawing, show the saint facing to the left (Cocke,
Cat. nos. 71 and L.67), so that the two drawings may possibly
have been made for them.

Top left in pen and brown ink, numerals:
47
Krahe's numerals in lead pencil on the
mount: *3*
Black chalk, heightened with white, on
grey-brown paper, 160 × 216 mm.
The sheet, together with Cat. no. 108, is
laid down on an old mount. Oil and size
stains
Inv. No. 952
Krahe, *Inv. II*, fol. 67 verso, No. 3: *La
Création d'Adam*, *7 × 9 Pouces*, as Pier
Francesco Mola
1932 Inventory: Creation of Adam. Mola
Unpublished

God the Father, standing on clouds, is touching Adam on the
shoulder and showing him the earth, inhabited by all sorts of
animals over which he is to have dominion. Still hesitant, as
though just roused from a deep sleep, Adam is walking in the
direction in which God is pointing.
Apart from the compositions mentioned by Pascoli (cf. Cat. no.
108) Mola may have planned and even painted other scenes from
Genesis as ceiling frescoes in the Palazzo Sonnino. In any case,
from the style of drawing, the technique and the paper this
drawing seems to belong with the one in Cat. no. 108.

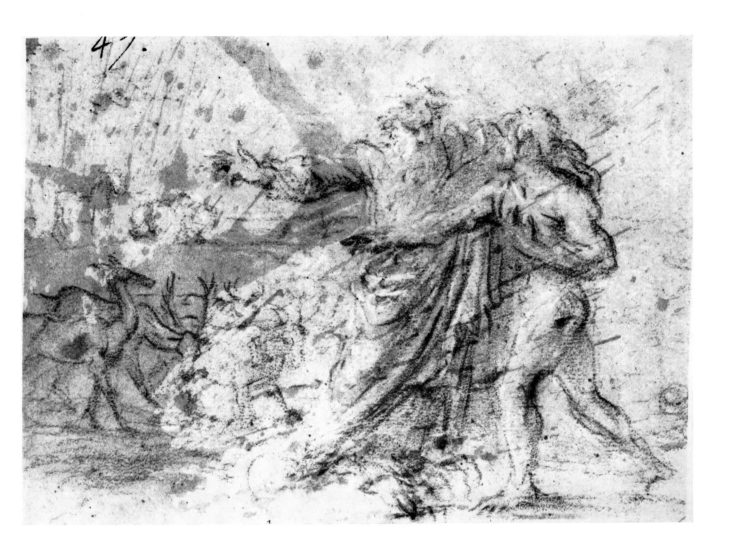

Krahe's numerals on the mount in lead pencil: *4*
Black chalk on grey-brown paper, 178 × 223 mm.
The sheet, together with Cat. no. 107, is laid down on an old mount
Inv. No. FP 951
Krahe, *Inv. II*, fol. 67 verso, No. 4: *La Création d'Eve, 7 × 9 Pouces*, as Pier Francesco Mola
1932 Inventory: Creation of Eve. Mola
Unpublished

God the Father, standing on clouds, is turning Adam and Eve out of the Garden of Eden: they kneel before him in an attitude of supplication. Pascoli (vol. i, pl. 125) mentions a ceiling painting on this theme by Mola: '*Dipinse le volte di due stanze nel palazzo del principe di Sonnino; ed effigio in una Adamo, ed Eva nell'esser discacciati dal Paradiso terrestre; e nell'altra Caino, che ammazza Abele.*' It is possible that this drawing is a design for the ceiling painting mentioned by Pascoli.

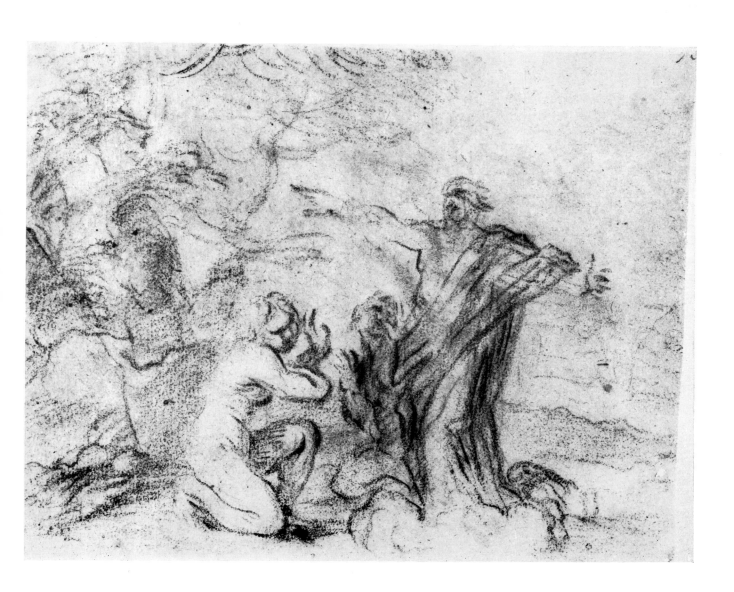

Pier Francesco Mola
LATONA TURNING THE LYCIAN PEASANTS INTO FROGS

Note in pen and dark brown ink, top
centre: *15*
Bottom centre: *quindeci*
Krahe's numerals in lead pencil on the
mount: *70*
Black chalk, heightened with white, on
blue paper, 165 × 122 mm.
The sheet is laid down on an old mount
Inv. No. FP 843
Krahe, *Inv. II*, fol. 69 recto, No. 71: *La
Fable de Latone, 6 × 4 Pouces* as Pier
Francesco Mola
1932 Inventory: Mythological scene. Mola
Unpublished

Latona, exhausted by the birth of her twins Apollo and Diana,
has come to a pond where peasants are cutting osiers, rushes
and sedge. The peasants prevent her from quenching her
burning thirst in the water of the lake. They abuse the goddess
and stir up the mud to dirty the water. As a punishment
Latona transforms the peasants into frogs (Ovid, *Metamorphoses*
vi, 314–81).
There is no written record or other evidence of a painting by
Mola on this subject. Richard Cocke lists a number of drawings
for lost paintings which he refers to only as landscapes or
without giving them a title (Cocke, L.2, L.6, L.14, L.21, L.42,
L.44, L.59). It is known that the Duke of Modena ordered his
Roman agents to obtain for him battle paintings by Rosa and
Borgognone, flower pictures by Mario de' Fiori and Cerquozzi,
landscapes by Gaspard Dughet and finally fables by Pier
Francesco Mola (cf. Haskell, p. 143). This shows that Mola
must have been known as a 'specialist' in painting scenes from
fables.

Pier Francesco Mola
ERMINIA AND VAFRINO TENDING THE WOUNDED TANCRED (?)

Top right, a note in black chalk: *fran. Mola*
Pen and brown ink, with brown wash, on blue paper, 154 × 184 mm.
Inv. No. FP 592 recto
1932 Inventory: Burial scene. Andrea Sacchi
Unpublished

The subject is taken from Tasso's *La Gerusalemme Liberata* (xix, 104–13). (Cf. Lee, 'Mola and Tasso', pp. 138–41.) Erminia is holding the wounded Tancred on her lap. Vafrino, Tancred's squire, is kneeling on the left holding a jar of ointment or a beaker.
Mola handled the subject in several other drawings now in the Berlin Print Room (*KdZ* 21027) and the Louvre (8434) (cf. Cocke, Cat. no. 55, pl. 52). The Berlin drawing, first published by Schleier ('Aggiunte a Guglielmo Cortese', p. 8, fig. 35), has on the same sheet a study for Mola's painting carried out in 1652, *St Barnabas preaching* (cf. Cocke, Cat. no. 55, pl. 55). As the present drawing is closely related in style to the Berlin study, it also may be dated in the beginning of the 1650s.
Cocke, *op. cit.*, connects the studies in Berlin and the Louvre with the preparation of a painting which evidently no longer exists. An extant picture on the subject of our drawing, acquired in 1685 for the collection of Louis XIV, and now in the M. H. de Young Memorial Museum in San Francisco, is dated by Cocke (*op. cit.*, Cat. no. 60, pl. 131) around 1662 because of its style. In this painting Vafrino is kneeling and supporting Tancred, lying wounded. Erminia is holding Tancred's right arm and is touching his wounds with tenderness and care. Vafrino is wearing a turban, as in Guercino's rendering of the subject in the Doria Gallery in Rome (cf. Lee, 'Mola and Tasso', fig. 3). In the present drawing, on the other hand, Vafrino is wearing a helmet, as in the paintings of the subject by Nicolas Poussin in Birmingham and Leningrad (cf. A. Blunt, *The paintings of Nicolas Poussin*, Cat. nos. 206–07).

On the verso: Fragment of a figure with drapery, in black chalk heightened with white

Krahe's numerals in lead pencil on the
mount: *67*
Pen and dark brown ink, with brown wash,
heightened with white, on beige, grey
tinted paper, 138 × 210 mm.
Bevelled corners. The sheet is laid down
on an old mount
Inv. No. FP 847
Krahe, *Inv. II*, fol. 69 recto No. 68: *2
feuilles Erminia chez le Pasteur, 5 × 8
Pouces*, as Pier Francesco Mola
1932 Inventory: Mythological scene. Mola
Unpublished

The subject is taken from Tasso's *La Gerusalemme Liberata*.
Erminia has watched the duel between Tancred and the
Saracen Argante from the walls of Jerusalem and now, dressed
in Clovinda's armour, is fleeing from the beleaguered city to
succour the wounded Tancred (see Cat. no. 110). On her way
she reaches the hut of a shepherd, whose children are frightened
by the sight of her in her armour. The shepherd persuades her
of the advantages of a peaceful, pastoral way of life far removed
from wars or the restlessness of court life, so that she decides
to live as a shepherdess among the shepherds (cf. Lee, 'Mola and
Tasso', pp. 137–38).
The drawing shows Erminia talking to the shepherd. The scene
takes place in an Arcadian landscape. She is listening thought-
fully to the words of the old shepherd. His children are on the
right. Frightened by the sight of the armed Erminia, yet full of
curiosity, they listen to the conversation from a safe distance.
Mola has handled the subjects of *Erminia and Vafrino tending
the wounded Tancred* and of *Erminia as a Shepherdess* in various
drawings and paintings (see Cat. no. 110 and Cocke, Cat. no.
26, pl. 27, and no. 33, pl. 123). No painting by him based on
the present drawing has so far been discovered. The technique
of the drawing is completely characteristic of Venetian art in
the *Seicento* (compare the technically rather similar drawings of
Johann Karl Loth in the Düsseldorf Print Room; cf. Cat.
Exh. *Düsseldorf 1969*, no. 190, fig. 134 and no. 191). Mola may
have become familiar with this method of accentuating painterly
values during his stay in Venice (before 1641 (?) and in 1644).
In style the sheet seems to belong to Mola's last phase. It may
be compared with his design for an undiscovered painting of
Venus and Adonis, a drawing, which like this, is handled
exactly as though it were a painting (London, Victoria and
Albert Museum, Dyce Bequest 309; cf. Cocke, *Master Drawings*,
p. 27, pl. 24).

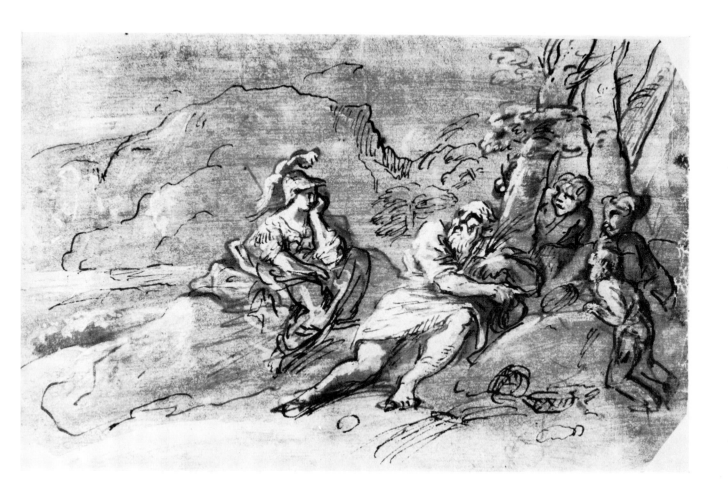

Pier Francesco Mola
CHRIST CARRYING THE CROSS

Krahe's numerals in lead pencil on the mount: *31*
Pen, brush and brown ink, with brown wash, heightened with white, on beige, grey tinted paper, 144 × 209 mm. Several small missing patches. Bevelled corners. The sheet is laid down on an old mount
Inv. No. FP 811
Krahe, *Inv. II*, fol. 68 recto, No. 32:
Jesus portant la Croix, 5 × 7 Pouces, as Pier Francesco Mola
1932 Inventory: Carrying the Cross. Mola
Unpublished

Christ is shown on the way to Golgotha bearing the heavy weight of the Cross. Near Christ is the figure of Veronica carrying a cloth with which to wipe the face of Christ. On the left are the two bound thieves accompanied by horsemen. In style and technique this is closely related to drawing Cat. no. 111. It must also date from the late period of Mola.

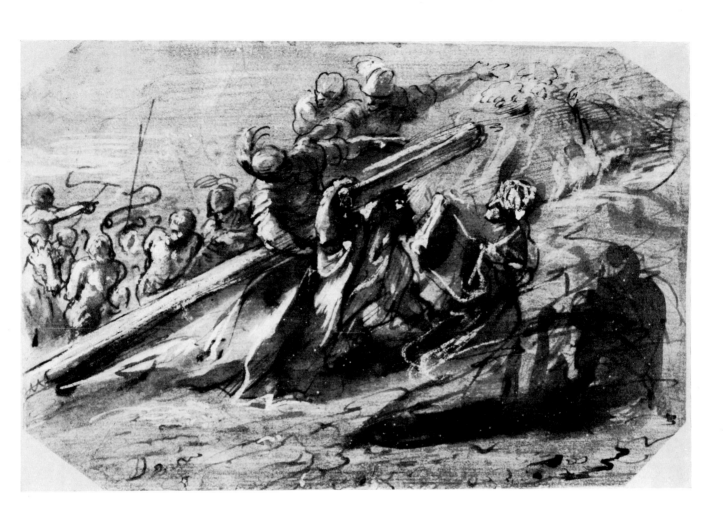

17

Giuseppe Passeri

Painter
Born Rome, 1654; died Rome, 1714
Cat. nos. 113–22

A note by Passeri in pen and brown ink along the bottom edge of the sheet has been crossed through and is illegible
Bottom centre – stamp: *Status Montium*
On the mount, Krahe's numerals in pencil: *106*
Bottom right – numerals in pen and brown ink: *u.N. 109* (crossed through); below this: *105*
Pen and brown ink on pale beige paper, 236 × 167 mm.
Oil stains. The top and bottom edges of the sheet are laid down on a white mount
Inv. No. FP 2436 recto
Krahe, *Inv. II*, fol. 39 recto, No. 106: *Même Sujet* (La Nativité du Sauveur) *varié*, *11 × 7 Pouces*
1932 Inventory: Adoration of the Shepherds. Passeri
Unpublished

Design by Passeri for the painting now in the Galleria Nazionale in the Palazzo Corsini in Rome (oil on canvas, 73·5 × 62 cm., Inv. no. 170).
Passeri's drawing is clearly a preliminary design for the painting and includes many more figures than the finished work. Whereas the figures of Mary with the Child have been transferred unaltered to the painting, the attitude of Joseph has been changed. The only figures in the right half of the painting are the shepherd kneeling in the foreground (see Cat. no. 115) and the couple standing behind him (see Cat. no. 114).
The shepherds shown entering from the right in the background in the drawing, and the other shepherds on the left looking over Joseph's shoulder into the stable, as well as the figures standing behind Mary, are omitted in the painting and may have been drawn by Passeri simply as alternative solutions. A second design for the painting is in the Gobiet Collection, Seeham-Johanneshaus.
Another drawing of the same subject, also unpublished, (Inv. No. FP 2434), may be an alternative design for the same painting, because it shows a different scheme of architecture for the stable which corresponds more closely with the picture. A drawing of the same subject in the Biblioteca Communale in Siena (Inv. Nr. S.III.3, C.21) attributed to Sebastiano Folli (1568–1621) by Renato Roli (*I disegni italiani del seicento*, Treviso, 1969, p. 54, fig. 69) also seems to me to be by or after Passeri, the composition being very similar to that of the Düsseldorf design Inv. No. FP 2434. A drawing by Passeri of the same subject in the National Gallery of Scotland in Edinburgh (Inv. No. D 3015 recto, cf. K. Andrews, *Catalogue of Italian drawings*, National Gallery of Scotland, Cambridge, 1968, vol. i, p. 90, vol. ii, fig. 628), which is in the same technique and of roughly similar proportions, may be another alternative design for the painting.
The painting is not on view in the Palazzo Corsini. I am very grateful to Professor Italo Faldi for kindly letting me see it.

On the verso: A list of various commissions in Passeri's hand

On the recto, bottom right, numerals in
pen and brown ink: *10*
Red chalk, heightened with white, on
greenish-brown paper, 422 × 551 mm.
Inv. No. FP 13752 verso
1932 Inventory: Studies. Unknown
Unpublished

Studies for Passeri's painting *The Adoration of the Shepherds* in
the Galleria Nazionale, Palazzo Corsini, Rome. Cat. no. 113 is
Passeri's design for the whole composition. In the left half of
the sheet before us there is a full-length study for the
shepherdess, who both in the design (see Cat. no. 113) and in the
painting stands on the right behind the kneeling shepherd. To
the right is a study of her head. Below are two studies of one of
the two angels who hover over the Madonna in the painting.
In the right half of the sheet, at the bottom, there is a study of
the Madonna, who holds the Infant Christ with her left hand
and with her right lifts the cloth that covers Him. Three other
studies are of Mary's robe, over her left arm. On the right, high
up, at right angles, a study for a shepherdess leaning on a staff.
The study is probably related to one of the two figures (the one
on the left) who, though omitted from the painting, are shown
standing between Mary and Joseph in the design for the
composition.

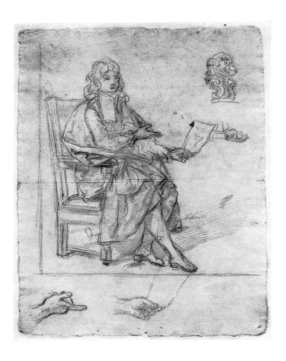

On the recto: Study for a portrait of a seated man

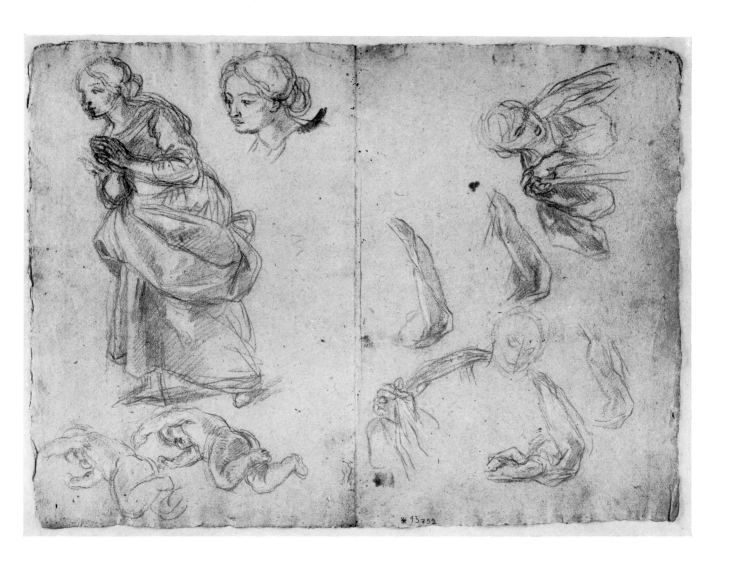

Bottom right – numerals in pen and
brown ink: *356*
Red chalk, heightened with white, on
grey-green paper, 425 × 280 mm.
Inv. No. FP 12740 recto
1932 Inventory: Studies. Unknown
Unpublished

Studies for the shepherd kneeling in the foreground on the
right in the *Adoration of the Shepherds* shown in Cat. no. 113.
The shepherd is shown full-length in the centre of the sheet,
and the lower part of the figure is studied again below. In the
lower half of the sheet on the right there are studies of his left
hand holding the staff. Top left there is a study of his left leg,
and underneath one of his right knee.

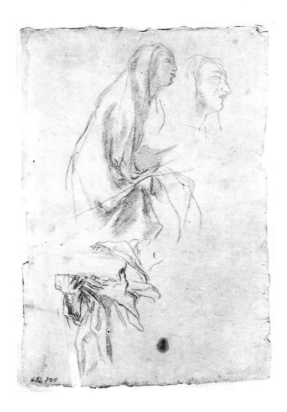

On the verso: Figure studies in the same technique

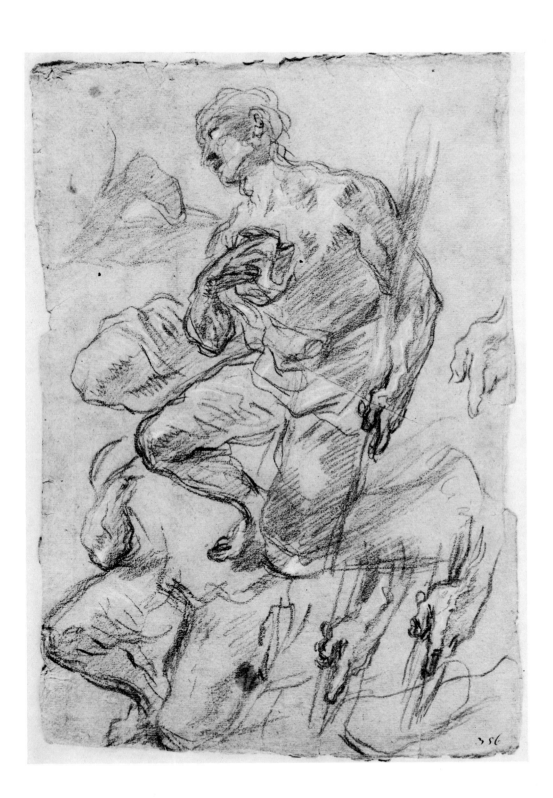

Numerals in pen and brown ink –
bottom right: *95*
Red chalk, heightened with white, on
grey-green paper, 410 × 268 mm.
Small paint marks and oil stains
Inv. No. FP 14071 recto
1932 Inventory: Studies. Unknown
Unpublished

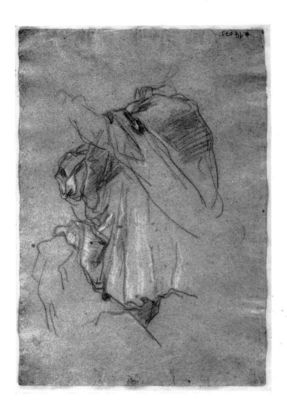

Studies for the angel playing the violin in Passeri's painting
The Ecstasy of the Blessed Giacinta Marescotti in the Collegiata
of Vignanello, the birthplace of the saint near Viterbo. In the
picture, which according to Eckhart Knab (*I grandi disegni*,
p. 77) was probably painted in the last years of Passeri's life,
the saint is shown lying back on her couch with outstretched
arms, experiencing a vision. Divine light is streaming into her
chamber from above and angels appear on clouds, singing and
playing music. The present studies relate to the angel nearest
her and were probably drawn from a model. To the right
of the study of the full-length figure there are more drawings
of a violin, the head of a violin and the left hand of the angel.
In the bottom part of the sheet there are studies of an arm and
hand with a violin bow and of the angel's head. The white
heightening in the studies corresponds with the areas of light
in the painting. The painting was engraved by Jacob Frey in
1726, the year of the saint's beatification (impression in the
Düsseldorf Print Room Inv. No. FP 5991 D). The Albertina in
Vienna has a detailed design for the composition (Inv. No.
R 796, cf. Knab, *op. cit.*, fig. 43), from which, however,
Passeri has deviated at many points in his painting.
Besides the study for the figure of St Giacinta published by
Eckhard Schaar (Cat. Exh. *Düsseldorf 1969*, no. 97, fig. 84), the
Düsseldorf Print Room possesses several other studies for this
picture: Inv. Nos. FP 12993 recto and FP 13310 recto show
studies for St Giacinta. Inv. No. FP 12993 verso includes a
drapery study for the angel shown playing a violin on this sheet
as well as studies of hands for another angel in the same painting.

On the verso: Figure studies in the same technique

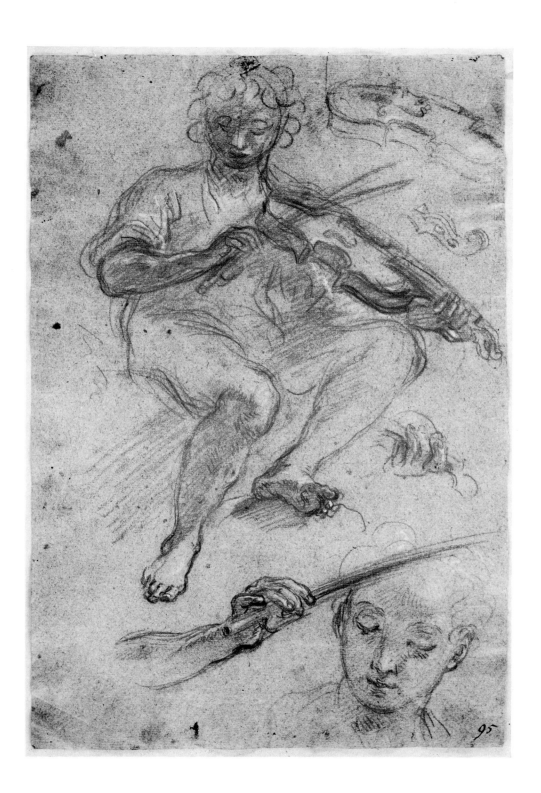

95

On the old mount, bottom centre, a stamp:
Status Montium; and Krahe's numerals
in pencil: *25;* bottom right, numerals in
pen and brown ink: *u.N.25;* and near that
in pencil: *26*
On the back of the mount an old note in
pencil: *passeri*
Red chalk, pen and brown ink, with grey
wash, heightened with white, on beige
paper, 320 × 207 mm.
Inv. No. FP 2311
Krahe, *Inv. II*, fol. 37 recto, No. 25: *Le
même Sujet* (la Descente de Croix) *en
Demi-Lune, 12 × 8 Pouces,* as
Giuseppe Passeri
1932 Inventory: Pietà. Passeri
Unpublished

A fully worked out design for an altarpiece which has not yet
been identified.

Passeri handles the subject of Mary mourning over her dead
Son in several drawings: another sheet in the Düsseldorf
Kunstmuseum (Inv. No. FP 2463) shows Mary with the dead
Christ and the three Maries in the sepulchre. A drawing of the
same subject in the Albertina shows Mary alone with Christ
and a mourning putto (Inv. No. 1131, cf. *Katalog der
Handzeichnungen der Albertina*, vol. iii, no. 788 with ill.). In
a third drawing at Windsor St John, two kneeling angels and a
putto are shown mourning with Mary (Inv. No. 278, cf. Cat.
Roman drawings, no. 571: 'The Painting (Rome, S. Francesco
a Ripa) differs in many details from the drawing, which is,
however, probably a preliminary sketch for it'). It is possible
that the drawing in Düsseldorf mentioned above (Inv. No. FP
2463) is also a study for the same painting, which hangs above
the main entrance of the church. The pose of the dead Christ is
inspired by Annibale Carracci's *Pietà* (Naples, Pinacoteca
Nazionale, repr. D. Posner, *Annibale Carracci*, London, vol. ii,
1971, fig. 119a). See Cat. no. 118, for a detailed study of
the figure of the dead Christ in this design, which is repeated in
an almost identical attitude in the drawings in Windsor and
Vienna.

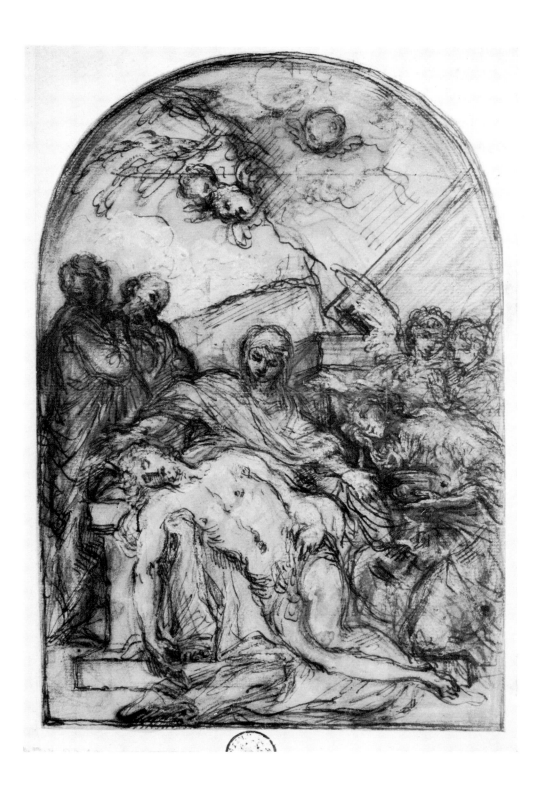

Giuseppe Passeri
STUDIES OF A FIGURE OF THE DEAD CHRIST

Bottom right – numerals in pen and
brown ink: *25*
Red chalk, heightened with white, on
grey-green paper, 268 × 411 mm.
Inv. No. FP 12746 recto
1932 Inventory: Studies. Unknown
Unpublished

Studies for the figure of the dead Christ in Passeri's design for
a Pietà shown in Cat. no. 117. The studies in the centre of the
sheet relate to the face, the upper part of the body and the
arms.
Below these, but placed a little further to the left, there is a
study of the legs and right foot. On the right, a study of
drapery, on the left a sketch of Christ's head.

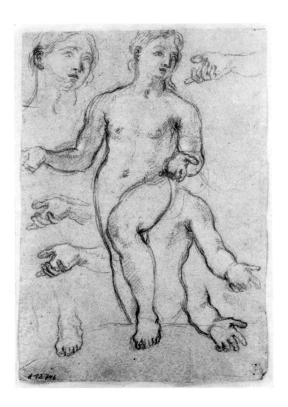

On the verso: Studies in the same technique of a standing figure of a
woman

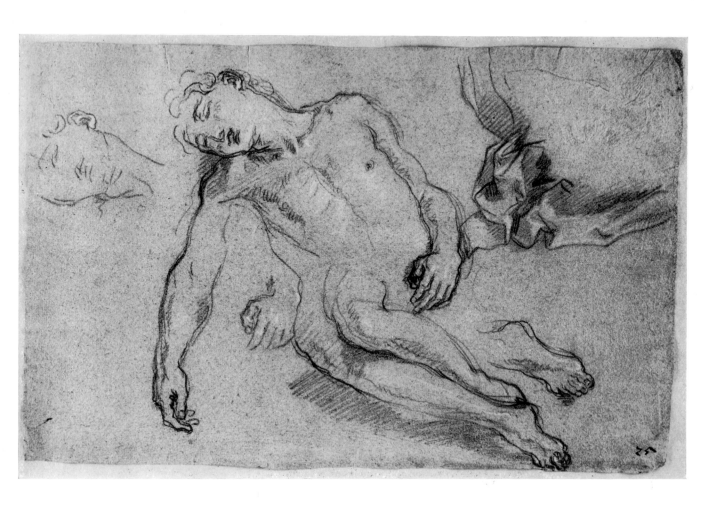

In the top righthand corner in pen and brown ink, an illegible note
On the mount, beneath the drawing, in pen and brown ink: *Giuseppe Passeri*
Bottom left – a stamp: *Status Montium*
On the old mount, bottom centre, Krahe's numerals in pencil: *124*
Other numerals in pen and brown ink: *73;* and: *U.N.126* (crossed out); below this: *124*
Pen and brown ink on pale beige paper, squared in red chalk, 245 × 186 mm.
The sheet has been laid down on a thin white mount and pasted on to an old passepartout
Inv. No. FP 2319
Krahe, *Inv. II*, fol. 39 verso, No. 125: Parail Sujet (*L'Asomption de la Ste. Vierge*) *varié dans la Composition, 9 × 7 Pouces,* as Giuseppe Passeri
1932 Inventory: Saint in the clouds Passeri
Unpublished

The scene described by Krahe as an Assumption of the Virgin represents the ascension of St Lawrence. Clearly this hastily drawn sketch of Passeri's is a *prima idea* for the ceiling fresco in the choir of the cathedral in Viterbo. There the central picture, the apotheosis of the saint, is surrounded by representations of the four cardinal virtues, which appear as though enthroned between caryatid figures in the open sky. Between each of them there is an oval framed picture, supported by *ignudi*, containing figurative scenes in grisaille.
Passeri's design shows the saint in the attitude in which he is painted in the finished fresco. His right arm has been drawn in two different positions. The arm used in the painting is the one extended sideways, not the raised one. The angels bearing up the kneeling saint had their poses and their grouping altered considerably in the finished version. Moreover, an angel sweeping down with the palm of martyrdom appears in the fresco in the place of the putti sketched among the clouds high up on the left.
Waterhouse (p. 86) has identified the arms painted below the ascension of the saint as those of Bishop Sacchetti, who was Bishop of Viterbo 1683–99, which provides a rough date for this sketch.
Passeri's design for a ceiling picture representing the ascension of St Nicholas of Bari (London, Victoria and Albert Museum, Museum No. 7014) shows St Nicholas in almost the same position as St Lawrence in the present sheet. As Christel and Gunther Thiem kindly informed me, there is another design by Passeri for a ceiling design showing the ascension of a male saint in the Stuttgart Print Room (Inv. No. C. 1922/61). Although the composition is very close to the fresco in Viterbo, the shape of the drawing is different and the saint does not appear to be St Lawrence. So this design may be connected with another project, subsequently destroyed or not yet discovered.
For Passeri's design for the ceiling fresco in the apse of the cathedral in Viterbo, see Cat. no. 120.

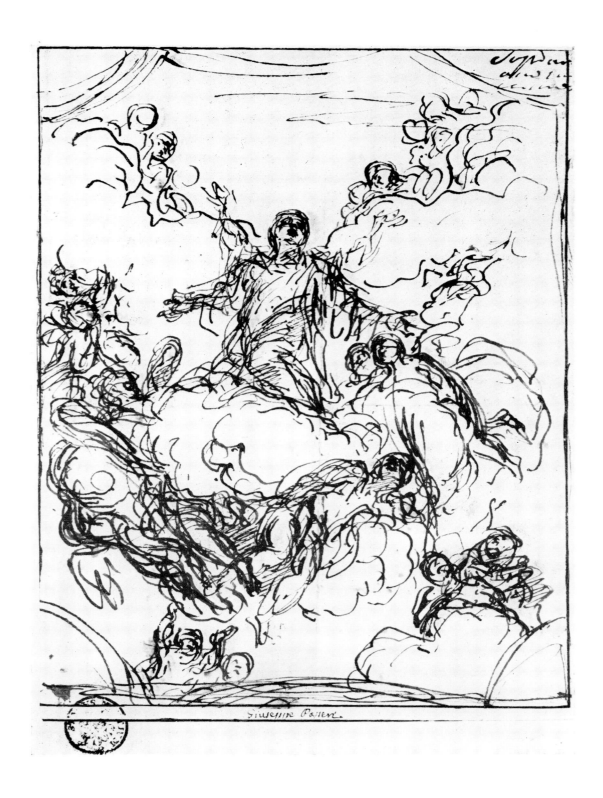

Krahe's numerals in pencil on the mount:
31
Pen and brush in brown ink, over red
chalk, with brownish, grey and reddish
wash, heightened with white, on pale
beige paper, washed in red and brown
Squared in red chalk, 250 × 430 mm.
Laid down on an old mount
Inv. No. FP 2304
Krahe, *Inv. II*, fol. 37 recto, No. 31: *Une
Gloire céleste. Plafond oval, 10 × 16
Pouces*, as Giuseppe Passeri
1932 Inventory: Saints in heaven. Passeri
Bibliography: Cat. Budde, p. 52, no. 393,
pl. 58. Illa Budde includes the sheet in
her catalogue but without relating it to
the relevant painting.

Design by Passeri for the ceiling fresco in the apse of Viterbo
cathedral. Christ is enthroned on clouds, giving His blessing
and surrounded by angels. To the right, above a group of saints,
sits Mary, pointing to St Lawrence, the titular saint of the
church, who is leading the group of saints on the left. In this
design Passeri has already found the forms finally used in
painting the figures of Christ, Mary, St Catherine and St
Lawrence. However, St Lawrence, who is wearing armour in
the drawing, wears liturgical vestments in the painting. The
saints beside Lawrence and Catherine were considerably altered
when the painting was carried out.
Passeri's design is drawn in a very elaborate, yet characteristic
style, which gives the drawing a painterly look. He clearly used
this technique when his drawings for a composition had
reached a final stage (cf. Cat. no. 117). On the other hand he
usually drew preliminary sketches with the pen (see Cat. nos.
113 and 119) and then made individual studies of the figures
from a model, using chalk.
For the dates and iconographic details of the other ceiling
frescoes by Passeri in the choir of the cathedral in Viterbo, see
Cat. no. 119.

On the back of the sheet, bottom right, numerals in pen and brown ink: *235*
Red chalk, heightened with white, on greenish-brown paper, 426 × 287 mm.
Inv. No. FP 13405 recto
1932 Inventory: Studies. Unknown
Unpublished

Studies for the figure of Moses in Passeri's painting *Moses breaking the Tables of the Law*. The painting hangs above the third arch on the right wall of the nave in S. Maria in Vallicella in Rome. The painting on the opposite wall of the nave, *The Handing over of the Keys to St. Peter*, was also painted by Passeri. These pictures belong to a series in which scenes from the Old and New Testaments, related typologically, were placed opposite each other. The cycle, which originated in the Holy Year 1700, was painted by other artists besides Passeri, amongst others Lazzaro Baldi, Giuseppe Ghezzi and Daniel Seiter (cf. Waterhouse under the names of the artists mentioned).
The studies on the sheet before us were made from a youthful model to define the attitude in which Moses was to appear in the painting. In the full-length study the shirt over the shoulder and left arm was particularly carefully observed, as it was to be transferred unaltered to the painting. The parts below the hips were less carefully drawn, because in the painting they would be covered by Moses's cloak (see Cat. no. 122). As, however, Moses appears in the painting with bare feet, these have been drawn by Passeri on this sheet several times in great detail.

On the verso: Studies in the same technique of a warrior, who stands to the left of Moses in the painting

Giuseppe Passeri
STUDIES FOR THE PAINTING 'MOSES BREAKING THE TABLES OF THE LAW'

On the back of the sheet, bottom right, in
pen and brown ink, numerals: *236*
Red chalk, heightened with white, on
grey-green paper. The study of the head,
bottom left, in black chalk heightened
with white, 285 × 424 mm.
Water stains
Inv. No. FP 12575 recto
1932 Inventory: Studies. Unknown
Unpublished

For the painting see Cat. no. 121.
Two studies for the figure of Moses are drawn next to each
other. Whereas Cat. no. 121 shows the whole figure drawn
from a model, in this drawing the hang of the drapery over the
hips and legs is the subject of the study. Along the right and
left edges of the sheet, at right angles, studies of the face and
helmet of the warrior who stands on Moses's left in the picture.
The study of a raised arm, at the bottom of the sheet, relates to
the man who is worshipping the Golden Calf, kneeling behind
Moses to the right.
The studies on this sheet and in Cat. no. 121 are perfect
examples of the way in which the artists of the seventeenth
century worked out the figures in their paintings by making
separate studies of models in the nude and of draperies.
Another sheet in the Düsseldorf Print Room (Inv. No. FP
13285) has on its recto studies for the figure of Aaron in the
same painting.

On the verso: Figure studies in the same technique

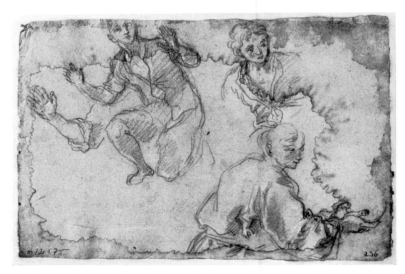

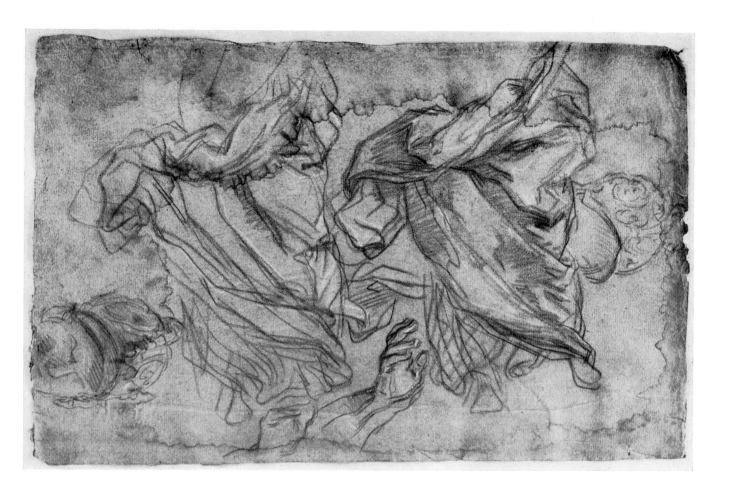

Andrea Sacchi

Painter
Born Nettuno, 1599; died Rome, 1661
Cat. nos. 123–40

Numerals in pen and brown ink, top
right: *45*
Bottom right: *49*
Bottom centre, a stamp: *Status Montium*
On the mount, Krahe's numerals in lead
pencil: *19*
Black chalk, heightened with white, on
grey-green paper, 403 × 263 mm.
The sheet is laid down on an old mount
Inv. No. FP 564
Krahe, *Inv. II*, fol. 28 recto, No. 19:
Une (pièce) *paraille où se trouve St
Isidore, 15 × 10 Pouces*, as Andrea Sacchi
1932 Inventory: Adoration of the
Madonna. Andrea Sacchi
Bibliography: Cat. Budde, no. 63, pl. 13;
Cat. Exh. *Düsseldorf 1964*, no. 139; *KSM*,
no. 1, pl. 3; Cat. Exh. *Düsseldorf 1969*,
no. 50, fig. 56; A. Sutherland Harris,
Andrea Sacchi (to be published soon),
Cat. no. 6

A fully worked out design for the composition of Sacchi's altarpiece painted in 1622–23 for the Roman church S. Isidoro (Posse, pp. 21–2, pl. viii). It is the earliest known drawing by Sacchi and the only one which has been related to the painting. The pose of the saint and the Madonna have only been slightly altered in the painting. What makes a big difference to the effectiveness of the composition as a whole – as Ann Sutherland Harris has pointed out – is that the angels surrounding Mary in the design have been omitted from the painting, with the result that the two central figures stand out more strongly.

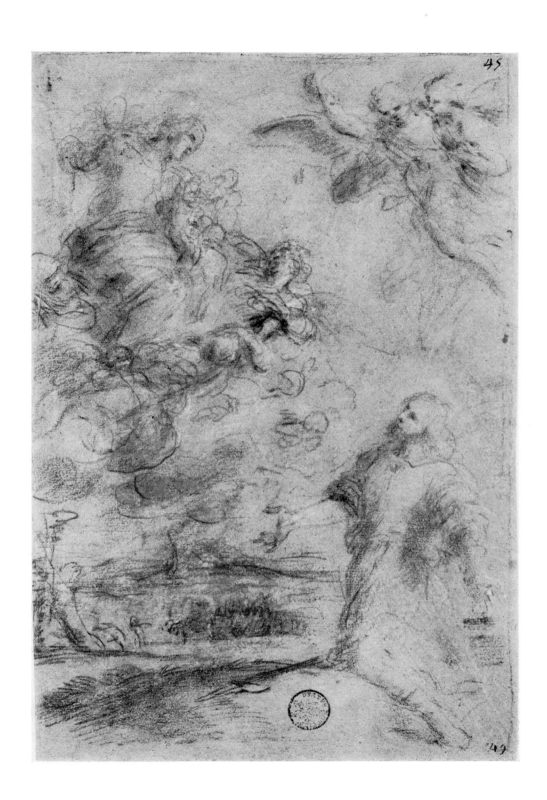

Top right, numerals in pen and brown
ink: *10*
Bottom right, a stamp: *Status Montium*
On the verso of the mount, a note in lead
pencil: *And. Sachi*
Black chalk, heightened with white, on
grey-yellow, formerly grey-green paper,
382 × 246 mm.
Oil and water stains. The sheet is laid
down on an old mount
Inv. No. FP 14118
1932 Inventory: Studies. A. Sacchi
Bibliography: *KSM*, no. 4; A.
Sutherland Harris, *Andrea Sacchi* (to be
published soon), Cat. no. 14

Study for the figure of Joachim in Sacchi's painting *The Birth of St John the Baptist* (Madrid, Prado; Posse, pl. xv). Posse dated the painting in the 1640s because of its compositional relationship to Sacchi's painting of the same subject in S. Giovanni in Fonte in Rome. As Ann Sutherland Harris demonstrates, however, the style of the studies for the painting in the Prado suggests it should be dated nearer the end of the 1620s.

The figure of Joachim is already conceived in the same attitude as that shown in the painting. For further studies in Berlin and Düsseldorf for the painting, see *KSM*, nos. 3, 5–8.

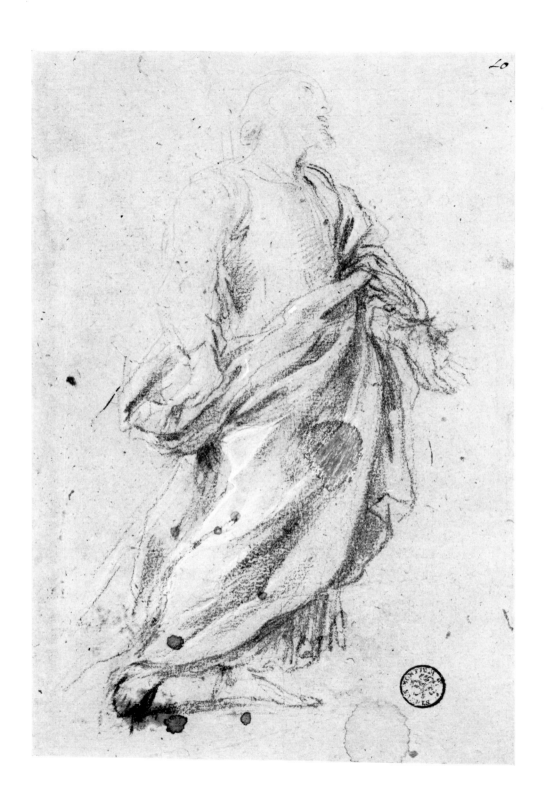

Bottom left, in pen a letter in dark brown: *F*
On the mount, Krahe's numerals in lead pencil: *87*
Red chalk over traces of lead on pale beige paper, 174 × 190 mm.
The sheet is laid down on an old mount
Inv. No. FP 526
Krahe, *Inv. II*, fol. 30 recto, No. 87: *J. Christ confie a St Pierre le soin de ses ouailles, 11 × 8 Pouces*, as Andrea Sacchi
1932 Inventory: Scene from the New Testament. Andrea Sacchi
Bibliography: *KSM*, no. 9, pl. 8; P. Dreyer, Review of *KSM*, pp. 171–72; Cat. Exh. *Düsseldorf 1969*, no. 51, pl. 51; A. Sutherland Harris, *Andrea Sacchi* (to be published soon), Cat. no. 15.

Bellori (p. 67) describes a *modello* in the Palazzo Barberini made by Sacchi for a painting of the scene intended for St Peter's, but never completed. Posse (p. 109) cites a *bozzetto* attributed to the artist in an undated Barberini inventory, which may be identical with the one mentioned by Bellori: '*Altro 1.p.5. a p.3 tondo da capo rapresentante Cristo che costituisse S. Pietro Pastore, con altri Apostoli, bozzetto.*' The payments which Sacchi received on 15 July and 9 September 1628, '*a bon conto della pittura che deve fare in S. Pietro per un sopraporto*' (Pollak, vol. ii, p. 89) were connected with this commission by Ann Sutherland Harris.
The design on this sheet shows Christ surrounded by Apostles. Peter kneels at his feet. A more detailed study for the picture (Florence, Uffizi, Inv. No. 9517 S, *KSM*, fig. 1) throws light on the hastily drawn sketches in the left-hand part of our study: to the left in the foreground some sheep are indicated, behind them some fishermen are pulling in their nets. Along the bottom edge of the sheet the top of a door frame has been sketched in to indicate the place where the painting was to be placed in St Peter's. As Ann Sutherland Harris has pointed out, it was to be placed in the niche in the crossing where the tomb of Clement X now is.
For Sacchi's individual studies for the painting see *KSM*, nos. 10–7. *KSM*, nos. 107 and 109 are copies of the whole composition. *KSM* no. 108 is a copy of a lost study by Sacchi for the figure of Christ. See also Cat. no. 126.

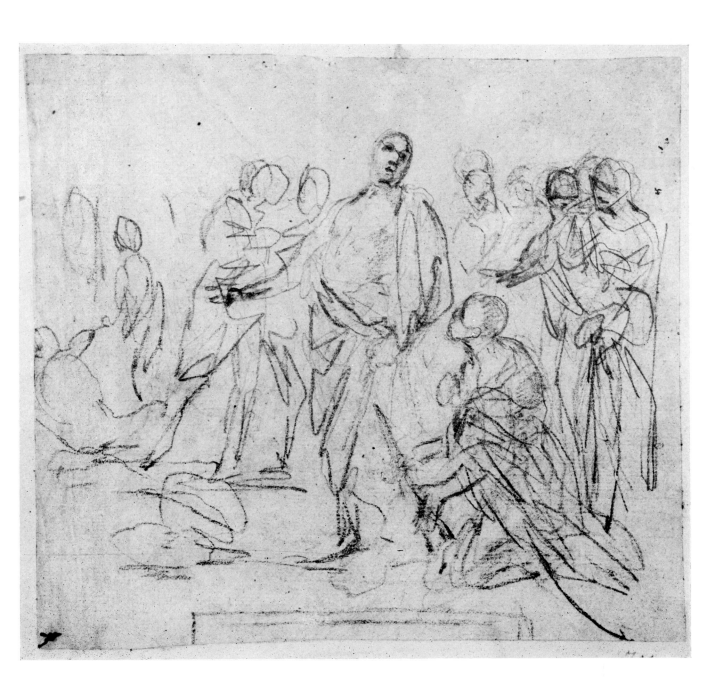

Bottom left, a note in black chalk: *Andrea Sachi*
Bottom centre, a stamp: *Status Montium*
Black chalk, heightened with white, on greenish paper, 290 × 207 mm.
Water and oil stains. The sheet is fastened down on an old mount at its corners
Inv. No. FP 14096
1932 Inventory: Figure study. A. Sacchi.
Bibliography: *KSM*, no. 11, pl. 6;
A. Sutherland Harris, *Andrea Sacchi* (to be published soon), Cat. no. 15

Study for the figure of Christ in the painting *Pasce Oves Mea* planned by Sacchi. The drawing shows Christ in the same attitude as in the design of the whole composition Cat. no. 125. In this study Sacchi was primarily interested in the drapery of the cloak. Head, hands and feet, on the other hand, have only been sketched in very summarily. In spite of the *pentimenti* the drawing is very light and elegant. For the origin of the painting and other studies for it, see Cat. no. 125.

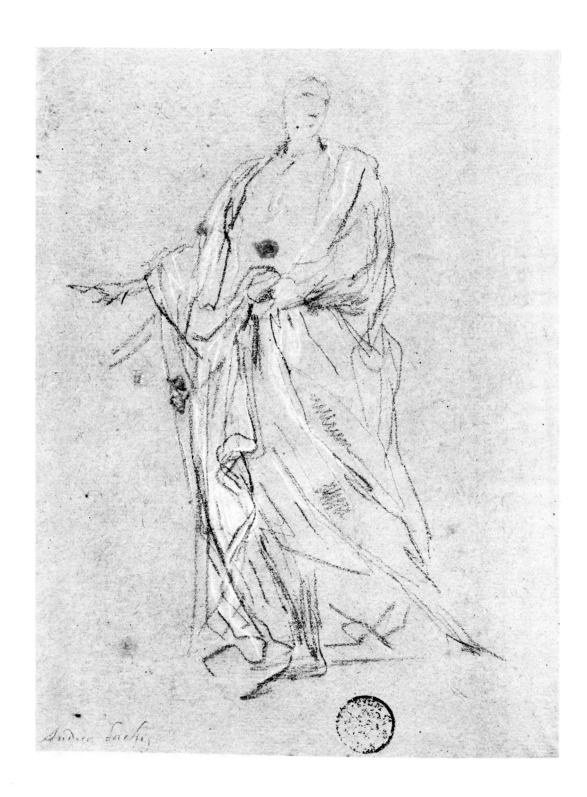

Andrea Sacchi

19

On the verso, a note in lead pencil: *4 flor(in)* and *And Sachi;* numerals in pen and brown ink: *92* and a stamp: *Status Montium*
Black and white chalk on grey-brown paper, 378 × 255 mm.
Oil and water stains. The sheet is fastened down on an old mount along its lower edge
Inv. No. FP 13226 recto
1932 Inventory: Studies. A. Sacchi
Bibliography: *KSM*, no. 18, pl. 1; Cat. Exh. *Düsseldorf 1969*, no. 52, fig. 53; A. Sutherland Harris, *Andrea Sacchi* (to be published soon) Cat. no. 17

Study for the figure of Divine Wisdom in Andrea Sacchi's ceiling fresco in the Sala del Mappamondo in the Palazzo Barberini in Rome.
As Posse (pp. 37–47) demonstrates, the composition is based on the subject of the Biblical *Liber Sapientiae*. In the centre of the fresco the personification of *Divine Wisdom* is seated on a throne flanked by lions, above the globe, in a wide expanse of heaven. Eleven female figures, recognizable by their attributes, surround her as the personifications of their special qualities. (Cf. Y. Bonnefoy, *Rome 1630. L'horizon du premier baroque*, Paris, 1970, figs. 80–2). The ceiling fresco was begun by Sacchi in the late spring of 1629 and was probably finished by 1631, as Ann Sutherland Harris has shown. The Cooper Union Museum, New York (Inv. No. 1901–39. 1714; cf. W. Vitzthum in *Burlington Magazine*, vol. ci, 1959, p. 466) has an earlier design. The drawing before us shows Divine Wisdom seated on a throne turned slightly to the right and looking up in the opposite direction towards that point where, in the fresco, a youth rides by on a lion, holding a javelin with which to set the hearts of men on fire. The crown on her head, the sun on her breast and the mirror in her right hand are already adumbrated here as they appear in the fresco. In the fresco she has a sceptre in her outstretched left hand and her cloak, falling over her lap to the left, covers her legs, which are uncovered in the drawings.
For other studies in the Düsseldorf Print Room for this fresco, see *KSM*, nos. 19–23 and Cat. nos. 128 and 129.

On the verso: Two studies in the same technique for the upper part of the body and the drapery of *Divine Wisdom*

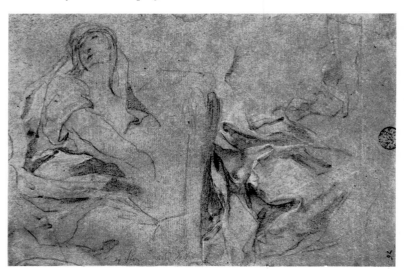

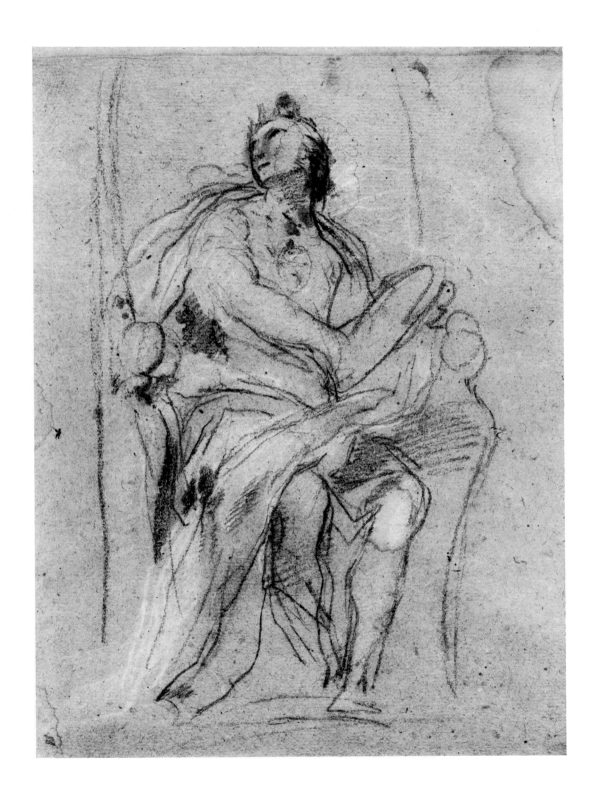

Top right, numerals in pen and brown ink: *30*
Below this, a stamp: *Status Montium*
Bottom left, a note in lead pencil: *3 florin*
On the verso of the mount, an impression of Cat. no. 131 and a note in lead pencil: *And. Sacchi*
Black chalk heightened with white, on grey-green, formerly blue-green paper, 385 × 248 mm.
The study of the hand in the bottom right corner is in red chalk
The sheet is laid down on an old mount
Inv. No. FP 13858
1932 Inventory: Figure study. A. Sacchi
Bibliography: *KSM*, no. 23; Cat. Exh. *Düsseldorf 1969*, no. 53; A. Sutherland Harris, *Andrea Sacchi* (to be published soon), Cat. no. 17

Studies for the personification of Sanctity in Andrea Sacchi's ceiling fresco of the allegory of Divine Wisdom (see Cat. no. 127). Below the study of the whole figure is a separate study of her right hand, and, top right, another of her head. In the fresco this allegorical figure is seated to the left of *Divine Wisdom* on the pedestal at her feet. She is shown there rather more in profile and is wearing a transparent veil which is not shown here. She is carrying in her hands – as can be recognized in the drawing – a crucifix and a vessel from which flames are rising. The drapery across her lower right leg, drawn carefully in this study, is hidden in the fresco by one of the two golden lions flanking the throne of *Divine Wisdom*. For other studies for the fresco, see Cat. nos. 127 and 129.

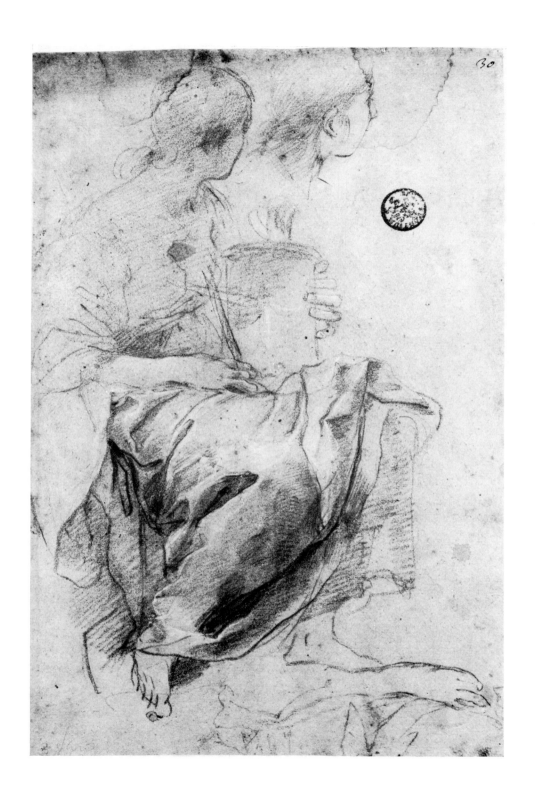

Top right, numerals in pen and brown ink: *50*

Bottom right, a note in lead pencil: *4 flor(in)*

Bottom centre, a stamp: *Status Montium*

On the verso of the mount, a note in lead pencil: *And Sacho*

Black chalk, heightened with white, on blue-greenish paper, 378 × 246 mm.

Paint marks. The sheet is laid down on an old mount

Inv. No. FP 14103

1932 Inventory: Figure study. A. Sacchi

Bibliography: *KSM*, no. 22, pl. 12;

A. Sutherland Harris, *Andrea Sacchi* (to be published soon), Cat. no. 17

Study for the personification of the Divine Spirit in Andrea Sacchi's ceiling fresco of the allegory of Divine Wisdom (see Cat. no. 127). Below the study for the whole figure Sacchi has drawn part of the robe over the knees a second time. In the fresco the allegorical female figure is seated on clouds to the right of *Divine Wisdom*. There she is wearing her hair falling down quite loose and is holding a triangle, which is barely apparent in the drawing, as a symbol of the Holy Trinity.

For further studies for the fresco, see Cat. nos. 127 and 128.

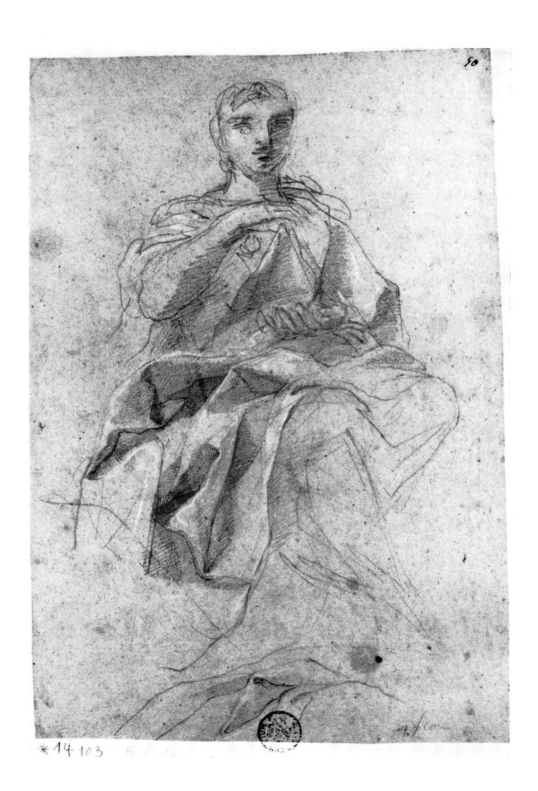

Note in lead pencil, bottom left: *3 flor(in)*
Numerals in pen and brown ink, bottom right (at right angles): *26*
Top left, a stamp: *Status Montium*
On the verso of the mount a note in lead pencil: *And: Sachi* and stamp *FP*
Black chalk and traces of white heightening on grey-green paper, 239 × 354 mm. Small paint marks and oil stains. The sheet is laid down on an old mount
Inv. No. FP 12913
1932 Inventory: Studies. Andrea Sacchi
Bibliography: *KSM*, no. 28, pl. 10; A. Sutherland Harris, *Andrea Sacchi* (to be published soon), Cat. no. 20

Top left, drapery study for figure of St Romuald. Four studies of his left hand. Below these, three studies for the head of the monk who in the painting is sitting on the left listening to the saint recounting his vision of a ladder to Heaven.

The painting, now in the Pinacoteca Vaticana (repr. Voss, p. 236) was painted in 1631–32 for the high altar of the Roman church S. Romualdo, which had recently been built in Rome for the Camaldolite Order. Ann Sutherland Harris considers that the delicacy of the drawing suggests that the painting was made in the early 1630s (*KSM*, p. 33).

The Düsseldorf Print Room has two other studies for the painting (*KSM*, nos. 29–30). There is a study for the figure of St Romuald at Windsor (Inv. No. 4931 verso, Cat. *Roman drawings*, no. 764). Ann Sutherland Harris was able to identify a study for the monk's head in Besançon (Musée des Beaux Arti, Inv. No. D 3037).

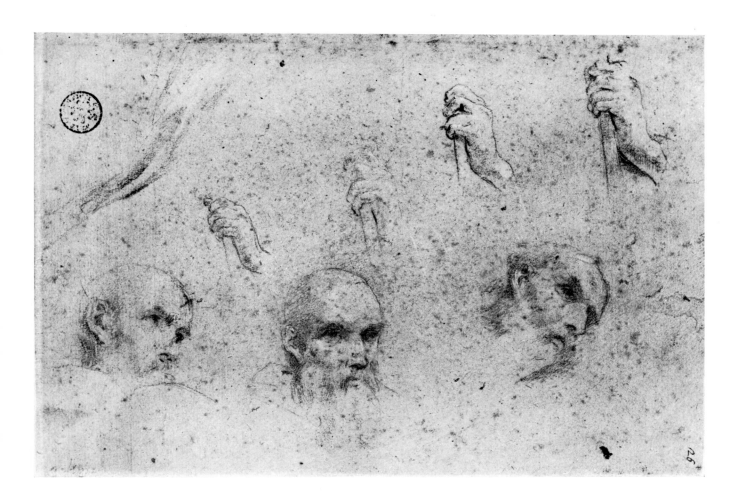

Bottom centre, a stamp: *Status Montium*
On the back of the mount a note in lead
pencil: *And. Sacchi*
Red chalk, heightened with white, on
greenish paper, 267 × 191 mm.
The sheet is laid down on an old mount
Inv. No. FP 14095
1932 Inventory: Figure study. A. Sacchi
Bibliography: *KSM*, no. 27;
A. Sutherland Harris, *Andrea Sacchi* (to
be published soon), Cat. no. 31

Study of the figure of St John of Damascus for a mosaic
pendentive in the Cappella della Colonna in St Peter's, Rome.
In 1631 Andrea Sacchi was commissioned to prepare cartoons
for four of the eight pendentives in the Cappella della Colonna
and the Cappella di San Michele Arcangelo in St Peter's. The
cartoon for St John of Damascus was ordered in 1632. Sacchi
received payments for this – in all 200 Scudi – from December
1632 to May 1635. The mosaic was carried out by G. B.
Calandra between March 1635 and March 1636. The cartoon
by Sacchi has apparently not survived and so far only the
present study has been traced.

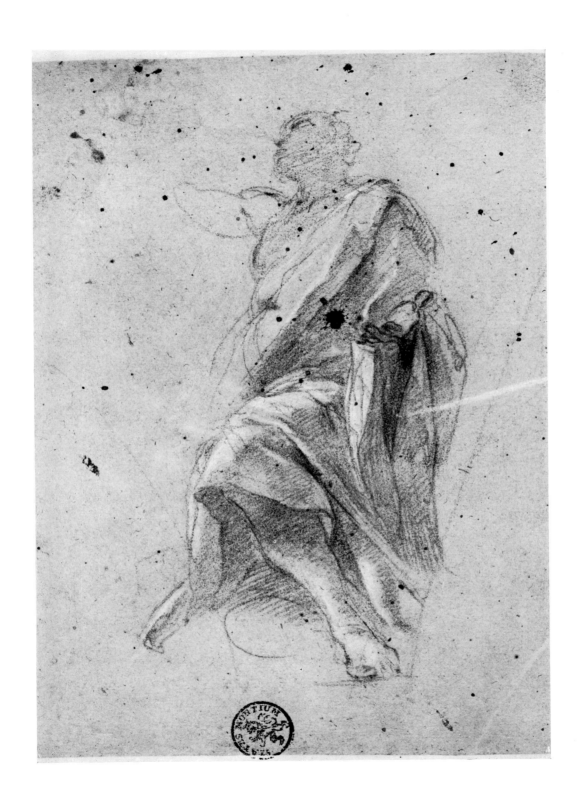

Numerals top left in lead pencil: *128*;
bottom right in pen and brown ink: *6*
Bottom left, a stamp: *Status Montium*
On the verso notes in lead pencil: *2 florin*
and *And. Sachi* and numerals in pen and
brown ink: *64*
Red chalk, traces of black chalk,
heightened with white, on yellow-brown
paper, 380 × 260 mm.
Strips of an old mount adhere to the
upper edge of the sheet. Paint marks and
oil stains
Inv. No. FP 8124 recto
1932 Inventory: Studies. Unknown artist
Bibliography: Cat. Exh. *Düsseldorf 1964*,
no. 144, pl. 16; *KSM*, no. 35, pl. 14;
A. Sutherland Harris, *Andrea Sacchi* (to
be published soon) Cat. nos. 28–9

Studies for the figure of St Peter in a painting of which two
versions are known. In contrast to the picture in the Galleria
Nazionale d'Arte Antica in Rome, the second version of this
theme in Forli in the Pinacoteca Communale shows the saint
with a landscape background (Posse, p. 74, fig. 20).
The attitude of the figure of Peter is the same in both variants,
so that the present studies could be related equally well to the
picture painted for Cardinal Antonio Barberini in Rome or to
the painting in Forli, which Ann Sutherland Harris has dated
around 1631–33.
The study lower right shows St Peter, his right hand pointing
to the open book, in the attitude in which he is shown in these
paintings. To the left there is a roughly drawn sketch of the
drapery of the cloak, and this has been redrawn carefully above.
There is also a study of the left hand holding a key. Perhaps
Peter was originally intended to hold a key in his left hand,
instead of the book. In the painting in Forli, this key has been
given to a small angel flying above the Saint. There is another
study for the figure of St Peter in the Ambrosiana in Milan
(cf. F. H. Dowley, 1959, p. 62 ff. fig. 21) as well as in the
Düsseldorf Print Room (Inv. No. FP 13243, *KSM*, no. 34).

On the verso: Studies in black chalk, heightened with white, for a
figure of Mary Magdalen. See *KSM*, no. 39

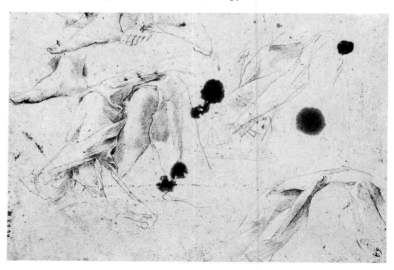

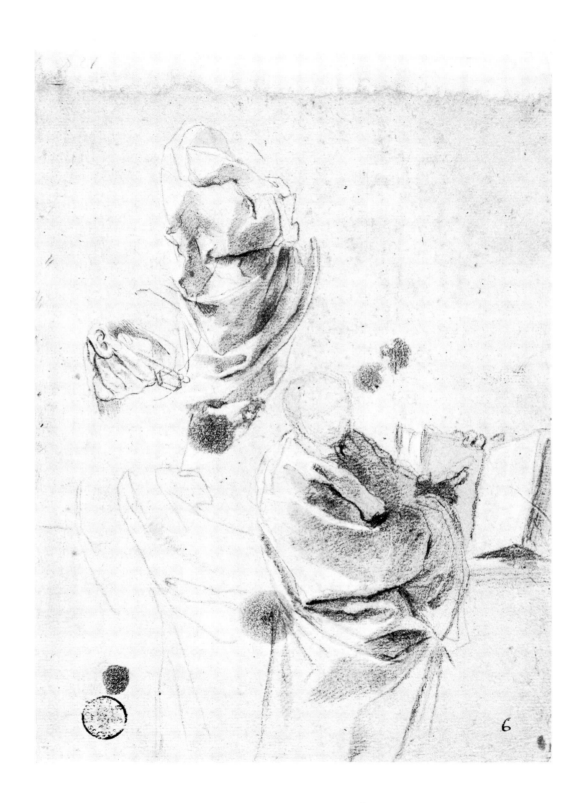

6

Bottom right, in pen and brown ink, numerals crossed through: *41*
Bottom left, a note in lead pencil: *5 flor(in)*
Bottom centre, a stamp: *Status Montium*
On the verso of the mount a note in lead pencil: *Andrea Sachi*
Red chalk, heightened with white, on yellow-brown paper, 250 × 361 mm.
The sheet is laid down on an old mount
Inv. No. FP 13676
1932 Inventory: Studies. A. Sacchi
Bibliography: Cat. Exh. *Düsseldorf 1964*, no. 142, pl. 20; *KSM*, no. 56, pl. 16; A. Sutherland Harris, *Andrea Sacchi* (to be published soon), Cat. no. 38

Studies for the altarpiece *The Martyrdom of St Longinus* (Rome, St Peter's, Sala Capitolare; Posse, pp. 55–9, fig. 18). The sheet shows three studies of the kneeling saint and to the right of these, one above the other, two studies of part of the cloak. The painting is one of the altarpieces which Sacchi painted for each of the four chapels which are in the crypt of St Peter's under the piers of the crossing. The altars contain the relics of Saints Andrew, Veronica, Helena and Longinus, the same saints of whom monumental statues were placed in the piers of the crossing (see Cat. no. 1). Payments for these paintings are recorded for the period from March 1633 to April 1634 (Pollak, vol. ii, pp. 516–17).
Among the studies for the figure of Longinus preserved in Windsor (Cat. *Roman drawings*, no. 763 verso) and in Düsseldorf (*KSM*, nos. 54–6), those on this sheet are the closest to the figure as it appears in the painting. Another study in the British Museum (Inv. No. Fawkener 5211–79) relates, as Ann Sutherland Harris (*KSM*, p. 42) has shown, to the spectator in the left background of the painting.

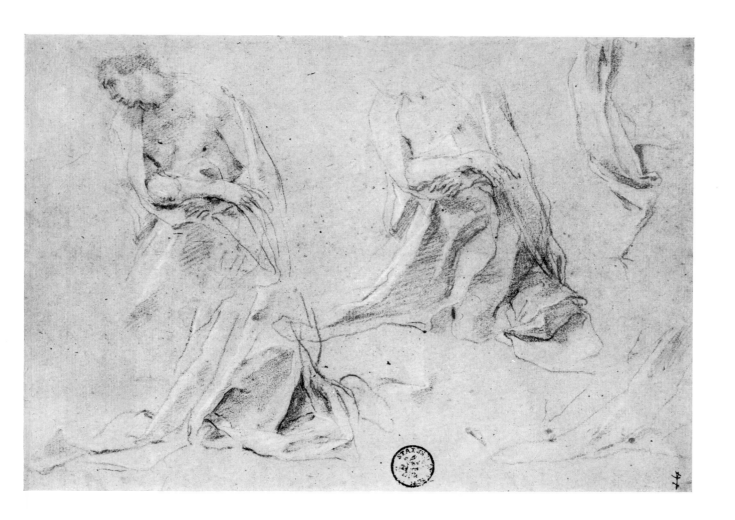

Bottom left, a note in lead pencil: *5 flor(in)*

Bottom right, numerals in pen and brown ink: *81;* to the left of these, a stamp: *Status Montium*

On the verso in lead pencil, a note: *And. Sachi* and numerals: *158*

Red chalk, heightened with white, on yellow-brown paper, 263 × 385 mm.

Inv. No. FP 14116 recto

1932 Inventory: Studies. A. Sacchi

Bibliography: Cat. Exh. *Düsseldorf 1964,* no. 145, pl. 17; *KSM,* no. 65; Cat. Exh. *Düsseldorf 1969,* no. 54, fig. 57; A. Sutherland Harris, *Andrea Sacchi* (to be published soon), Cat. no. 53

Studies for the various figures in the fresco *The Destruction of the Heathen Idols* in S. Giovanni in Fonte (the Lateran Baptistery), Rome. After the early Christian baptismal chapel of the Lateran basilica, San Giovanni in Fonte, had been reconstructed architecturally in 1625–37, Andrea Sacchi was commissioned to carry out the decoration. During the years 1641–49, Sacchi himself executed the eight paintings on the interior of the octagon which depict scenes from the life of St John the Baptist (see Cat. no. 138). On five of the interior walls of the octagonal ambulatory of the chapel there are scenes depicting the life of Constantine the Great, who enabled the Christian Church to operate openly after the period of the persecutions and to expand, and on whose land the Lateran Basilica and the Baptistery were erected.

Sacchi handed over the Constantine series of frescoes to his pupils. *The Destruction of the Heathen Idols* was painted by Carlo Maratta, his most important pupil, from a cartoon by Sacchi. Carlo Magnone (c. 1620–53) painted *The Burning of heretical Books at the Council of Nicaea,* also from a cartoon of Sacchi's and probably under his personal supervision. On the other hand, Andrea Camassei (1602–49) and Giacinto Gimignani (1611–81) painted their frescoes from their own designs. Gimignani painted *Constantine's Vision of the Cross* and *The Battle of the Milvian Bridge,* and Camassei *Constantine's Triumphal Entry into Jerusalem.*

The fresco of the *Destruction of the Heathen Idols* (Posse, pp. 85–90, fig. 25), to which the present studies and Cat. no. 135 relate, was probably carried out in 1646–47. The present sheet shows, from left to right, a study of the central figure of the fresco, the priest with a censer, a study for the priest with a processional cross, two studies for the priests' attendant with a candle. Below this, to the right and again on the left, a study for the man who in the painting stands behind the priest with the processional cross, and between these two studies a study for the acolyte with the censer.

There are in all nine sheets with studies by Sacchi for this fresco in Windsor and eight in Düsseldorf (*KSM,* no. 64–71).

On the verso: In the same technique a drapery study for the priest with a censer; study for the head and chest of a man with a helmet, shown in the fresco on the right; study for the two women behind the men who in the fresco are in the right foreground destroying the head and arm of the heathen idol

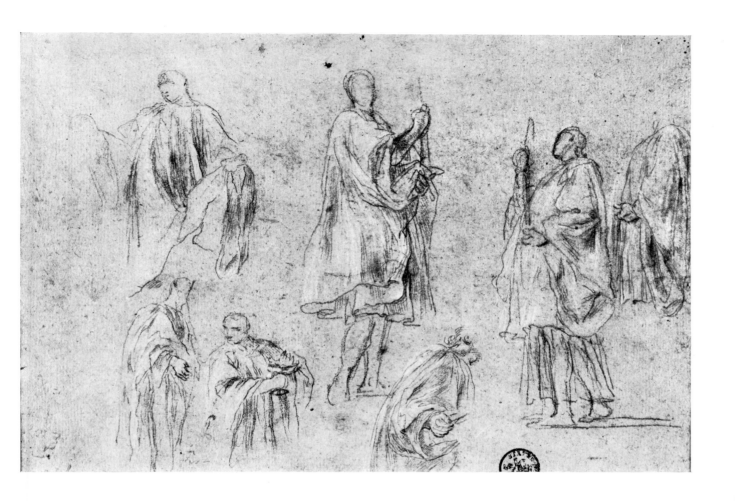

Top left, numerals in pen and brown ink:
68
Bottom right, a stamp: *Status Montium*
On the verso, a note in lead pencil: *C. Maratti*
Red chalk, partly heightened with white, on pale brown paper, 275 × 395 mm.
The sheet has been divided vertically into two halves and joined together again
Inv. No. FP 13808 recto
1932 Inventory: Studies. C. Maratti
Bibliography: Cat. Exh. *Düsseldorf 1964*, no. 146, pl. 18; *KSM*, no. 67, pl. 27; A. Sutherland Harris, *Andrea Sacchi* (to be published soon), Cat. no. 53

For the fresco executed by Carlo Maratta from Andrea Sacchi's cartoon in S. Giovanni in Fonte, Rome, see Cat. no. 134. The sheet shows three nude studies. The central one is related to the central figure in the fresco, a priest with a censer. The studies on the right and left are for the two acolytes who stand on each side of this priest in the fresco holding candlesticks with burning candles. There are also two studies for the priest's hands and the censer. Top right, at right angles, drapery studies for Elizabeth's left shoulder in Sacchi's painting *The Visitation* from the life of St John the Baptist painted for S. Giovanni in Fonte (see Cat. nos. 134 and 138).

On the verso: In red chalk, diagrammatic and barely identifiable studies of architecture. Ann Sutherland Harris thinks they may be connected with wall measurements in the Baptistery carried out during the early stages of designing the frescoes, but admits the possibility that they may relate to other commissions of this period

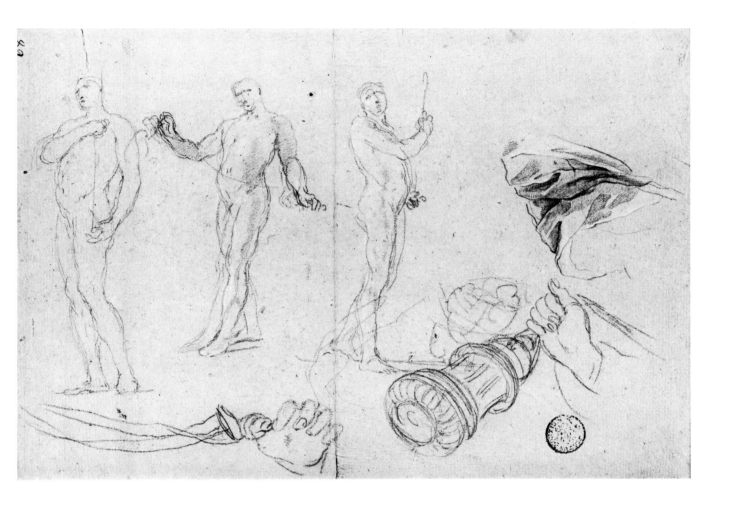

Bottom right, numerals in pen and brown
ink: *(1)32* and *58* crossed through
Left centre a stamp: *Status Montium*
On the verso a note in lead pencil: *A.
Sachi* and *f(lorin) 3*
Red chalk, heightened with white, on
yellow-brown paper, 257 × 360 mm.
Strip of an old mount along the upper
edge of the sheet
Inv. No. FP 14108 recto
1932 Inventory: Study. A. Sachi
Bibliography: Cat. Exh. *Düsseldorf 1964*,
no. 149, pl. 19; *KSM*, no. 68;
A. Sutherland Harris, 'Drawings by
Andrea Sacchi: additions and problems'
in *Master Drawings*, vol. 9, no. 4, 1971,
p. 385, pl. 32b; the same, *Andrea Sacchi*
(to be published soon), Cat. no. 53

Two studies of a youth in profile with a dish in his raised
hands. There is also a study for the youth's left arm. He is
drawn nude on the left and draped on the right. Eckhard Schaar
(Cat. Exh. *Düsseldorf 1964*) tentatively related these studies to
Sacchi's frescoes painted in the late 1620s in the Villa Sacchetti
in Castelfusano. This seemed unlikely to Ann Sutherland Harris
on grounds of style. Yet so far no work by Sacchi from the late
forties or the fifties has been found or identified from written
sources, with which these studies could be connected.

On the verso: Three studies in the same technique for a youth striding
to the right and a hastily drawn study of a shoulder and right arm,
presumably of the same figure. Ann Sutherland Harris has tentatively
related these studies with the figure of the boy wearing a helmet in
the fresco *The Destruction of the Heathen Idols* in S. Giovanni in Fonte,
Rome (Posse, fig. 25, see also Cat nos. 134 and 135).

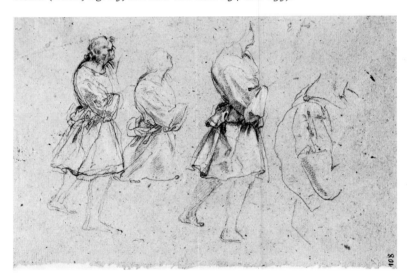

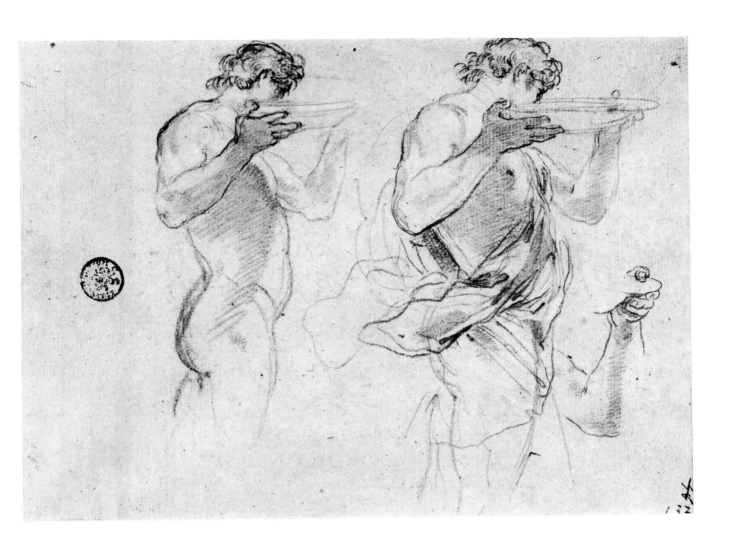

2

Bottom left, a note in lead pencil: *5 flor(in)*
Numerals in pen and brown ink, top right: *66;* bottom right: *24*
Centre left, a stamp: *Status Montium*
On the verso in lead pencil, a note: *And. Sachi*
Red chalk, heightened with white, on beige paper, 400 × 260 mm.
Missing piece from bottom right corner of sheet. On the verso, at the bottom edge of the sheet, a strip still adheres from an old mount
Inv. No. FP 13599 recto
1932 Inventory: Studies. Unknown artist
Bibliography: *KSM*, no. 71;
A. Sutherland Harris, *Andrea Sacchi* (to be published soon), Cat. no. 53

Drapery study for a man seated on a podium, turning to the left. Over this two studies for details of drapery.
The study, which is particularly beautiful in the thoroughness of its execution, is, in comparison with Sacchi's other drawings, on a relatively large scale. It cannot be related to any of his paintings, nor to the frescoes carried out by his pupils in the Baptistery of the Lateran (compare Cat. no. 134).

On the verso: Studies in red chalk for the fresco carried out by Carlo Maratta from Sacchi's cartoon *The Destruction of the Heathen Idols* in the Lateran Baptistery (Posse, fig. 25, see also Cat nos. 134–35). At the top, drapery study for the female figure shown bottom left in the fresco. Below that drapery study for the man with the shrunken arms, also on the left of the fresco, and two drapery details.
The fresco was painted around 1646–47. This is also the probable date of the studies on the recto, which are in the same style

Bottom right, in pen and brown ink, numerals which have been crossed through: *52*
Bottom left, in lead pencil: *5 flor(in)*
Bottom centre, a stamp: *Status Montium*
On the verso of the mount, a note in lead pencil: *Andrea Sachi*
Red chalk, heightened with white, on beige paper, 248 × 395 mm.
Bottom left, large oil stain. The sheet is fastened along its lower edge to an old mount
Inv. No. FP 12451 recto
1932 Inventory: Studies. Andrea Sacchi
Bibliography: *KSM*, no. 78, pl. 24;
A. Sutherland Harris, *Andrea Sacchi* (to be published soon), Cat. no. 58

Studies for the figure of Elizabeth in Sacchi's painting *The Blessing of the Baptist before his Sojourn in the Wilderness.* This is one of a cycle of eight oil paintings of scenes from the life of St John the Baptist, painted by Sacchi between 1641–49 for San Giovanni in Fonte in Rome.
The study of the face and upper part of the body for the figure of Elizabeth, who is holding John's cloak in her raised arms, is surrounded by other detailed studies of her hands and of the drapery. The studies relate closely to their counterpart in the finished painting.
The cycle also deals with the following subjects: The Annunciation to Zacharias (Posse, fig. 29); The Visitation (see Cat. no. 135); The Birth of St John; The Naming; St John Preaching; The Baptism of Christ; The Beheading of John the Baptist (Posse, fig. 30, see also Cat. no. 9). The Düsseldorf Print Room has studies for six of these paintings (*KSM*, nos. 67, 72–82), but not for the Annunciation to Zacharias or The Beheading of St John.

On the verso: Drapery studies in the same technique for Zacharias and two drapery studies for the figure of Elizabeth, shown seated in the painting

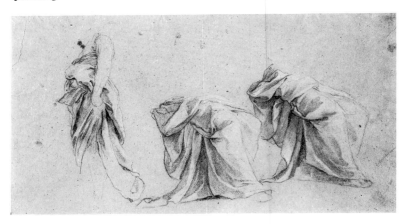

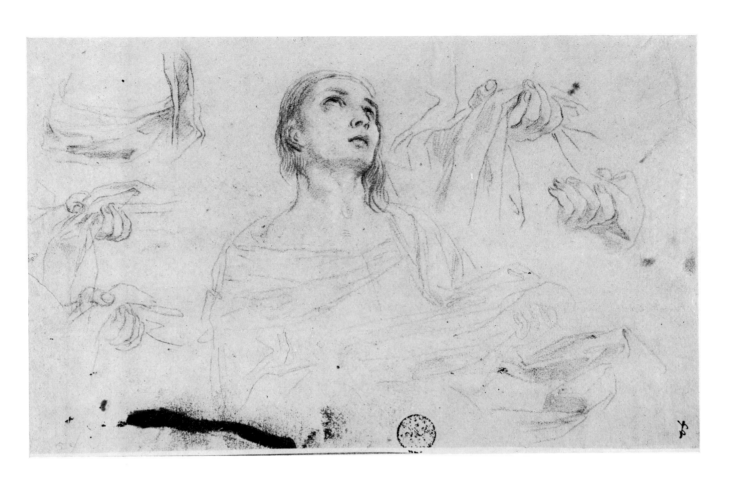

Along the lower edge of the sheet, an illegible note in red chalk
On the upper edge of the sheet, the fragment of a stamp: *Status Montium*
On the verso, a note in pen and brown ink: *L'h* (?) *umana/deimano* (?) *splendore/ breve baleno* (?)
Red chalk on pale beige paper, 164 × 214 mm.
Inv. No. FP 470 recto
Krahe, *Inv. II*, fol. 28 verso, No. 33: *Noé enivré. Deux Pieces de différente invention, 6 × 8 Pouces*, as Andrea Sacchi *1932 Inventory:* The drunken Noah. Andrea Sacchi
Bibliography: Voss, p. 690; Cat. Budde, no. 68, pl. 15; Cat. Exh. *Düsseldorf 1964*, no. 143; *KSM*, no. 83; A. Sutherland Harris, *Andrea Sacchi* (to be published soon), Cat. no. 73

Design for Sacchi's painting in the Staatliche Museen in East Berlin (Posse, p. 103 f., pl. xix). Ham's left arm has been redrawn in the upper part of the sheet.
Ham, one of Noah's sons, is jeeringly drawing the attention of his brothers Shem and Japheth to their father, who, in his drunkenness, has uncovered himself. Shem and Japheth cover Noah with a cloth (Genesis 9, 21–7).
Although the composition of the picture has already reached an advanced stage in this design, the painting contains some important alterations. In the painting Noah is lying under a tree surrounded by vines. Shem and Japheth, seen here from the front, are turning towards each other and are transposed to the centre of the picture. Ham is not sharply foreshortened, as in the design, but is standing still, his body turned to the right, looking towards the spectator and pointing with both hands at the drunken Noah.
The painting should be dated about 1645. Ann Sutherland Harris has emphasized the difficulties of relating this drawing on the basis of technique and style with other compositional designs by Sacchi, of which only a relatively small quantity has survived and which, moreover, vary considerably from each other. She considers it shows a resemblance to Bernini's drawings, dating from the late 1650s, for the title page of the sermon of Padre Oliva (Brauer/Wittkower, nos. 138–39). The resemblance between Ham and the man standing in the right foreground in Bernini's studies is particularly striking.
For other versions of the painting see *KSM*, pp. 51–2, and A. Sutherland Harris, *Andrea Sacchi*, Cat. no. 73. As Ann Sutherland Harris kindly informed me, the prime original, the *Noah* painted for Cardinal Antonio Barberini, is now in Catanzaro. The painting can be traced back to the Barberini Collections, whereas the Berlin picture cannot be.

On the verso: Studies in red chalk

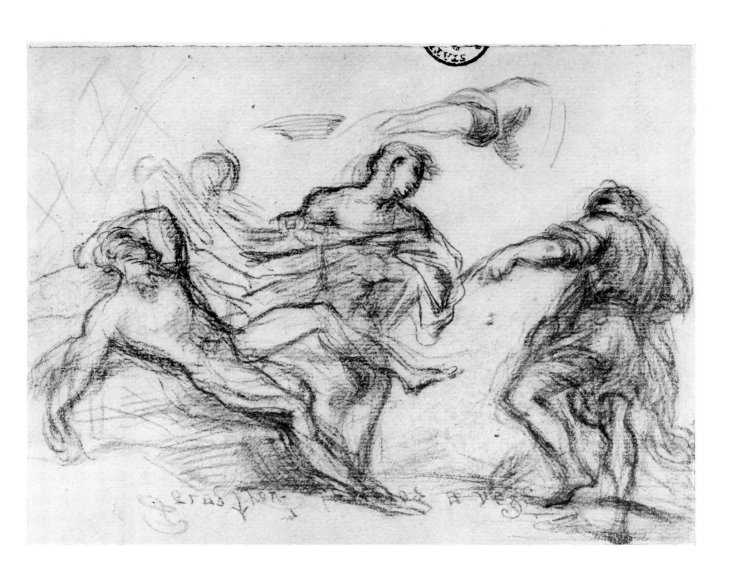

Bottom left, note in lead pencil: *2 flor(in)*
Bottom right, numerals in pen and brown ink: *11*
Bottom centre, a stamp: *Status Montium*
On the back of the mount, a note in lead pencil: *And Sachi*
Black chalk, heightened with white, on greenish-grey paper, 235 × 364 mm.
On the right, water stains. The sheet is laid down on an old mount
Inv. No. FP 13063
1932 Inventory: Studies of drapery. A. Sacchi
Bibliography: *KSM*, no. 90;
A. Sutherland Harris, *Andrea Sacchi* (to be published soon), Cat. no. 80

Three studies of a kneeling figure, turned to the right, for Mary with the Infant Christ in Andrea Sacchi's painting *The Dream of Joseph* in the Roman church S. Giuseppe a Capo le Case.
As Bellori (p. 75), Passeri (p. 304) and Pascoli (vol. i, p. 17) state, the fresco is the last that Sacchi finished as a public commission (Posse, pp. 112–13, fig. 32). It must have been painted around 1652, and the very flowing, painterly and soft modelling of the present study endorses this dating.
Sacchi's composition was clearly very well known. Ann Sutherland Harris mentions a whole series of copies or variations. Even Giuseppe Passeri in his fresco on the same theme in S. Francesco a Ripa, Rome (third chapel on the right, cf. Waterhouse, p. 85) uses Sacchi's composition.

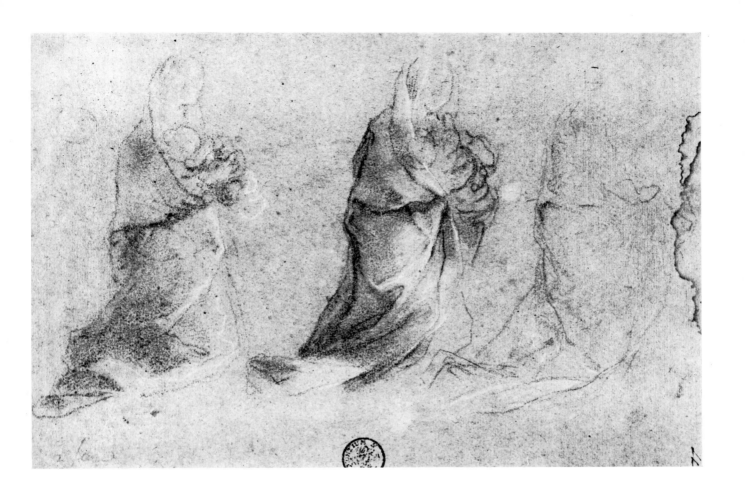

List of books referred to in abbreviated form

AMAM Bulletin Bulletin of the Allan Memorial Art Museum

Bean/Vitzthum J. Bean und W. Vitzthum, 'Disegni del Lanfranco e del Benaschi' in *Bolletino d'Arte*, anno xlvi, serie iv, 1961, pp. 106–22

Bellori G. P. Bellori, *Le vite inedite* (Guido Reni, Andrea Sacchi, Carlo Maratta), ed. M. Piacentini, Rome, 1942

Blunt, *The paintings of Nicolas Poussin* A. Blunt, *The paintings of Nicolas Poussin. A critical catalogue*, London, 1966

Blunt, *The paintings of Poussin, Plates* A. Blunt, *Nicolas Poussin*, 2 vols., London/New York, 1967

Brauer/Wittkower H. Brauer und R. Wittkower, *Die Zeichnungen des Gianlorenzo Bernini*, Römische Forschungen der Bibliotheca Hertziana, vol. ix, Berlin, 1931

Briganti G. Briganti, *Pietro da Cortona o della pittura barocca*, Florence, 1962

Brugnoli, 1956 M. V. Brugnoli, 'Inediti del Gaulli' in *Paragone*, no. 81, 1956, pp. 21–33

Campbell M. Campbell, *Mostra di disegni di Pietro Berrettini da Cortona per gli affreschi di Palazzo Pitti*, Florence, Uffizi, 15 July–15 October, 1965

Canestra Chiovenda, 1959 B. Canestra Chiovenda, 'Ciro Ferri, G. B. Gaulli e la cupola della Chiesa di S. Agnese in Piazza Navona' in *Commentari*, vol. x, 1959, pp. 16–23.

Canestra Chiovenda, 1966 B. Canestra Chiovenda, 'Cristina di Svezia, il Bernini, il Gaulli, e il libro di appunti di Nicodemo Tessin d. y. (1687–1688)' in *Commentari*, vol. xvii, 1966, pp. 171–81

Cat. Alcaide V. M. N. Alcaide, *Carlo Maratti, cuaranta y tres dibujos de tema religioso de la Real Academia de San Fernando*, Madrid, 1965

Cat. Budde I. Budde, *Beschreibender Katalog der Handzeichnungen in der Staatlichen Kunstakademie Düsseldorf*, Düsseldorf, 1930

Cat. Dreyer P. Dreyer. *Römische Barockzeichnungen aus dem Berliner Kupferstichkabinett*, Austellung Berlin, Staatliche Museen Preussischer Kulturbesitz, January–June 1969

Cat. Exh. *Bologna 1962* *L'ideale classico del Seicento in Italia e la pittura di paesaggio*, catalogo, testi critici di Francesco Arcangeli, Gian Carlo Cavalli, Andrea Emiliani, Michael Kitson, Denis Mahon, Amalia Mezzetti, Carlo Volpe, Bologna 8 September–11 November 1962 (2nd ed., November 1962)

Cat. Exh. *Düsseldorf 1964* E. Schaar, *Italienische Handzeichnungen des Barock aus den Beständen des Kupferstichkabinetts im Kunstmuseum Düsseldorf*, Ausstellung im Kunstmuseum Düsseldorf March–May 1964

Cat. Exh. *Düsseldorf 1969* E. Schaar und D. Graf, *Meisterzeichnungen der Sammlung Lambert Krahe*, Katalog der Ausstellung im Kunstmuseum Düsseldorf, 14 November 1969–11 January 1970

Cat. Exh. *Oberlin*

An exhibition of paintings, bozzetti and drawings by Giovanni Battista Gaulli, called il Baciccio, 16 January–13 February 1967, in *Bulletin of the Allan Memorial Art Museum,* vol. xxiv, no. 2, Winter 1967

Cat. Newcome

M. Newcome, *Genoese baroque drawings. A loan exhibition.* University Art Gallery at Binghampton and Worcester Art Museum, 1972

Cat. Parker

K. T. Parker, *Catalogue of the collection of drawings in the Ashmolean Museum,* vol. ii, Italian Schools, London, 1956

Cat. *Roman drawings*

A. Blunt and H. L. Cooke, *The Roman drawings of the xvii & xviii centuries in the collection of Her Majesty the Queen at Windsor Castle,* London, 1960

Chiarini

M. Chiarini, 'Gaspard Dughet. Some drawings connected with paintings' in *Burlington Magazine,* vol. cxi, 1969, pp. 750–54

Cocke

R. Cocke, *Pier Francesco Mola,* Oxford, 1972

Cocke, *Master Drawings*

R. Cocke, 'Some late drawings by Pier Francesco Mola' in *Master Drawings,* vol. 10, no. 1, 1972, pp. 25–31

F. H. Dowley, 1957

F. H. Dowley, 'Some Maratti drawings at Düsseldorf' in *Art Quarterly,* vol. xx, 1957, pp. 163–79

F. H. Dowley, 1965

F. H. Dowley, 'Carlo Maratti, Carlo Fontana, and the Baptismal Chapel in Saint Peter's' in *Art Bulletin,* vol. xlvii, 1965, pp. 57–81

Dreyer, Review of *KSM*

P. Dreyer, 'Sacchi and Maratta in the Kunstmuseum at Düsseldorf' in *Master Drawings,* vol. 7, no. 2, 1969, pp. 170–73

Enggass

R. Enggass, *The painting of Baciccio,* Pennsylvania State University Press, 1964

Faldi, *Pittori viterbesi*

I. Faldi, *Pittori viterbesi di cinque secoli,* Rome, 1970

Friedländer/Blunt

W. Friedländer and A. Blunt, *The drawings of Nicolas Poussin,* vol. 4, London, 1963

Gnudi/Cavalli

C. Gnudi and G. C. Cavalli, *Guido Reni,* Florence, 1955

Graf, 'Christ in the House of Mary and Martha'

D. Graf, 'Christ in the House of Mary and Martha. Observations concerning the creation of an altarpiece by Guglielmo Cortese' in *Master Drawings,* vol. x, no. 4, 1972, pp. 356–60

Graf, 'Guglielmo Cortese's paintings of the Assumption of the Virgin'

D. Graf, 'Guglielmo Cortese's paintings of the Assumption of the Virgin and some preliminary drawings' in *Burlington Magazine,* vol. cxv, no. 1, 1973, pp. 24–31.

Haskell

F. Haskell, *Patrons and painters. A study in the relations between Italian art and society in the age of the Baroque,* London, 1963

Katalog der Handzeichnungen der Albertina, vol. iii

A. Stix and L. Fröhlich-Bum, *Die Zeichnungen der toskanischen, umbrischen und römischen Schulen. Beschreibender Katalog der Handzeichnungen in der Graphischen Sammlung Albertina,* vol. iii, Vienna, 1932

Knab, *I grandi disegni* W. Koschatzky, K. Oberhuber, E. Knab, *I grandi disegni italiani dell'Albertina di Vienna*, Milan, 1972

Kruft H. W. Kruft, 'Zeichnungen der Sammlung Lambert Krahe', review of the Exhibition *Düsseldorf 1969* in *Kunstchronik*, vol. 23, 1970, pp. 85–9

KSM A. Sutherland Harris and E. Schaar, *Die Handzeichnungen von Andrea Sacchi und Carlo Maratta*, Kataloge des Kunstmuseums Düsseldorf, Serie III, vol. 1, Düsseldorf, 1967

Küffner M. Küffner, 'Meisterzeichnungen der Sammlung Lambert Krahe', review of the Exhibition *Düsseldorf 1969* in *Pantheon*, vol. 29, 1971, pp. 169–72

Lanckoronska K. Lanckoronska, *Decoracja Kosciola 'Il Gesù' na tle Rozwoju Barocku w Rzymie*, Lwów, 1935

Le Blanc Ch. Le Blanc, *Manuel de l'amateur d'estampes*, 4 vols., Paris, 1854

Lee, 'Mola and Tasso' R. W. Lee, 'Mola and Tasso' in *Studies in Renaissance and Baroque art presented to Sir Anthony Blunt*, London, 1967, pp. 136–41

Macandrew H. Macandrew, 'I. Baciccio's early drawings: a group from the artist's first decade in Rome' in *Master Drawings*, vol. 10, no. 2, 1972, pp. 111–25

Macandrew/Graf H. Macandrew, in collaboration with D. Graf, 'II. Baciccio's later drawings: A re-discovered group acquired by the Ashmolean Museum' in *Master Drawings*, vol. 10, no. 3, 1972, pp. 231–59

Mezzetti A. Mezzetti, 'Contributi a Carlo Maratti' in *Rivista dell' Istituto Nazionale D'Archeologia e Storia dell'Arte*, n.s., anno iv, 1961, pp. 253–354

Pascoli L. Pascoli, *Vite de' pittori, scultori ed architetti moderni*, 2 vols., Rome, 1730–34. Reprint Amsterdam, 1965

Passeri G. B. Passeri, *Vite de' pittori, scultori ed architetti, dall'anno 1641 sino all'anno 1673*, Rome, 1773. Ed. J. Hess, Leipzig, 1934

Pollak O. Pollak, *Die Kunsttätigkeit unter Urban VIII*, 2 vols., Vienna, 1927–31

Posse H. Posse, *Der römische Maler Andrea Sacchi*, Leipzig, 1925

Roli R. Roli, *I disegni italiani del seicento*, Treviso, 1969

Rosenberg P. Rosenberg, *I disegni dei maestri. Il seicento francese*, Milan, 1971

Salvagnini F. A. Salvagnini, *I pittori borgognoni cortese (courtois) e la loro casa in Piazza di Spagna*, Rome, 1937

Schaar E. Schaar, 'G. B. Gaullis Düsseldorfer Entwürfe zur Sala del Maggior Consiglio in Genua' in *Jahrbuch der Hamburger Kunstsammlungen*, vol. 17, 1972, pp. 53–66

Schleier, 1962 E. Schleier, 'Lanfranco's "Notte" for the Marchese Sannesi and some early Drawings' in *Burlington Magazine*, vol. civ, 1962, pp. 246–57

Schleier, 1968 E. Schleier, 'Vouet's destroyed St Peter Altar-piece: Further evidence' in *Burlington Magazine*, vol. cx, 1968, pp. 273–74

Schleier, 'Aggiunte a Guglielmo Cortese' E. Schleier, 'Aggiunte a Guglielmo Cortese, detto il Borgognone' in *Antichita Viva*, no. 1, 1970, pp. 3–25

Shearman J. Shearman, 'Gaspard not Nicolas' in *Burlington Magazine*, vol. cii, 1960, pp. 326–29

Soprani/Ratti R. Soprani und C. G. Ratti, *Delle vite de' pittori, scultori, ed architetti genovesi*, 2 vols., Genoa, 1769

Sutherland Harris, *New drawings by Bernini* A. S. Harris, 'New drawings by Bernini for "St Longinus" and other contemporary works' in *Master Drawings*, vol. 6, no. 4, 1968, pp. 383–91

Sutton D. Sutton, 'Gaspard Dughet. Some Aspects of his Art' in *Gazette des Beaux-Arts*, 6me période, vol. lx, 1962, pp. 269–312

Torriti P. Torriti, 'Marcantonio Franceschini's drawings for the frescoes in the Sala del Maggior Consiglio, Ducal Palace, Genoa' in *Burlington Magazine*, vol. civ, 1962, pp. 423–28

Vitzthum W. Vitzthum, 'Drawings from the collection of Lambert Krahe at Düsseldorf', review of the Exhibition *Düsseldorf 1969* in *Burlington Magazine*, vol. cxii, 1970, p. 188

Vitzthum, *Il barocco a Roma* W. Vitzthum, *I disegni dei maestri. Il barocco a Roma*, Milan, 1971

Voss H. Voss, *Die Malerei des Barock in Rom*, Berlin, 1924

Waterhouse E. K. Waterhouse, *Baroque painting in Rome*, London, 1937

Wittkower R. Wittkower, *Gian Lorenzo Bernini, The Sculptor of the Roman Baroque*, 2nd ed., London, 1966